15.95

ART SPEAK

D0311303

OFFICIALLY WITHDRAWN

ART SPEAK

A Guide to Contemporary

Ideas, Movements, and Buzzwords

Robert ATKINS

Abbeville Press Publishers New York

This book is dedicated to Sylvia and Leonard Atkins and to Steven Watson, in appreciation of their loving support.

Editor: Nancy Grubb
Designer: Scott W Santoro/WORKSIGHT
Production Editor: Laura Lindgren
Picture Editor: Robin Mendelson
Production Supervisor: Hope Koturo

Compilation copyright © 1990 Cross River Press, Ltd. Text copyright © 1990 Robert Atkins. All rights reserved under international copyright conventions. No part of this book may be reproduced or utilized in any form or by any means, electronic or mechanical, including photocopying, recording, or by any information storage and retrieval system; without permission in writing from the publisher. Inquiries should be addressed to Abbeville Press, 488 Madison Avenue, New York, N.Y. 10022. Printed and bound in Hong Kong.

First edition, second printing

Library of Congress Cataloging-in-Publication Data
Atkins, Robert.
 ArtSpeak: a guide to contemporary ideas, movements, and buzzwords.
1. Art, Modern—20th century—Dictionaries.
I. Title. II. Title: ArtSpeak
N6490.A87 1990 700'.9'045 89-18465
ISBN 1-55859-127-3
ISBN 1-55859-010-2 (pbk.)

"Artspeak" is a trademark of Art Liaison, Inc., 253 West 28th Street, Suite 407, New York, New York 10001, the publisher of "Artspeak" magazine, and is used by arrangement with Art Liaison, Inc.

CONTENTS

MOVEMENTS	1950	1960	1970	1980
ABSTRACT EXPRESSIONISM	• • • • • • • • • • • • •			
COBRA	• • • •			
BAY AREA FIGURATIVE STYLE	• • • • • • • • • • • • • •			
ASSEMBLAGE	• •			
ART INFORMEL	• • • • • • • • • •			
JUNK SCULPTURE	• • • • • • • • • •			
COLOR-FIELD PAINTING		• • • • • • • • • • • • • • • • • • •		
CHICAGO IMAGISM		• •		
NEO-DADA		• • • • • • • • • • • • • • •		
CERAMIC SCULPTURE		• •		
SITUATIONISM		• • • • • • • • • • • • • • • •		
NOUVEAU REALISME		• • • • • • • • • •		
POP ART		• • • • • • • • • • • •		
HARD-EDGE PAINTING		• • • • • • • • • • • •		
ACTION/ACTIONISM		• •		
SNAPSHOT AESTHETIC		• •		
PRINT REVIVAL		• •		
FLUXUS		• • • • • • • • • •		
SHAPED CANVAS		• • • • • • • • • •		
MINIMALISM		• • • • • • • • • • • • • • • • • •		
HAPPENING		• • • • • • •		
OP ART		• • • • •		
LOS ANGELES "LOOK"		• • • • • • • •		
PROCESS ART		• • • • • • • • • • • • •		
ART AND TECHNOLOGY		• • • • • • • • • • • • •		
FUNK ART		• • • • • • • • • • • • • •		
PHOTO-REALISM		• • • • • • • • • • • • • • • •		
ARTE POVERA		• • • • • • • • • • • • • • • • • •		
CONCEPTUAL ART		• • • • • • • • • • • • • • • • • • •		
EARTH ART		• • • • • • • • • • • • • • • •		
NEW REALISM		• • • • • • • • • • • • • • • •		
NARRATIVE ART		• •		
VIDEO ART		• •		
ARTISTS' BOOKS			• • • • • • • • • • • • • •	
BODY ART			• • • • • • • • • • • • •	
LIGHT-AND-SPACE ART			• • • • • • • • • • • • •	
FASHION AESTHETIC			• •	
FEMINIST ART			• •	
PERFORMANCE ART			• •	
PUBLIC ART			• •	
"BAD" PAINTING			• • • • • • • • • •	
SOUND ART			• • • • • • • • • •	
HIGH-TECH ART			• •	
INSTALLATION			• •	
MEDIA ART			• •	
POLITICAL ART			• •	
CRAFTS-AS-ART			• • • • • • • • • • • • • • • • • • • •	
SOTS ART			• • • • • • • • • • • • • • • • • • • •	
NEW IMAGE			• • • • • • • • • • •	
PATTERN AND DECORATION			• • • • • • • • • • •	
FABRICATED PHOTOGRAPHY			• • • • • • • • • • • • • • •	
MANIPULATED PHOTOGRAPHY			• • • • • • • • • • • • • • • •	
GRAFFITI ART			• • • • • • • • • • • •	
NEO-EXPRESSIONISM				• • • • • • • • • •
TRANSAVANTGARDE				• • • • • • • • • •
APPROPRIATION				• • • • • • • • • •
EAST VILLAGE ART				• • • • • • •
NEO-GEO				• • • • •

Words in CAPITALS are defined in the entries (pages 35–160).

ABSTRACT EXPRESSIONISM

Mid-1940s through 1950s

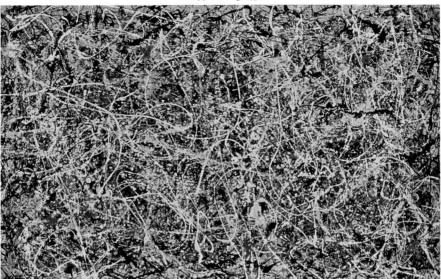

1945

THE WORLD

Franklin D. Roosevelt dies; Harry S. Truman becomes U.S. president.

U.S. drops atomic bomb on Hiroshima and Nagasaki.

World War II ends.

United Nations Charter signed in San Francisco.

U.S. Federal Communications Commission (FCC) sets aside twelve channels for commercial television.

Roberto Rossellini directs *Open City*, establishing neo-realism in film.

JACKSON POLLOCK (1912–1956).
No. 1, 1949. Duco and aluminum on canvas, 63 1/8 x 102 1/8 in. Museum of Contemporary Art, Los Angeles; The Rita and Taft Schreiber Collection. Given in loving memory of my husband, Taft Schreiber, by Rita Schreiber.

THE ART WORLD

Jean Dubuffet coins the term ART BRUT.

The Dutch painter Hans van Meegeren is convicted of forging paintings by the seventeenth-century Dutch artist Jan Vermeer.

Influential Henri Matisse retrospective, Paris.

Salvador Dali designs the dream sequence for Alfred Hitchcock's film *Spellbound*.

1946

THE WORLD

French war in Vietnam begins.

Nuremburg trial ends in conviction of fourteen Nazi war criminals.

Winston Churchill delivers a controversial speech in Fulton, Missouri, warning of the threat that lies behind a Communist "iron curtain."

BAY AREA FIGURATIVE STYLE
Late 1940s to early 1960s

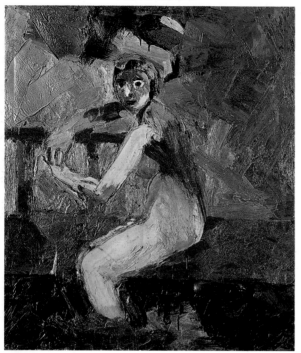

JOAN BROWN (b. 1938).
Lolita, 1962. Oil on canvas, 72 x 60 in. Private collection.

Xerography is invented.

THE ART WORLD

The term ABSTRACT EXPRESSIONISM is first applied to contemporary New York painting, by Robert Coates.

1947

THE WORLD

India becomes independent from Great Britain and is partitioned into India and Pakistan.

Jackie Robinson becomes the first African-American to be hired by a major league baseball team.

THE ART WORLD

Institute of Contemporary Arts is founded in London.

1948

THE WORLD

Marshall Plan is passed by U.S. Congress, providing $17 billion in aid for European economic recovery.

Truman is elected U.S. president.

Organization of American States (OAS) is established.

Mahatma Gandhi is assassinated in India.

State of Israel is founded.

Transistor is invented.

THE ART WORLD

Georges Braque receives first prize at Venice Biennale.

1949

THE WORLD

North Atlantic Treaty Organization (NATO) is established.

Mao Ze-dong proclaims People's Republic of China.

USSR tests its first atomic bomb.

Apartheid is enacted in South Africa.

Simone de Beauvoir publishes *The Second Sex*.

George Orwell publishes *1984*.

THE ART WORLD

First COBRA exhibition, Amsterdam.

1950

THE WORLD

Korean War begins.

Senator Joseph McCarthy charges that the U.S. State Department has been infiltrated by Communists.

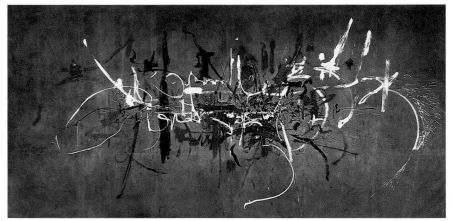

FCC authorizes color-television broadcasts in U.S.

GEORGES MATHIEU (b. 1921).
The Capetians Everywhere, 1954. Oil on canvas, 9 ft. 7 in. x 19 ft. 7 in.
Musée National d'Art Moderne, Centre Georges Pompidou, Paris.

THE ART WORLD

The Irascibles, a group of AVANT-GARDE New York artists, protest the conservative policies of the Metropolitan Museum of Art.

Arshile Gorky, Willem de Kooning, and Jackson Pollock represent U.S. at Venice Biennale.

1951

THE WORLD

Churchill becomes British prime minister again.

Ethel and Julius Rosenberg are sentenced to death for espionage (executed in 1953).

First transcontinental television broadcast, San Francisco to New York.

Rachel Carson publishes *The Sea around Us*, which spurs environmental awareness.

THE ART WORLD

Last COBRA exhibition, Liège.

The influential *Dada Painters and Poets*, edited by Robert Motherwell, is published.

Jean Dubuffet spreads the ART BRUT gospel with his "Anticultural Positions" lecture at the Chicago Arts Club.

Festival of Britain signals postwar cultural renewal in London.

1952

THE WORLD

Dwight D. Eisenhower is elected U.S. president.

Elizabeth II assumes British throne.

U.S. explodes first hydrogen bomb.

Chinese Premier Jou En-lai visits Moscow.

Samuel Beckett publishes *Waiting for Godot*.

THE ART WORLD

Michel Tapié publishes *Un Art autre* (*Another Art*), which popularizes the term ART INFORMEL.

Harold Rosenberg coins *Action painting* as a synonym for ABSTRACT EXPRESSIONISM.

Independent Group is formed at Institute of Contemporary Arts, London; it will be instrumental in the development of POP ART.

COLOR-FIELD PAINTING
Mid-1950s to late 1960s

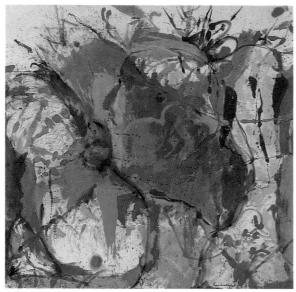

HELEN FRANKENTHALER (b. 1928).
Before the Caves, 1958. Oil on canvas, 102 3/8 x 104 3/8 in. University Art Museum, University of California at Berkeley; Anonymous gift.

1953

THE WORLD

Soviet premier Joseph Stalin dies, succeeded by Georgy M. Malenkov; Nikita S. Khrushchev is appointed first secretary of the Communist party.

Korean War ends.

Dag Hammarskjöld becomes United Nations secretary-general.

Double-helix structure of DNA is discovered.

Alfred Kinsey publishes *Sexual Behavior in the Human Female*; Hugh Hefner founds *Playboy* magazine.

THE ART WORLD

First São Paulo Bienal.

1954

THE WORLD

Gamal Abdal Nasser seizes power in Egypt.

Algerian War begins.

U.S. Supreme Court rules segregation by race in public schools unconstitutional.

U.S. Senate censures Joseph McCarthy.

The French are defeated at Dienbienphu; Vietnam is divided into the Democratic Republic of Vietnam and the Republic of Vietnam; U.S. involvement begins.

THE ART WORLD

GUTAI group is founded in Osaka.

Peter Voulkos establishes ceramics center at Otis Art Institute, Los Angeles.

1955

THE WORLD

African-Americans boycott segregated city buses in Montgomery, Alabama.

President Juan Domingo Perón is ousted in Argentina.

Warsaw Treaty Organization is formed to counter NATO.

Commercial television broadcasts begin in Britain.

THE ART WORLD

First Documenta, Kassel, Germany.

The Family of Man, an exhibition of 503 pictures from 68 countries at New York's Museum of Modern Art, is the photographic event of decade; its message is "We are all one."

1956

THE WORLD

Eisenhower is re-elected U.S. president.

Nasser is elected president of Egypt and nationalizes the Suez Canal, which results in war with England,

France, and Israel.

USSR crushes resistance in Poland and Hungary.

Japan is admitted to the U.N.

Transatlantic cable telephone service is inaugurated.

Elvis Presley makes *rock 'n roll* a household phrase.

Allen Ginsberg publishes *Howl*, is tried for obscenity, and acquitted.

John Osborne's play *Look Back in Anger* is produced in London, marking the debut of Britain's Angry Young Men.

THE ART WORLD

Richard Hamilton's collage *Just What Is It That Makes Today's Home So Different, So Appealing?* regarded as the first POP ART work, is shown at the Institute of Contemporary Arts, London.

Frank Lloyd Wright builds controversial Solomon R. Guggenheim Museum in New York (completed in 1958).

NEO-DADA

Mid-1950s to mid-1960s

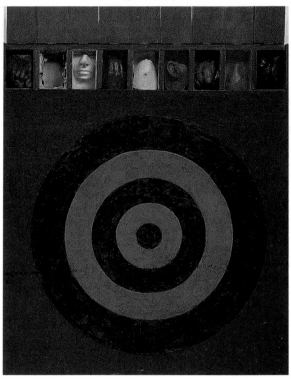

JASPER JOHNS (b. 1930).
Target with Plaster Casts, 1955. Encaustic and collage on canvas with plaster casts, 51 x 44 x 3 1/2 in. Leo Castelli, New York.

1957

THE WORLD

Common Market (European Economic Community) is established.

USSR launches Sputnik I and II, the first man-made satellites.

The first large nuclear-power plant in America opens at Shippingport, Pennsylvania.

Jean-Paul Sartre coins the term *anti-novel* to describe a non-narrative AVANT-GARDE form.

THE ART WORLD

Tatyana Grosman founds Universal Limited Art Editions in West Islip, Long Island, triggering the PRINT REVIVAL.

SITUATIONIST International is founded in Paris.

Contemporary Bay Area Figurative Painting, Oakland Museum.

ZERO is founded in Düsseldorf to stimulate dialogue between artists and scientists.

CERAMIC SCULPTURE

Since mid-1950s

ROBERT ARNESON (b. 1930).
Portrait of George, 1981. Polychrome ceramic, 94 x 31 1/2 x 31 1/4 in.
Foster Goldstrom, New York.

1958

THE WORLD

Charles de Gaulle is elected first president of France's Fifth Republic.

Pope John XXIII, a liberal, succeeds Pius XII.

Race riots in Notting Hill, London.

National Aeronautics and Space Administration (NASA) is established in the U.S.

Xerox produces first commercial copying machine.

Claude Lévi-Strauss publishes *Structural Anthropology*.

Soviets pressure Boris Pasternak to retract his acceptance of Nobel Prize for *Doctor Zhivago*.

THE ART WORLD

The term NEO-DADA first appears, in *Artnews*.

Jules Langsner coins the term HARD-EDGE PAINTING.

Lawrence Alloway first uses the term POP ART in print.

1959

THE WORLD

Cyprus is granted independence; Archbishop Makarios is elected its first president.

Fidel Castro overthrows Fulgencio Batista regime in Cuba.

Saint Lawrence Seaway opens.

French New Wave cinema becomes a force in international film.

U.S. Postmaster General bans D. H. Lawrence's *Lady Chatterley's Lover* on grounds of obscenity.

THE ART WORLD

Robert Frank's book *The Americans* introduces the SNAPSHOT AESTHETIC.

18 Happenings in 6 Parts, Reuben Gallery, New York.

First Biennale of Young Artists, Paris.

Daniel Spoerri founds Editions M.A.T. (Multiplication Arts Transformable) to produce MULTIPLES, Paris.

1960

THE WORLD

Leonid Brezhnev becomes president of USSR.

Nixon-Kennedy debates demonstrate importance of television in politics.

John F. Kennedy is elected U.S. president.

Belgium grants freedom to the Congo (now Zaire); UN forces intervene to keep peace.

Optical microwave laser constructed.

THE ART WORLD

The term POSTMODERNISM appears in Daniel Bell's *End of Sociology.*

Pierre Restany coins the term NOUVEAU REALISME.

June Wayne founds Tamarind Lithography Workshop, Los Angeles.

First exhibition of Frank Stella's SHAPED CANVASES, Leo Castelli Gallery, New York.

Groupe de Recherche d'Art Visuel (GRAV) founded to encourage art-science inter-action, Paris.

Yves Klein uses nude women as "brushes" in a public performance at Galerie Internationale d'Art Contemporain, Paris.

Jean Tinguely's *Hommage*

NOUVEAU REALISME

Late 1950s to mid-1960s

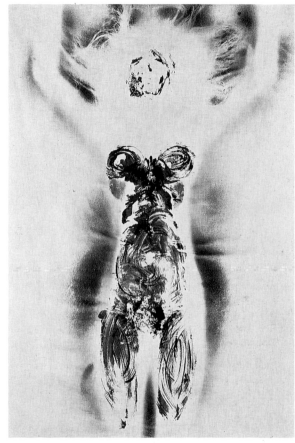

YVES KLEIN (1928–1962).
Shroud Anthropometry 20—Vampire, 1960. Pigment on canvas, 43 x 30 in. Private collection.

to New York self-destructs at the Museum of Modern Art.

1961

THE WORLD

Yuri Gargarin (USSR) orbits Earth in the first manned space flight.

Alan Shepard makes the first American manned space flight.

U.S. President Kennedy acknowledges responsibility for Cuban exiles' failed invasion of Cuba at the Bay of Pigs.

Berlin Wall erected.

POP ART

Late 1950s through 1960s

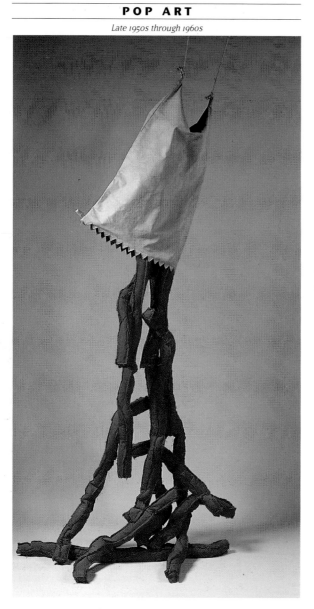

CLAES OLDENBURG (b. 1929).
Falling Shoestring Potatoes, 1965. Painted canvas and kapok, 108 x 46 x 42 in.
Walker Art Center, Minneapolis; Gift of the T. B. Walker Foundation, 1966.

Birth-control pills become available.

Henry Miller publishes *Tropic of Cancer* in U.S. after a nearly thirty-year ban for obscenity.

Dancer Rudolf Nureyev defects from USSR.

THE ART WORLD

The term FLUXUS first used by George Maciunas.

ASSEMBLAGE named by William Seitz and Peter Selz for the exhibition *The Art of Assemblage*, Museum of Modern Art, New York.

1962

THE WORLD

Cuban missile crisis triggered by American discovery of Soviet missile bases in Cuba. President Kennedy demands their removal and orders a blockade; Soviet Premier Khrushchev agrees to remove them and dismantle bases.

Pope John XXIII opens Vatican Council II in Rome to promote Christian unity.

U.S. Supreme Court declares mandatory prayer in public schools unconstitutional.

First transatlantic television broadcast via Telstar satellite.

Georges Pompidou is appointed premier of France.

The sedative thalidomide is linked to thousands of birth defects.

Exhibition of POP ART, *The New Realists*, Sidney Janis Gallery, New York.

POP ART appears on the covers of *Time, Life, Newsweek*.

1963

THE WORLD

John F. Kennedy is assassinated in Dallas; Lyndon B. Johnson becomes U.S. president.

Pope Paul VI succeeds Pope John XXIII.

Civil rights demonstrations in Birmingham, Alabama, culminate in the arrest of Martin Luther King, Jr.; 200,000 "Freedom Marchers" rally in Washington, D.C.

Nuclear test ban signed by the U.S., USSR, and Britain.

De Gaulle blocks Britain's entry into the Common Market.

Michael De Bakey first uses an artificial heart during surgery.

Betty Friedan publishes *The Feminine Mystique*.

THE ART WORLD

First exhibition of television sculpture by Nam June Paik, Wuppertal, Germany.

Soviet authorities begin campaign to suppress "artistic rebels."

Andy Warhol establishes his studio, the Factory, and shoots his first film, *Sleep*.

HARD-EDGE PAINTING

Late 1950s through 1960s

KENNETH NOLAND (b. 1924).
Inner Green, 1969. Acrylic on canvas, 97 7/8 x 28 7/8 in. Courtesy Salander-O'Reilly Galleries, Inc.

Marcel Duchamp: A Retrospective Exhibition, Pasadena Museum, Pasadena, California, marks postwar emergence of widespread interest in DADA's *eminence gris*.

1964

THE WORLD

Khrushchev replaced as Soviet prime minister by Alexei Kosygin and as party secretary by Brezhnev.

Johnson is elected U.S. president.

U.S. Congress passes Civil Rights Act, prohibiting discrimination for reason of color, race, religion, or national origin in places of public accommodation, and initiates the "War on Poverty."

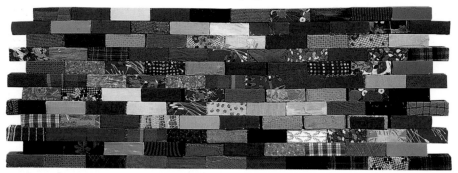

MICHELANGELO PISTOLETTO (b. 1933).
Wall of Rags, 1968. Bricks and rags, 39 3/8 x 102 3/8 x 8 5/8 in.
Gian Enzo Sperone, New York.

People's Republic of China explodes its first atomic bomb.

Free Speech movement begins in Berkeley, California.

Music becomes international language of youth; the British beat is exemplified by the Beatles, the Motown sound by the Supremes.

Martin Luther King, Jr., is awarded the Nobel Peace Prize.

Sartre declines the Nobel Prize in Literature.

Marshall McLuhan publishes *Understanding Media: The Extensions of Man*.

THE ART WORLD

The term OP ART is coined by the sculptor George Rickey.

Robert Rauschenberg receives first prize at Venice Biennale.

Vatican sends Michelangelo's *Pietà* to the New York World's Fair.

Post-Painterly Abstraction, Los Angeles County Museum.

1965

THE WORLD

India and Pakistan fight for control of Kashmir.

U.S. bombs North Vietnam; students demonstrate in Washington, D.C.

The Black Muslim leader Malcolm X is assassinated in New York.

Race riots in Watts district of Los Angeles.

THE ART WORLD

The term MINIMALISM comes into common usage.

First artist's VIDEO by Nam June Paik shown at Cafe à Go Go, New York.

National Endowment for the Arts (NEA) and National Endowment for the

Humanities (NEH) are established, Washington, D.C.

Exhibition of OP ART, *The Responsive Eye*, Museum of Modern Art, New York.

1966

THE WORLD

Indira Gandhi becomes India's prime minister.

National Organization of Women (NOW) is founded by Betty Friedan; Black Panthers is founded by Huey P. Newton and Bobby Seale.

2,000 Madrid University students clash with police in demonstration.

Cultural Revolution begins in China (ends 1969).

Mao Ze-dong publishes *Quotations of Chairman Mao*.

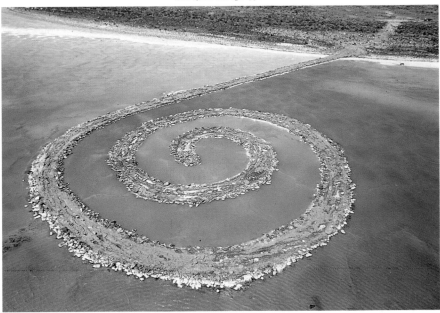

THE ART WORLD

Primary Structures, Jewish Museum, New York.

Experiments in Art and Technology (EAT) is founded in New York.

Systemic Painting, Guggenheim Museum, New York.

Robert Venturi publishes his influential POSTMODERN treatise, *Complexity and Contradiction in Architecture*.

Exhibition of Edward Kienholz's *Back Seat Dodge '38* creates furor because of its sexual content; Board of Supervisors nearly closes down Los Angeles County Museum of Art.

ROBERT SMITHSON (1938–1973).
Spiral Jetty, 1970. Black rocks, salt crystal, earth, red water, algae, length: 1,500 ft., width: 15 ft. Estate of Robert Smithson.

1967

THE WORLD

Six-Day War between Israel and Arab countries.

Bolivian troops kill Cuban revolutionary Ernesto "Che" Guevara.

China explodes its first hydrogen bomb.

Widespread antiwar demonstrations in U.S.

Race riots break out in U.S.

Christiaan N. Barnard performs first heart-transplant operation.

Rolling Stone begins publication.

THE ART WORLD

The term ARTE POVERA is coined by Germano Celant.

The term CONCEPTUAL ART is popularized.

Funk, University Art Museum, Berkeley, California.

Center for Advanced Visual Studies opens at Massachusetts Institute of Technology, Cambridge.

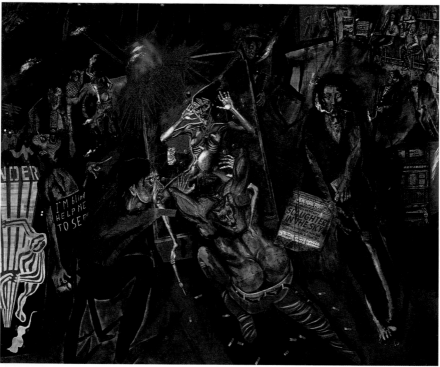

NEA establishes ART IN PUBLIC PLACES program.

1968

SUE COE (b. 1951).
Woman Walks into Bar—Is Raped by 4 Men on the Pool Table—While 20 Men Watch, 1983. Mixed media on paper mounted on canvas, 91 x 113 in. Mr. and Mrs. Werner Dannheiser.

THE WORLD

USSR invades Czechoslovakia.

Student uprisings in Europe and U.S.; general strike in Paris.

Robert F. Kennedy and Martin Luther King, Jr., are assassinated.

Pierre Trudeau becomes prime minister of Canada.

Richard Nixon is elected U.S. president.

Tet offensive by North Vietnamese army and the Viet Cong; My Lai massacre.

THE ART WORLD

Cybernetic Serendipity: The Computer and the Arts, Institute of Contemporary Arts, London.

The Machine as Seen at the End of the Mechanical Age, Museum of Modern Art, New York.

POP ART dominates Documenta 4, Kassel.

Andy Warhol is shot by Valerie Solanis, founder and sole member of SCUM (Society for Cutting Up Men), and nearly dies.

Earth Art, White Museum, Cornell University, Ithaca, New York.

Marcel Duchamp dies; his last work, *Etant donnés*

(1946–66), will be perma-
nently installed in the
Philadelphia Museum.
of Art.

1969

THE WORLD

Violent riots in Northern
Ireland between
Protestants and Roman
Catholics.

U.S. troops begin to be
withdrawn from Vietnam.

Golda Meir becomes fourth
prime minister of Israel.

U.S. spacecraft *Apollo 11*
lands on moon; Neil
Armstrong steps out onto
the moon.

Human ovum is success-
fully fertilized in test tube.

Woodstock and Altamont
music festivals.

Native Americans seize
Alcatraz Island, San
Francisco.

Stonewall Rebellion in New
York triggers Gay
Liberation.

THE ART WORLD

Exhibitions of PROCESS ART:
*When Attitudes Become
Form*, Berne Kunsthalle,
and *Procedures/Materials*,
Whitney Museum of
American Art, New York.

Judy Chicago founds first
FEMINIST ART program, at
California State University,
Fresno.

First ALTERNATIVE SPACES
open in New York.

"BAD" PAINTING

1970s

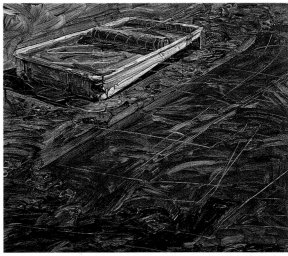

NEIL JENNEY (b. 1945).
Coat and Coated, 1970. Acrylic on canvas, 50 x 57 3/4 in. The Corcoran
Gallery of Art; Museum purchase through funds of the Friends of The
Corcoran Gallery of Art and the National Endowment for the Arts,
Washington, D.C., a federal agency.

First entirely CONCEPTUAL
exhibition, Seth Siegelaub
gallery, New York.

Art-Language begins publi-
cation, London.

1970

THE WORLD

U.S. bombs Communist
strongholds in Cambodia.

Antiwar demonstrations in
the U.S.; the National Guard
kills four students at Kent
State University in Ohio.

Marxist Salvador Allende is
elected president of Chile.

Nigerian civil war ends.

Twenty million Americans
participate in first Earth
Day.

Kate Millet publishes
Sexual Politics.

THE ART WORLD

Exhibitions of CONCEPTUAL
ART: *Information*, Museum
of Modern Art, and
Software, Jewish Museum,
both New York.

Happenings and Fluxus,
Kölnischer Kunstverein,
Cologne.

Museum of Conceptual Art
is founded by Tom Marioni
in San Francisco.

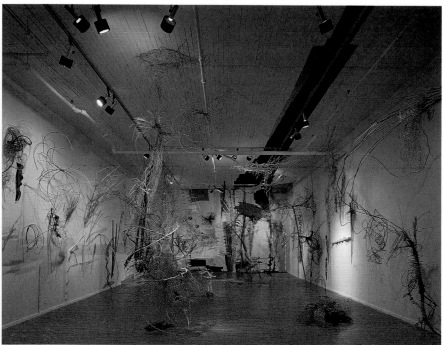

Exhibitions of SOUND ART: *Sound* (1969–70), Museum of Contemporary Crafts, New York, and *Sound Sculpture As*, Museum of Conceptual Art, San Francisco.

Conceptual Art/Arte Povera/Land Art, Galleria Civica d'Arte Moderna, Turin.

JUDY PFAFF (b. 1946).
Deep Water, 1980. Mixed-media installation. Holly Solomon Gallery, New York.

1971

THE WORLD

200,000 march on Washington to demand end of Vietnam War.

Idi Amin seizes power in Uganda.

East Pakistan achieves sovereignty and becomes Bangladesh.

U.S. Lt. William Calley convicted of premeditated murder of civilians in My Lai.

New York Times publishes the "Pentagon Papers."

Women are granted the right to vote in Switzerland.

Astronomers confirm the "black hole" theory.

Cigarette advertisements are banned from U.S. television.

Germaine Greer publishes *The Female Eunuch.*

THE ART WORLD

ART AND TECHNOLOGY program (1967–71) culminates in exhibition, Los Angeles County Museum of Art.

Robert Pincus-Witten coins the term POST-MINIMALISM.

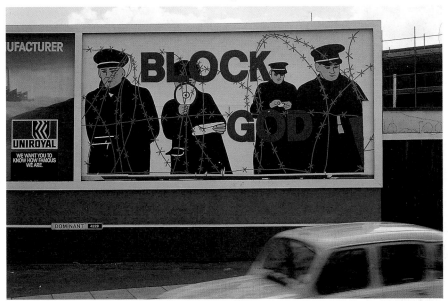

Hans Haacke's exhibition about New York real estate ownership is canceled by Guggenheim Museum, New York.

LES LEVINE (b. 1935).
Block God, 1985. Printed outdoor billboard, 10 x 22 ft. Mott Art U.S.A., Inc.

1972

THE WORLD

Watergate scandal begins with apprehension of Republican operatives in Democratic National Headquarters.

President Nixon visits China and USSR.

U.S. Supreme Court rules the death penalty unconstitutional.

Nixon is re-elected U.S. president.

Arab terrorists kill two Israeli Olympic athletes in Munich; take nine others hostage, all of whom are killed in shoot-out with police and military.

Gloria Steinem founds *Ms.* magazine (monthly publication is suspended in 1989).

The military draft is phased out in the U.S.

Moog (electronic music) synthesizer patented.

THE ART WORLD

First exhibition of ARTISTS' BOOKS, Nigel Greenwood Gallery, London.

Retrospective exhibition of photographs by Diane Arbus at Museum of Modern Art, New York, so disturbs viewers that some spit on the pictures.

Documenta 5 offers international survey of new art, including PHOTO-REALISM, Kassel.

Exhibition of CONCEPTUAL ART: *"Konzept"-Kunst*, Offentliche Kunstsammlung, Basel.

SOTS ART named by Komar and Melamid in Moscow.

1973

THE WORLD

U.S., North Vietnam, South

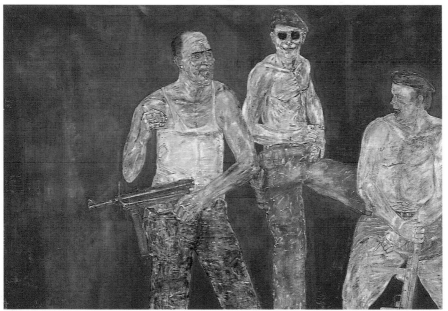

LEON GOLUB (b. 1920).
Mercenaries II, 1979. Acrylic on loose canvas, 120 x 144 in. Montreal Museum of Fine Arts; Purchase, Horsley and Annie Townsend Bequest.

Vietnam, and the National Liberation Front's provisional government sign peace treaty in Paris.

Chilean President Salvador Allende is overthrown by military junta and either commits suicide or is assassinated.

Arab oil-producing nations embargo shipments to the U.S., Western Europe, and Japan in retaliation for their support of Israel.

U.S. Supreme Court rules a state may not prevent a woman from having an abortion during the first six months of pregnancy.

THE ART WORLD

The term ARTISTS' BOOKS is coined by Dianne Vanderlip for the exhibition *Artists Books*, Moore College of Art, Philadelphia.

Auction of Robert and Ethel Scull's collection signals meteoric rise in prices for contemporary art, New York.

1974

THE WORLD

On the verge of impeachment, Nixon resigns; Gerald Ford becomes U.S. president.

Worldwide inflation and recession.

Author Aleksandr Solzhenitsyn is deported from USSR.

Patricia Hearst is kidnapped.

India becomes sixth nation to explode a nuclear device.

THE ART WORLD

International conference on VIDEO ART, "Open Circuits," is held at Museum of Modern Art, New York.

Soviet officials mow down an open-air show of unofficial art in Moscow, which becomes known as the "Bulldozer" show.

1975

THE WORLD

Civil wars in Lebanon, Angola, and Ethiopia.

Generalissimo Francisco Franco dies; Juan Carlos I becomes king of Spain.

Phnom Penh falls to Khmer Rouge troops, U.S. Embassy closes and Americans leave Cambodia.

THE ART WORLD

First exhibition of GRAFFITI ART, Artists Space, New York.

Body Works, Institute of Contemporary Art, Chicago.

1976

THE WORLD

First functional synthetic gene constructed at Massachusetts Institute of Technology, Cambridge.

Mao Ze-dong and Jou En-lai die.

North and South Vietnam are reunited after twenty-two years of separation; renamed the Socialist Republic of Vietnam.

Jimmy Carter is elected U.S. president.

THE ART WORLD

Christo's twenty-four mile *Running Fence* in northern California catapults the

ARTISTS' FURNITURE

Since 1970s

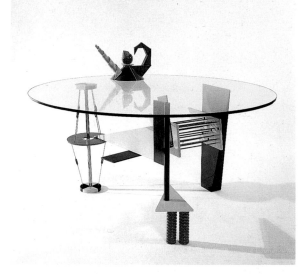

PETER SHIRE
Rod and Transit, 1984. Anodized aluminum, steel, glass, height: 29 in.; diameter: 60 in. Collection of the artist.

artist to fame.

Women Artists: 1550–1950, Los Angeles County Museum of Art.

Robert Wilson and Philip Glass first present the PERFORMANCE ART spectacle *Einstein on the Beach* at the Festival d'Avignon in France.

1977

THE WORLD

Egyptian president Anwar Sadat flies to Israel on peace mission, the first Arab leader to visit the Jewish state since its founding in 1948.

U.S. signs treaty to relinquish control of Panama Canal to Panama.

Military deposes Zulfikar Bhutto in Pakistan.

Nobel Peace Prize is awarded to Amnesty International; the 1976 Nobel Peace Prize is belatedly awarded to the Irish women Mairead Corrigan and Betty Williams.

Disco craze begins with the film *Saturday Night Fever*.

THE ART WORLD

Exhibition of EARTH ART, *Probing the Earth*, Hirshhorn Museum and

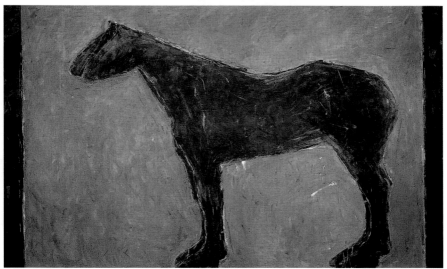

Sculpture Garden, Washington, D.C.

Susan Sontag publishes *On Photography.*

Centre National d'Art et de Culture Georges Pompidou (popularly known as the Beaubourg) opens in Paris.

U.S. tour of *The Treasures of Tutankhamen*, the biggest of the so-called blockbusters.

SUSAN ROTHENBERG (b. 1945).
Hector Protector, 1976. Acrylic and tempera on canvas, 67 x 111 5/8 in. Gagosian Gallery, New York.

1978

THE WORLD

Former Italian premier Aldo Moro is kidnapped and killed by Red Brigade terrorists.

Reverend Jim Jones and over 900 followers commit suicide at People's Temple, Guyana.

Civil war begins in Nicaragua.

First "test-tube baby" is born in Britain.

Karol Cardinal Wojtyla becomes Pope John Paul II.

THE ART WORLD

"Bad" Painting, New Museum of Contemporary Art, New York.

New Image Painting, Whitney Museum of American Art, New York.

I. M. Pei's East Building, for modern art, opens at the National Gallery of Art, Washington, D.C.

1979

THE WORLD

Israel and Egypt sign peace treaty.

Margaret Thatcher becomes Britain's prime minister.

USSR invades Afghanistan.

Seven-year war ends in Rhodesia (now Zimbabwe).

After the shah flees Iran, the Ayatollah Khomeini establishes an Islamic government; American hostages are held.

Major nuclear accident at Three Mile Island, Pennsylvania.

MIRIAM SCHAPIRO (b. 1923).
Black Bolero, 1980. Fabric, glitter, paint on canvas, 6 x 12 ft. Art Gallery of New South Wales, Australia; Purchased 1982.

Pioneer II photographs Saturn's rings.

Christopher Lasch publishes *The Culture of Narcissism*, about the "me generation."

THE ART WORLD

Frederic Edwin Church's *Icebergs* (1861) is auctioned for $2.5 million, a record price for an American painting.

Judy Chicago's *Dinner Party* opens at San Francisco Museum of Modern Art.

Hara Museum of Contemporary Art opens in Tokyo.

1980

THE WORLD

Ronald Reagan is elected U.S. president.

Green Party is formed in Germany to politicize ecological issues.

Voters in Quebec reject separatism.

Indira Gandhi becomes prime minister of India in dramatic political comeback.

Archbishop Oscar Romero is assassinated in El Salvador; civil war rages.

THE ART WORLD

Venice Biennale features major survey of international POSTMODERN architecture, *The Presence of the Past*.

Exhibition of NEW WAVE art, *Times Square Show*, New York.

Pablo Picasso retrospective at Museum of Modern Art, New York, is seen by over one million viewers.

1981

THE WORLD

François Mitterand becomes president of France.

Pope John Paul II and President Reagan are wounded in assassination attempts.

President Sadat is assassinated by Moslem extremists in Egypt.

Martial law is declared in Poland, suspending operation of the new Solidarity trade union.

Massive nuclear-disarmament demonstrations in London, Paris, Brussels, Potsdam, and Amsterdam.

GRAFFITI ART
Mid-1970s to mid-1980s

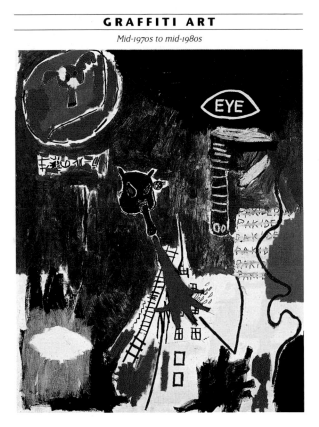

JEAN-MICHEL BASQUIAT (1960–1988).
Pakiderm, 1984. Oil and acrylic on canvas, 86 x 68 in. The Eli and Edythe L. Broad Collection, Los Angeles.

MTV debuts on U.S. television.

THE ART WORLD

Picasso's *Guernica* returns to Spain following resumption of democracy there, in accordance with the artist's wishes.

Fun Gallery opens in the EAST VILLAGE, New York (closes 1985).

Exhibition of NEO-EXPRESSIONISM, *A New Spirit in Painting*, Royal Academy, London.

1982

THE WORLD

USSR President Brezhnev is succeeded by Yuri Andropov.

Falklands War fought by Britain and Argentina over British possession of south Atlantic islands.

Equal Rights Amendment, prohibiting discrimination on the basis of sex, fails to be ratified by a sufficient number of U.S. state legislatures.

AIDS (Acquired Immune Deficiency Syndrome) is named by the U.S. Centers for Disease Control; 1,208 AIDS deaths are reported in U.S. by end of year.

Mexico defaults on international bank loans, triggering Third World debt crisis.

THE ART WORLD

Transavanguardia, Italia-America: Mostra, Galeria Civica, Modena.

Completion of Michael Graves's Portland Public Services Building draws attention to POSTMODERNISM in architecture.

Extended Sensibilities: Homosexual Presence in Contemporary Art, New Museum of Contemporary Art, New York.

1983

THE WORLD

Rául Alfonsín is elected president of Argentina, a rejection of the military government and the "disappearance" of thousands.

U.S. invades Grenada; overthrows Marxist regime.

237 U.S. Marines killed in Beirut by truck-bomb driven by pro-Iranian Shiite Moslems.

Lech Walesa, Solidarity leader, receives Nobel Peace Prize.

THE ART WORLD

Exhibition of GRAFFITI ART at Boymans–van Beuningen Museum, Rotterdam; *Post-Graffiti*, Sidney Janis Gallery, New York.

Museum of Contemporary Art opens, Los Angeles.

1984

THE WORLD

Reagan is re-elected U.S. president.

Massive rioting and school boycotts begin in South Africa; Anglican Bishop Desmond Tutu receives Nobel Peace Prize for non-violent campaign to end apartheid.

Gas leak from Union Carbide chemical plant kills some 2,500 in Bhopal, India.

Famine in Ethiopia threatens the lives of six million.

THE ART WORLD

Difference: On Representation and Sexuality, New Museum of Contemporary Art, New York.

Neue Staatsgalerie opens in Stuttgart.

1985

THE WORLD

Mikhail Gorbachev becomes general secretary of the Soviet Communist party; initiates campaigns for perestroika and glasnost.

NEO-EXPRESSIONISM
Late 1970s to mid-1980s

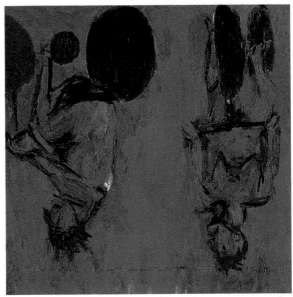

GEORG BASELITZ (b. 1938).
Die Mädchen von Olmo II (The Girls from Olmo II), 1981.
Oil on canvas, 98 1/2 x 98 1/2 in. Musée National d'Art Moderne, Centre Georges Pompidou, Paris.

1.6 billion people watch the Live Aid concert by satellite from London and help raise funds to alleviate African famine.

Rajiv Gandhi becomes prime minister of India in electoral landslide.

1986

THE WORLD

Philippine President Ferdinand Marcos is overthrown by "People Power"; Corazon Aquino becomes president.

The illegal diversion of funds to Iran for the release of hostages and the arming of Nicaraguan contras—known as the Iran-Contra scandals—comes to light in U.S.

U.S. bombs Libya in response to terrorism in the Middle East.

Accident at Chernobyl nuclear plant in USSR results in evacuation of 135,000.

The U.S. space shuttle Challenger explodes, killing entire crew.

Olof Palme, prime minister

TRANSAVANTGARDE

Late 1970s to mid-1980s

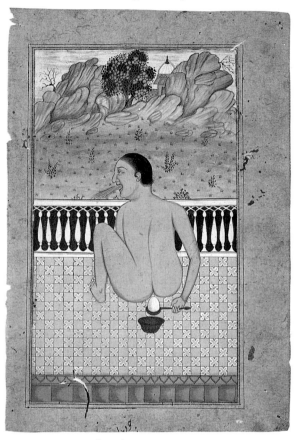

FRANCESCO CLEMENTE (b. 1952).
Francesco Clemente Pinxit (detail,one of 24 miniatures), 1981. Natural pigment on paper, 24 miniatures: 8 3/4 x 6 in. each. Virginia Museum of Fine Arts, Richmond; Gift of Sydney and Frances Lewis.

of Sweden, is assassinated.

THE ART WORLD

Exhibition of NEO-GEO, Sonnabend Gallery, New York.

The Spiritual in Art: Abstract Painting, 1890–1985, Los Angeles County Museum of Art.

Sots Art, New Museum of Contemporary Art, New York.

"Artisco" trend of artist-produced INSTALLATIONS for nightclubs peaks at Area, New York, with temporary works by Jean-Michel Basquiat, Francesco Clemente, Keith Haring, Julian Schnabel, Andy Warhol, and others.

Centro de Arte Reina Sofia opens in Madrid.

Museum Ludwig opens in Cologne, Germany.

1987

THE WORLD

Palestinian uprising (or *Intifada*) protesting economic and social inequality begins in occupied territories and West Bank of Israel.

U.S. congressional "Iran-Contra" hearings are televised.

Stock market crashes in New York.

Largest gay-lesbian demonstration for civil rights in history, Washington, D.C.

James Gleick publishes *Chaos: Making New Science.*

THE ART WORLD

NAMES Project Quilt, devoted to those who have died of AIDS, is first shown, on the Mall, Washington, D.C.

Art against Aids is launched; raises over $5 million in first two years.

Andy Warhol dies; his assets, auction, retrospective exhibition, foundation, diaries, museum, and possible forgeries keep him in the news for the next two years.

Hispanic Art in the United States, Museum of Fine Arts, Houston.

Vincent van Gogh's *Irises* (1889) auctioned for record $53.9 million, New York.

1988

THE WORLD

George Bush is elected U.S. president.

USSR begins to pull its troops out of Afghanistan.

Iran-Iraq war ends.

THE ART WORLD

National Gallery of Canada moves into Moshe Safdie—designed building, Ottawa.

"Unofficial" Soviet art begins to be widely exhibited in U.S. and Western Europe.

New York City Department of Consumer Affairs forces art galleries to post prices.

Instituto Valenciana de Arte Moderna (IVAM) opens in Valencia, Spain.

Luigi Pecci Center of Contemporary Art opens in Prato, Italy.

1989

THE WORLD

Oil spill from Exxon tanker *Valdez* causes ecological disaster in Alaska.

Pro-democracy demonstrations in China are violently suppressed.

Momentous shifts in policies and governments

APPROPRIATION

1980s

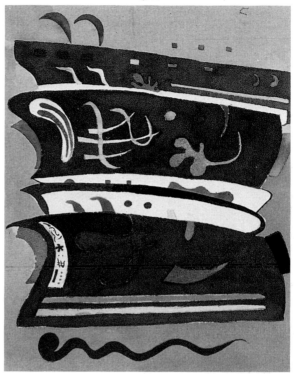

SHERRIE LEVINE (b. 1947).
Untitled (After Vasily Kandinsky), 1985. Watercolor on paper, 14 x 11 in. Mary Boone Gallery, New York.

throughout Eastern Europe (symbolized by the opening of the Berlin Wall) signal the diminution of Communism and a re-definition of the balance of power in Europe.

U.S. Supreme Court narrows abortion rights; pro-choice demonstrations are held throughout the country.

Battle against the world-wide AIDS epidemic is being lost; more than 66,000 dead in U.S. (a greater toll than the Vietnam War).

Abortion pill developed in France.

U.S. invades Panama.

Samuel Beckett dies.

THE ART WORLD

Exhibition of SITUATIONIST art, *On the Passage of a Few People through a*

EAST VILLAGE ART

1981 to 1987

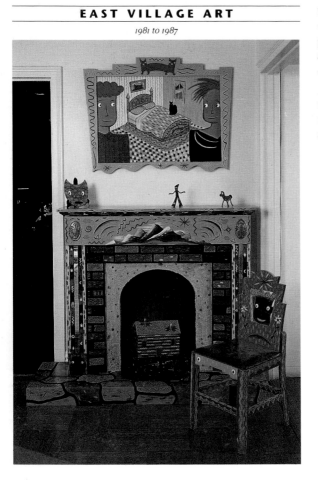

RODNEY ALAN GREENBLAT (b. 1961).
Fireplace, 1983. Mixed media with found fireplace, 50 x 49 x 17 in.
Private collection.

U.S. Senator Jesse Helms writes legislation to bar public funding of "obscene" art.

Willem de Kooning's *Interchange* (1955) is auctioned for $20.7 million, setting a record for a work by a living artist.

Rather Brief Moment in Time, Centre Georges Pompidou, Paris.

Les Magiciens de la terre, Centre Georges Pompidou, Paris.

Richard Serra's PUBLIC ART work, *Tilted Arc*, is removed from its New York site after years of legal wrangling.

Corcoran Gallery of Art, Washington, D.C., cancels exhibition of Robert Mapplethorpe's photographs, setting off anti-censorship protests.

To the uninitiated, contemporary art can seem as indecipherable as Egyptian hieroglyphics. Gallery- and museum-goers are frequently confronted with a perplexing variety of art, ranging from Arte Povera to Neo-Geo to video installations. Strange terms like *semiotics*, *Outsider art*, and *appropriation* may pierce the decorous hush of a gallery. Even reading about art can be an arduous task, given the jargon-ridden prose favored by so many critics. Ironically, in this era of ever-increasing fascination with contemporary art, interest far exceeds comprehension. Today's art *is* hard to understand, and that's why contemporary art—like every professional discipline—requires a specialized vocabulary for all but the most rudimentary communication.

ArtSpeak is the key to that specialized vocabulary. It identifies and defines the terminology essential for understanding art made since World War II. That language is made up of art movements, art forms, and critical terms explained here in short, alphabetically arranged essays. Many, but not all, of the entries are divided into the journalistic categories of **WHO, WHEN, WHERE,** and **WHAT.**

WHO is a list of the principal artists involved with a movement or art form. Capitalized names indicate the pioneers or virtuosos of that approach. The nationality of non-American artists appears in parentheses after their names. (Exceptions have been made for foreign-born artists such as Willem de Kooning and Nam June Paik, whose creative lives have largely been lived in the United States.) Certain artists appear in several entries. The prodigious German artist Joseph Beuys, for instance, is listed under Action/Actionism, assemblage, Conceptual art, Fluxus, installation, media art, and process art.

WHEN signifies the moment of greatest vitality for a particular attitude toward, or method of, art making. Pop art, for example, is associated with the 1960s, but Pop artists continued making Pop art after 1969, and they are likely to continue to do so well into the twenty-first century.

WHERE identifies the cities, countries, or continents in which a movement was centered.

WHAT defines the nature, origins, and implications of the art movements or art forms. Cross references to other entries are CAPITALIZED.

What's the best way to use this volume? That depends on who you are. *ArtSpeak* has been designed for different kinds of readers. The expert can use it to find specific facts—say, the name of the curator who coined the term *New Image painting* or the location of the first feminist art program. The student, collector, or casual art buff will find it useful to read the book from beginning to end and then return to it as needed, guidebook fashion.

ArtSpeak's aim is to provide access to contemporary art. Equipped with the necessary vocabulary, viewers will enjoy the stimulation provided by knowledgeable interaction with today's art. What follows that is pure pleasure.

ABSTRACT/ABSTRACTION

The adjective *abstract* usually describes artworks—known as *abstractions*—without recognizable subjects. Synonyms for *abstract* include *nonobjective* and *nonrepresentational.*

Abstract painting was pioneered between 1910 and 1913 by the Russian-born Wassily Kandinsky in Munich and, in Paris, by the Czech Frantisek Kupka and the Frenchman Robert Delaunay. Kandinsky, the most influential of the three, was the first to plunge into pure or total abstraction. The Russian CONSTRUC-TIVIST Vladimir Tatlin was the first artist to create three-dimensional abstractions, which assumed the form of reliefs produced between 1913 and 1916. Since then, abstract paintings and sculpture have been produced by thousands of artists, in styles ranging from EXPRESSIONISM to MINIMALISM.

Many people, in fact, equate modern art with abstraction. But even though the MODERNIST mainstream has tended toward the abstract, numerous artists—Salvador Dali, Georgia O'Keeffe, Willem de Kooning, and Pablo Picasso among them—have bucked its currents and pursued their own, nonabstract inclinations.

In addition to its meaning as an adjective, *abstract* is also a verb. *To abstract* is to generalize. For instance, imagine a dozen drawings of the same face that grow increasingly abstract as particulars are deleted. The first drawing shows the subject in detail—wrinkles, freckles, and all. The second is more sketchy and focuses on the subject's eyes. By the tenth drawing, even the subject's sex is indeterminate. Finally, the twelfth drawing is a perfect oval with no features, which we take to be a face. This is the *process* of abstraction. Abstraction and REPRESENTATION are at the opposite ends of a continuum. The first drawing described is representational, the twelfth is abstract, and the others fall somewhere in between. The tenth drawing is more abstract than the second. The adjective *abstract* and the noun *abstraction* often refer to works, like the twelfth drawing, that are entirely abstract. But the *entirely* is usually omitted.

An abstract image can be grounded in an actual object, like the twelve drawings of the face. Or it can give visual form to something inherently nonvisual, like emotions or sensations. Red, for example, can represent anger or passion. The idea that a musical, visual, or literary sensation has an equivalent in another medium of expression was a popular nineteenth-century idea called *synesthesia,* which helped fuel the drive toward abstraction.

Abstractions come in two basic variations. The first is geometric, or hard edge, which often suggests rationality and is associated with such modern movements as Constructivism and CONCRETE ART. The second is the looser and more personal style usually known as *organic.* Works in this style that evoke floral, phallic, vaginal, or other animate forms are termed *biomorphic.* Organic abstraction is associated with such modern movements as German Expressionism and ABSTRACT EXPRESSIONISM.

ABSTRACT EXPRESSIONISM

▷ **WHO** William Baziotes, Willem DE KOONING, Adolph Gottlieb, Philip Guston, Franz Kline, Lee Krasner, Robert Motherwell, Barnett Newman, Jackson POLLOCK, Mark ROTHKO, Clyfford Still, Mark Tobey

▷ **WHERE** United States

▷ **WHEN** Mid-1940s through 1950s

▷ **WHAT** The term *Abstract Expressionism* originally gained currency during the 1920s as a description of Wassily Kandinsky's ABSTRACT paintings. It was first used to describe contemporary painting by the writer Robert Coates, in the March 30, 1946, issue of the *New Yorker.* Abstract Expressionism's most articulate advocates, the critics Harold Rosenberg and Clement Greenberg, originated the names *Action painting* and *American-style painting,* respectively. In the United States, *Abstract Expressionism* (or simply *Ab Ex* or even *AE*) was the name that stuck. The European variant was dubbed ART INFORMEL by the French critic Michel Tapié in his 1952 book *Un Art autre (Another Art).*

Abstract Expressionism was the first art movement with joint European-American roots, reflecting the influence of European artists who had fled Hitler-dominated Europe (Max Ernst, Fernand Léger, Matta, and Piet Mondrian among them). Abstract Expressionists synthesized numerous sources from the history of modern painting, ranging from the EXPRESSIONISM of Vincent van Gogh to the abstraction of Kandinsky, from the saturated color fields of Henri Matisse to the ORGANIC forms and fascination with the psychological unconscious of the SURREALIST Joan Miró. Only geometric and REALIST art played no part in this mixture of intensely introspective and even spiritual elements, often painted on mural-size canvases.

Abstract Expressionism was less a STYLE than an attitude. The calligraphic poured (or "drip") paintings by Jackson Pollock, for instance, share little

visually with the intensely colored, landscapelike fields by Mark Rothko. Of paramount concern to all the Abstract Expressionists was a fierce attachment to psychic self-expression. This contrasted sharply with the REGIONALISM and SOCIAL REALISM of the 1930s but closely paralleled postwar existential philosophy's championing of individual action as the key to modern salvation. In existentialist fashion Harold Rosenberg described the Action painter's canvas as "an arena to act in," in his influential essay "The American Action Painters," published in the December 1952 issue of *Artnews.*

The term *Abstract Expressionist* has been applied to some postwar photography, sculpture, and ceramics, but in such cases it rarely clarifies meaning. Neither photography nor the welded CONSTRUCTIVIST works that constitute the best sculpture of that era allow for the spontaneous interaction with art-making materials that characterizes Abstract Expressionism. The term is appropriately applied to the CERAMIC SCULPTURE of Peter Voulkos.

ACADEMIC ART

Academic art once meant simply the "art of the Academy"—that is, art based on academic principles. Having now acquired a negative connotation, it is often used to describe an artist or artwork that is long on received knowledge and technical finesse but short on imagination or emotion.

Art academies originated in late sixteenth-century Italy, replacing the medieval guild-apprentice system previously used to train artists and raising their social status in the process. Academies such as London's Royal Academy of Arts and Paris's Académie des Beaux-Arts institutionalized art training and established a strict hierarchy of subjects. History painting (biblical or classical subjects) ranked first, then portraits and landscapes, and finally still lifes. Academic artists—who were almost invariably men—were initially taught to draw from white plaster casts of classical statues and then progressed to drawing from nude models, acquiring additional skills in a carefully programmed sequence.

The British Pre-Raphaelites and French Impressionists were among the first to reject academic standards and practices, taking aim not only at the academic aesthetic but also at the Academies' stranglehold on patronage in the cultural capitals of Western Europe. By the turn of this century public attention was starting to shift from artists associated with the Academy and toward those of the AVANT-GARDE. Not until the 1970s was there a revival of interest in the work of nineteenth-century academic artists such as Adolphe William Bouguereau.

The POSTMODERN attention to discredited historical forms has also extended to discredited academic STYLES. Artists such as the Russian expatriates Komar and Melamid and the Italian Carlo Maria Mariani employ such styles to comment, often ironically, on contemporary subjects and on the notion of style itself.

ACTION PAINTING—*see* ABSTRACT EXPRESSIONISM

ACTION/ACTIONISM

▷ **WHO** Joseph BEUYS (Germany), Günter Brus (Austria), Yves KLEIN (France), Piero MANZONI (Italy), Otto Mühl (Austria), Hermann NITSCH (Austria), Arnulf Rainer (Austria), Alfons Schilling (Austria), Rudolf Schwarzkogler (Austria)

▷ **WHEN** Late 1950s to mid-1970s

▷ **WHERE** Europe

▷ **WHAT** The idea of the artist as actor and the related interest in artistic process were twin outgrowths of ABSTRACT EXPRESSIONISM and its European variant ART INFORMEL. The notion of the painting as a record of the artist's encounter with it inspired some artists to act out their artworks. HAPPENINGS, FLUXUS events, and Actions were three such live approaches—all precursors of PERFORMANCE ART. Happenings were precisely choreographed, formally arranged events that eluded explicit interpretation. Fluxus's diverse activities evolved from an open-ended poetic sensibility inflected with Zen, DADA, and Beat elements. *Actions* was a catchall term for live works presented inside galleries or on city streets by artists like Yves Klein and Piero Manzoni.

Action artists grappled with concerns that ranged broadly from the spiritual and aesthetic to the social and political. About 1960 Klein started to make paintings with living "brushes"—nude women doused in paint and "blotted" onto canvas. Manzoni signed various individuals, transforming them into living sculpture. During the early 1970s Joseph Beuys created the Free University, a multidisciplinary informational network, and called it a "social sculpture."

A preoccupation with the artist's role as shaman and the desire for direct political action outside the art world characterized Actions, linking them with what is known in German as *Aktionismus* or "Actionism." It usually refers to a group of Viennese artists who created thematically related Actions starting about 1960. Artists such as Günter Brus, Otto Mühl, Hermann Nitsch, Alfons

ACTION/ACTIONISM

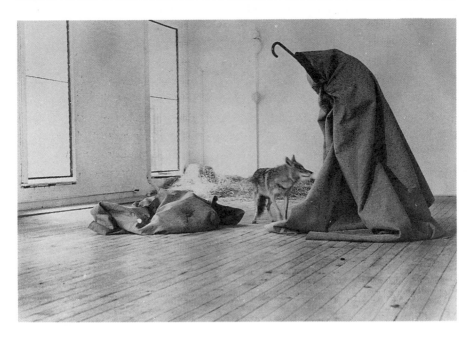

JOSEPH BEUYS (1921–1986).
I Like America and America Likes Me, 1974.
Photograph by Caroline Tisdall.

Schilling, and Rudolf Schwarzkogler explored Freudian themes of erotic violence in ritualistic performances utilizing bodily materials such as blood, semen, and meat. A typical Action—presented by Schilling to a small audience in Vienna on March 16, 1963—opened with the presentation of a skinned and bloody lamb. A white cloth on the floor was covered with the animal's entrails. Blood was repeatedly poured on the lamb, which was swung around by the legs, splashing the audience and the gallery. The artist threw raw eggs against the walls and chewed a rose. Such histrionic events were sometimes enacted especially for the camera.

In their exploration of the psyche's darkly destructive side, these events were a reaction against the canonization of creativity that typified Abstract Expressionism and Art Informel. Actions and Aktionismus are the bridge between those movements of the 1950s and the performance and BODY ART that would follow in the late 1960s and the 1970s.

ALLEGORY

An allegory is an image or a story that refers to something else entirely—usually concepts such as good or evil. Although symbols and allegories are related—the term *symbolize* rather than *allegorize* is standard usage—a crucial distinction separates them. Many symbols have their origins in visual reality: the cross symbolizing Christianity, for instance, and the heart symbolizing love. Allegories, on the other hand, have no such basis: consider the correspondence between Venus and romantic love. The most straightforward allegories are known as *personifications*, figures that stand for ideas like good government or the seven deadly sins. The traditional use of such imagery deepened an artwork's meaning by referring to information outside the work, but it also demanded that the audience be educated enough to understand those references.

The use of allegory was a staple of Western art until the MODERNIST determination to purge art of literary content made it seem old-fashioned. Nonetheless, modern artists such as Max Beckmann, Georges Braque, Giorgio de Chirico, Max Ernst, Paul Gauguin, Fernand Léger, José Clemente Orozco, Pablo Picasso, and Odilon Redon used allegories in numerous paintings to comment on the human condition. Few allegorical references appeared in art from the 1950s to the mid-1970s, except in work by NEW REALIST painters such as Jack Beal. POST-MODERNISM changed that. The return of historical imagery and FIGURATIVE—as opposed to ABSTRACT—art made the return of allegory almost inevitable.

The premier allegorical artists of the late twentieth century are Italian and German—Francesco Clemente, Enzo Cucchi, Jörg Immendorff, Anselm Kiefer, and Helmut Middendorf among them. Obsessed with the effects of Nazism, German artists have attempted to reclaim their cultural past in a society committed to repudiating all that transpired before 1946. The paradigmatic figure in this regard is Kiefer, whose works use biblical history, historical sites, Teutonic myth, Johann Wolfgang von Goethe's *Faust* (1808/32), and other cultural emblems as allegories of contemporary German life. Because Kiefer's allegorical representations are unfamiliar to most of his viewers, even in Germany, they are often difficult to interpret. What the American painter Robert Colescott aptly termed his art historical "masterpieces in Black face" are more accessible allegories of racism.

ALTERNATIVE SPACE

Alternative spaces first appeared in New York in 1969 and 1970 with the founding of 98 Greene Street, Apple, and 112 Greene Street, all of which were small-scale nonprofit institutions run by and for artists. These independent organizations were considered a necessity in an era of widespread artistic experimentation inimical to many museums, commercial galleries, and artist-run cooperatives. Alternative spaces also championed feminism and ethnic diversity by presenting work by women artists and artists of Asian, African, and Latin descent. Throughout the 1970s alternative spaces proliferated in major American, Canadian, and (to a lesser extent) Western European cities. (In Canada they are known as parallel galleries.) The PLURALISM of that decade is virtually unimaginable without alternative spaces as a site for INSTALLATIONS, VIDEO, PERFORMANCE, and other CONCEPTUAL ART forms.

By the early 1980s the nature of such organizations had diversified. Recent art-school graduates could still find storefront venues for their video and performance endeavors, but some alternative spaces had evolved into highly structured institutions with large staffs and funding from foundations, municipalities, and the National Endowment for the Arts. *Artists' organization* or *artist-run organization* is now the preferred nomenclature, and the organization that represents American alternative spaces is the National Association of Artists' Organizations (NAAO), based in Washington, D.C.

Ironically, the generation of the early 1980s began to regard such institutions as "the establishment," far removed from the art world's commercial center of gravity. This attitude led EAST VILLAGE artists in New York to open more or less conventional galleries as showplaces for their work.

ANTI-ART—*see* DADA

APPROPRIATION

▷ **WHO** Mike BIDLO, David Diao, Komar and Melamid, Jeff Koons, Igor Kopystiansky (USSR), Louise Lawler, Sherrie LEVINE, Carlo Maria Mariani (Italy), Sigmar Polke (Germany), Richard PRINCE, Gerhard Richter (Germany), David SALLE, Julian SCHNABEL, Peter Schuyff, Elaine Sturtevant

▷ **WHEN** 1980s

▷ **WHERE** United States and Europe

▷ **WHAT** To appropriate is to borrow. Appropriation is the practice of creating a new work by taking a pre-existing image from another context—art history, advertising, the media—and combining that appropriated image with new ones. Or, a well-known artwork by someone else may be represented as the appropriator's own. Such borrowings can be regarded as the two-dimensional equivalent of the FOUND OBJECT. But instead of, say, incorporating that "found" image into a new COLLAGE, the POSTMODERN appropriator redraws, repaints, or rephotographs it. This provocative act of taking possession flouts the MOD-ERNIST reverence for originality. While modern artists often tipped their hats to their art historical forebears (Edouard Manet borrowed a well-known composi-tion from Raphael, and Pablo Picasso paid homage to Peter Paul Rubens and Diego Velázquez), they rarely put such gleanings at the intellectual center of their work. A sea change occurred when Campbell's soup cans and Brillo boxes began to inspire artworks; POP ART was appropriation's precursor and Andy Warhol its godfather.

Like collage, appropriation is simply a technique or a method of working. As such, it is the vehicle for a variety of viewpoints about contemporary society, both celebratory and critical. In perhaps the most extreme instances of recent appropriation, Sherrie Levine rephotographed photographs by Edward Weston and made precisely rendered facsimiles of Piet Mondrian's watercolors. Her work questions conventional notions of what constitutes a masterpiece, a

master, and indeed, art history itself. By choosing to appropriate only the work of male artists, this FEMINIST ARTIST asks viewers to consider the place of women within the art historical canon, and, in the case of Weston's nude photographs of his young son, to consider whether the gender of the photographer affects how pictures are viewed.

Jeff Koons, one of the few appropriators working in three dimensions, has his sculpture fabricated in stainless steel or porcelain to replicate giveaway liquor decanters and KITSCH figurines. Other artists such as David Salle and Julian Schnabel use appropriation to create a dense network of images from history, contemporary art, and POPULAR CULTURE. The multilayered, pictorial equivalent of free association, their art frequently defies logical analysis.

ART AND TECHNOLOGY

▷ **WHO** Helen and Newton Harrison, Robert Irwin, Gyorgy KEPES, Piotr Kowalski (France), Julio Le Parc (France), Nam June Paik, Otto PIENE (Germany), Robert Rauschenberg, Bryan Rogers, Nicolas Schöffer (France), James Seawright, TAKIS (France), James Turrell

▷ **WHEN** Mid-1960s to mid-1970s

▷ **WHERE** United States, primarily, and Western Europe

▷ **WHAT** Technology is a staple subject of MODERN art. Artistic responses to technology have ranged from celebration (by the Italian Futurists) to satire (by the DADA artists Marcel Duchamp and Francis Picabia). Visions of technological utopia were nurtured by the CONSTRUCTIVISTS, who imagined a future union of art with architecture, design, and science. In the late 1950s and the 1960s European artists picked up where the Constructivists had left off. Numerous groups—most notably ZERO, founded in Düsseldorf in 1957, and Groupe de Recherche d'Art Visuel (GRAV), founded in Paris in 1960—presented light sculpture, KINETIC SCULPTURE, and other machinelike artworks. Most of these groups disbanded by the late 1960s without having made the crucial connection with scientists that characterizes the art-and-technology phenomenon. ZERO's founder, Otto Piene, and many of the others then moved to the United States.

By the late 1960s the United States had produced the world's most advanced technology. At the same time POP ART was providing an optimistic vision of

contemporary life, CONCEPTUAL ART was offering a model of problem solving and engagement with non-art systems of thought, and the modern faith in science and technology was at its peak.

Several particularly effective collaborations between artists and scientists were initiated. Experiments in Art and Technology (EAT) was founded in 1966 by the Swedish engineer Billy Klüver and the artist Robert Rauschenberg. New York–based EAT, which still exists, has linked hundreds of artists and scientists and has presented numerous programs—the most famous being *Nine Evenings*, which was held at New York's 69th Regiment Armory in October 1966 and featured the participation of John Cage, Buckminster Fuller, Gyorgy Kepes, and Yvonne Rainer, among others. The Art and Technology program at the Los Angeles County Museum of Art (1967–71) paired seventy-eight well-known artists with scientific-industrial facilities in California and then exhibited the results, some of them multimedia or environmental pieces involving sound, light, and kinetic elements. In 1967 Kepes opened the Center for Advanced Visual Studies at the Massachusetts Institute of Technology, which continues to promote dialogue among resident artists and Cambridge-area scientists.

The 1970s began with the enthusiasm generated by the moon landing, but soon technology came to be associated with environmental destruction, the use of napalm in Vietnam, and the near meltdown of a nuclear reactor at Three-Mile Island. As a result, many artists—along with much of the American public—grew disenchanted with technology.

See HIGH-TECH ART, LIGHT-AND-SPACE ART

ART BRUT

The French artist Jean Dubuffet came up with the term *Art Brut* (pronounced broot) in 1945. It means "raw art" and refers to the art of children, NAIVE artists, and the mentally ill (in this regard Dubuffet was strongly influenced by Hans Prinzhorn's 1922 book *Bildnerei der Geisterkranken*, or *The Art of the Insane*). Dubuffet found the work of these nonprofessionals refreshingly direct and compelling. "[It is] art at its purest and crudest . . . springing solely from its

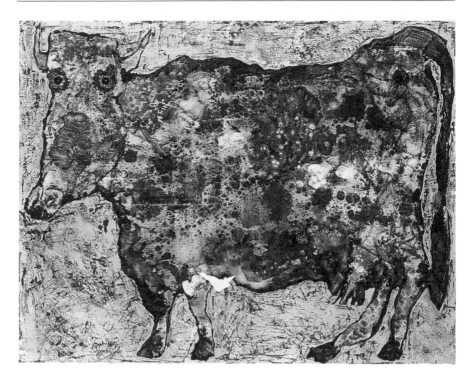

JEAN DUBUFFET (1901–1985).
The Cow with the Subtile Nose, 1954. Oil and enamel on canvas, 35 x
45 3/4 in. Collection, The Museum of Modern Art, New York; Benjamin
Scharps and David Scharps Fund.

maker's knack of invention and not, as always in cultural art, from his power of aping others or changing like a chameleon," he wrote in the essay "Art Brut Preferred to the Cultural Arts"(1949). In fact, we know now that schizophrenic and naive artists frequently pattern their art after extremely well-known paintings and sculptures.

Finding inspiration for his own art in the work of these nonprofessionals, Dubuffet began using quirky materials (including mud and a paste of asphalt and broken glass), odd methods (scraping and slashing into this paste), and a crude but expressive drawing style. Ironically, the term *Art Brut* has come to be applied to Dubuffet's anything-but-naive art. An enthusiastic proselytizer of the authenticity and humanity he saw in Art Brut, he lectured widely on the subject; a 1951 address at the Chicago Arts Club radically altered the course of CHICAGO IMAGIST art. Dubuffet also collected thousands of examples of Art Brut, which are now in a museum devoted to them, opened by the city of Lausanne, Switzerland, in 1976.

ART INFORMEL

▷ **WHO** Alberto Burri (Italy), Jean Fautrier (France), Hans HARTUNG (France), Georges Mathieu (France), Pierre SOULAGES (France), Nicolas de Staël (Belgium), Antoni Tàpies (Spain), Bram van Velde (Netherlands), Wols (France)

▷ **WHEN** 1950s

▷ **WHERE** Paris

▷ **WHAT** The term *Art Informel* was originated by the French critic Michel Tapié and popularized in his 1952 book *Un Art autre* (*Another Art*). A Parisian coun-terpart of ABSTRACT EXPRESSIONISM, Art Informel emphasized intuition and spon-taneity over the Cubist tradition that had dominated SCHOOL OF PARIS painting. The resulting ABSTRACTIONS took a variety of forms. For instance, Pierre Soulages's black-on-black paintings composed of slashing strokes of velvety paint suggest the nocturnal mood of Europe immediately after the war.

Tachisme (from the French *tache* or blot) is a subset of Art Informel that yield-ed works related to Jackson Pollock's Abstract Expressionist poured (or "drip") paintings. The Tachiste Georges Mathieu abandoned brushes entirely, prefer-ring to squeeze paint directly from the tube onto the canvas.

Translating *Art Informel* as "informal art" or "informalism" is misleading. The point is not that artists renounced their concern for FORMAL values but that they rejected the discipline and structure of geometric abstraction in favor of a less cerebral approach.

ART-IN-PUBLIC PLACES—*see* PUBLIC ART

ARTE POVERA

▷ **WHO** (all Italian) Giovanni Anselmo, Alighiero Boetti, Luciano Fabro, Jannis Kounellis, Mario MERZ, Giulio PAOLINI, Giuseppe Penone, Michelangelo PISTOLETTO, Gilberto Zorio

▷ **WHEN** Mid-1960s through 1970s

▷ **WHERE** Italy

▷ **WHAT** Coined by the Italian critic Germano Celant in 1967, the term *Arte Povera* (pronounced *ar*-tay poh-*vair*-uh), which means "Poor Art," refers to usually three-dimensional art created from everyday materials. The associations evoked by humble cement, twigs, or newspapers contrast sharply with those summoned up by the traditional sculptural materials of stone and metal. It wasn't only materials that concerned the Arte Povera artist, though, and many artworks fashioned from "poor" or cast-off materials are not Arte Povera.

Metaphorical imagery culled from nature, history, or contemporary life was frequently employed by Arte Povera artists. Coupling idealism about the redemptive power of history and art with a solid grounding in the material world, they typically made the clash—or reconciliation—of opposites a source of poignancy in their work. Michelangelo Pistoletto, for instance, evoked the issue of class stratification by presenting a plaster statue of Venus de Milo contemplating a pile of brightly colored rags in his *Venus of the Rags* (1967). He gathered the rags near the gallery, siting his INSTALLATION in the geographical and sociological terrain of a specific neighborhood.

The term *Arte Povera* is now applied almost exclusively to Italian art, although that was not Celant's original intent. It could aptly be used to describe the work of non-Italian PROCESS artists—including Joseph Beuys, Hans Haacke, Eva Hesse, and Robert Morris—who have used unconventional materials and forms to make metaphorical statements about nature or culture.

ARTISTS' BOOKS

▷ **WHO** ART & LANGUAGE (Great Britain), John Baldessari, George BRECHT (Germany), Marcel Broodthaers (Belgium), Nancy Buchanan, Victor Burgin (Great Britain), John Cage, Ulises Carrion (Mexico), Hanne Darboven (Germany), Marcel Duchamp (France), Felipe Ehrenberg (Mexico), Robert Filiou (France), Hamish Fulton (Great Britain), General Idea (Canada), Dick HIGGINS, Anselm Kiefer (Germany), Alison Knowles, Margia Kramer, Sol LeWitt, George Maciunas, Mario Merz (Italy), Richard Olson, Richard Prince, Martha Rosler, Dieter ROTH (Germany), Ed RUSCHA, Paul Zelevansky

▷ **WHEN** Late 1960s through 1970s

▷ **WHERE** International

▷ **WHAT** *Artists' books* refers not to literature about artists nor to sculptures constructed from books but to works by visual artists that assume book form. The term is credited to Dianne Vanderlip, who organized the exhibition *Artists Books* at Moore College of Art, Philadelphia, in 1973. The same year Clive Philpott, the librarian at the Museum of Modern Art, put the synonymous term *book art* into print in the "Feedback" column of the July–August issue of *Studio International.* The first major show of artists' books had been mounted in 1972 at the Nigel Greenwood Gallery in London.

Precursors of artists' books date back at least as far as William Blake's illustrated epics from the early nineteenth century and—closer at hand—Marcel Duchamp's *Green Box* of the 1930s. Primary prototypes for contemporary artists' books include Ed Ruscha's POP-inspired foldout photo-books from the mid-1960s (one pictures every building on the Sunset Strip) and Dieter Roth's multivolume collection of meticulously filed debris from the street.

An artist's book may have images without words or narratives without images. It may assume sculptural form as a pop-up book or investigate the nature of the book format itself. It may take the DOCUMENTATION of ephemeral PERFORMANCES or INSTALLATIONS as its point of departure. The thematic concerns of artists' books ranged as widely as those of the PLURALIST late 1960s and 1970s, with autobiography, NARRATIVE, and humor being favored.

Many artists working mainly in other media turned to books as a form suited to expressing ideas too complex for a single painting, photograph, or sculpture. FLUXUS and CONCEPTUAL artists who wanted to communicate ideas in accessible, inexpensive formats were also attracted to artists' books. Compared to the

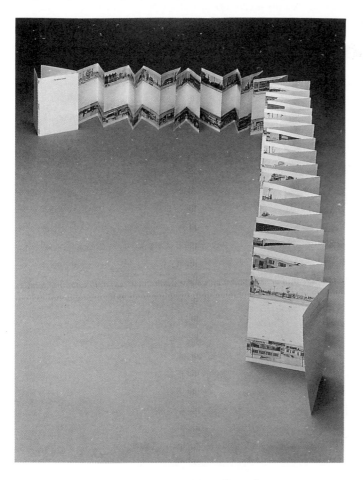

EDWARD RUSCHA (b. 1937).
Every Building on the Sunset Strip, 1966. Photo-book in continuous strip, 7 1/8 x 5 5/8 in. (closed). Los Angeles County Museum of Art Library Special Collections.

more precious products of the PRINT REVIVAL, artists' books seemed the essence of populism—even if the public-at-large did not always recognize them as art.

ARTISTS' FURNITURE

▷ **WHO** Harry Anderson, Scott BURTON, Stephen De Staebler, R. M. Fischer, Frank Gehry, David Ireland, Yayoi Kusama (Japan), Kim MacCONNEL, Main and Main, Judy McKie, Howard Meister, Memphis (Italy), Isamu NOGUCHI, Peter Shire, Robert Wilhite, Robert Wilson

▷ **WHEN** Since the late 1970s

▷ **WHERE** Primarily the United States

▷ **WHAT** *Artists' furniture* is furniture designed and often made by painters, sculptors, craftspersons, or architects, generally as one-of-a-kind pieces available only in galleries. Scott Burton created sculptural seating for indoor or outdoor sites as PUBLIC ART. R. M. Fischer's witty oversize lamps are constructed from FOUND OBJECTS and debris.

Examples of furniture by artists, including Pablo Picasso and Constantin Brancusi, date back at least as far as the early twentieth century. Although artists and architects of that era frequently designed furniture as part of populist programs initiated after the Revolution in the Soviet Union and at the Bauhaus school in Germany, the results were not generally regarded as art. The development of POSTMODERNISM in the 1970s and the blurring of the boundaries that had traditionally separated craft and art set the stage for the acceptance of artists' furniture as a hybrid art form.

See CRAFTS-AS-ART

ASSEMBLAGE

▷ **WHO** Karel Appel (Netherlands), Arman (France), Tony Berlant, Wallace Berman, Joseph BEUYS (Germany), Louise Bourgeois, John Chamberlain, Bruce CONNER, Joseph Cornell, Edward KIENHOLZ, Donald Lipski, Marisol, Louise NEVELSON, Robert Rauschenberg, Richard Stankiewicz, H. C. Westermann

▷ **WHEN** Despite its early twentieth-century origins, assemblage moved above ground only during the 1950s

ASSEMBLAGE

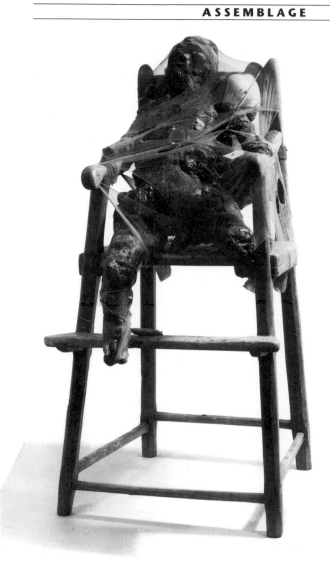

BRUCE CONNER (b. 1933).
Child, 1959–60. Wax figure with nylon, cloth, metal, and twine in a high chair, 34 5/8 x 17 x 16 1/2 in. Collection, The Museum of Modern Art, New York; Gift of Philip Johnson.

▷ **WHERE** International but especially in the United States

▷ **WHAT** The three-dimensional counterpart of COLLAGE, *assemblage* similarly traces its origin to Pablo Picasso. In collaboration with Georges Braque, he created the first assemblage in 1912 with his sheet-metal *Guitar*, three years before the DADA artist Marcel Duchamp attached a bicycle wheel to a stool and called it a READYMADE. Previously known simply as "objects," assemblages were named by Peter Selz and William Seitz, curators at the Museum of Modern Art, for the exhibition *The Art of Assemblage* in 1961.

Assemblage involves the transformation of non-art objects and materials into sculpture through combining or constructing techniques such as gluing or welding. This radically new way of making sculpture turned its back on the traditional practices of carving stone or modeling a cast that would then be translated into bronze.

The use of non-art elements or even junk from the real world often gives assemblages a disturbing rawness and sometimes a poetic quality. Assemblage shares with Beat poetry of the late 1950s a delight in everyday things and a subversive attitude toward "official" culture.

Assemblage can be mysterious and hermetic, like the shrouded figures of Bruce Conner, or aggressively extroverted, as in the biting tableaux of down-and-outers by Edward Kienholz. Assemblages are not always REPRESENTATIONAL: John Chamberlain fashions ABSTRACT sculptures from crumpled auto fenders, and Louise Nevelson made enigmatic and sensuous painted-wood abstractions. Assemblage is a technique, not a STYLE.

AUTOMATISM—*see* SURREALISM

AVANT-GARDE—*see* MODERNISM

"BAD" PAINTING

▷ **WHO** James Albertson, Joan BROWN, Robert Colescott, Cply, Charles Garabedian, Neil JENNEY, Judith Linhares, Earl Staley

▷ **WHEN** 1970s

▷ **WHERE** United States

▷ **WHAT** *"Bad" Painting*—with ironic quotation marks—was the name of a 1978 exhibition curated by Marcia Tucker at the New Museum of Contemporary Art in New York. With its expressive, sometimes deliberately crude paint handling and intimations of narrative, "bad" painting was more an approach than a movement. Its subjects were predominantly FIGURATIVE, ranging from Joan Brown's scenes of holiday romances to Charles Garabedian's broadly brushed renderings of classical architecture and fragmented figures. The often autobiographical and eccentric imagery of "bad" painting contrasted sharply with the emotionally detached MINIMALISM and CONCEPTUALISM that a critical consensus deemed the "good" art of that day.

"Bad" painting had precedents in the highly personal, sometimes humorous postwar painting and sculpture of Philip Guston, Red Grooms, the CHICAGO IMAGISTS, and the BAY AREA FIGURATIVE and FUNK artists. In turn, it helped pave the way for the return of non-ABSTRACT painting in the 1980s.

BAY AREA FIGURATIVE STYLE

▷ **WHO** Elmer BISCHOFF, Joan Brown, Richard DIEBENKORN, Frank Lobdell, Manuel Neri, Nathan Oliveira, David PARK, Paul Wonner

▷ **WHEN** Late 1940s to mid-1960s

▷ **WHERE** San Francisco Bay Area

▷ **WHAT** The Bay Area figurative style embodies the attraction *and* repulsion many artists felt toward the ABSTRACT EXPRESSIONISM emanating from New York. The attraction was made evident through thick paint surfaces, expressive color, and GESTURAL brushwork, the repulsion through the rejection of total ABSTRACTION in favor of FIGURATIVE imagery. Bay Area figurative style artists tended to portray figures not as specific individuals but as elements in a still life, a generalizing approach that reflected the existentialist ZEITGEIST of the early 1950s.

Postwar San Francisco boasted the United States' most up-to-date art scene outside New York. As Abstract Expressionism was emerging in the late 1940s, local artists learned about it from the New York painters Ad Reinhardt, Mark Rothko, and Clyfford Still, all of whom taught at the California School of Fine Arts (now the San Francisco Art Institute) between 1946 and 1950. Their Californian colleagues at the school, David Park and Elmer Bischoff, emulated their abstract, gestural approach and transmitted it to star pupil Richard Diebenkorn.

By the mid-1950s all three Californians had made the radical move away from abstraction and back to paintings of the figure or landscape. Bischoff's account of this about-face to critic Thomas Albright (in the December 1975 issue of *Currant*) was typical: "The thing [Abstract Expressionism] was playing itself dry; I can only compare it to the end of a love affair." For the generation of Bay Area painters who began their careers in the mid-1950s to early 1960s—including Joan Brown, Manuel Neri, and Nathan Oliveira—Abstract Expressionism was already history. Figurative painting and sculpture remained the dominant local tradition until CONCEPTUAL ART emerged at the end of the 1960s.

See FUNK ART

BIOMORPHISM—*see* ABSTRACT/ABSTRACTION

BODY ART

▷ **WHO** Marina Abramovic/Ulay (Netherlands), Vito ACCONCI, Stuart Brisley (Great Britain), Chris BURDEN, Terry FOX, Gilbert and George (Great Britain), Rebecca Horn (Germany), Barry Le Va, Tom Marioni, Ana MENDIETA, Linda Montano, Bruce Nauman, Dennis Oppenheim, Gina Pane (Italy), Mike Parr (Australia), Klaus Rinke (Germany), Jill Scott (Australia), Stelarc (Australia)

▷ **WHEN** Late 1960s through the 1970s

▷ **WHERE** United States, Europe, and Australia

▷ **WHAT** A subset of CONCEPTUAL ART and a precursor of PERFORMANCE ART, *body art* is just what its name implies: an art form in which the artist's body is the medium rather than the more conventional wood, stone, or paint on canvas. Body art often took the form of public or private performance events and was then seen in DOCUMENTARY photographs or videotapes.

Frequently motivated by masochistic or spiritual intentions, body art varied enormously: Chris Burden had himself shot; Gina Pane cut herself in precise patterns with razor blades; Terry Fox attempted to levitate after constructing what he termed a "supernatural" gallery environment; and Ana Mendieta created earthen silhouettes of herself in poses reminiscent of ancient goddess figures from the Near East.

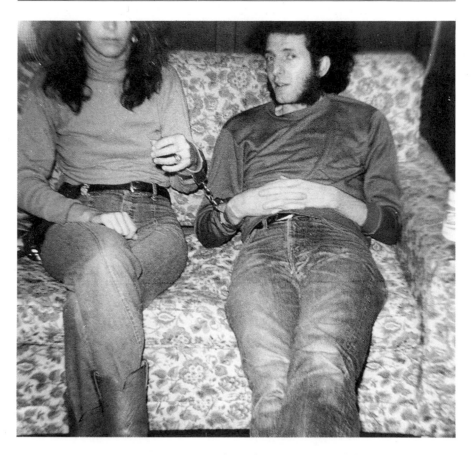

LINDA MONTANO (b. 1942) and **TOM MARIONI** (b. 1937).
Handcuff, 1973. 3-day performance.

Precedents for body art include some of Marcel Duchamp's early twentieth-century DADA gestures (a star-shaped haircut, for example) and the ACTIONS of Yves Klein and Piero Manzoni during the early 1960s. Body art was at once a rejection of the cool MINIMALISM of the 1960s and an embrace of the body-oriented ferment of that moment. The experimentation with sex, drugs, and psychosexual frankness in society at large was mirrored—and enacted—by body artists.

CAMP—*see* KITSCH

CERAMIC SCULPTURE

▷ **WHO** Robert ARNESON, Billy Al Bengston, Robert Brady, Stephen De Staebler, Viola Frey, John MASON, Jim Melchert, Ron Nagle, Ken PRICE, Richard Shaw, Peter Vandenberge, Peter VOULKOS

▷ **WHEN** Since the mid-1950s

▷ **WHERE** Primarily California

▷ **WHAT** *Ceramic sculpture* refers to three-dimensional artworks made of clay and to the campaign that elevated clay from a crafts material (even in the hands of Pablo Picasso or Joan Miró) to the stuff of sculpture. The granddaddy of that campaign was Peter Voulkos, who arrived at the Otis Art Institute in Los Angeles in 1954 and moved on to the University of California at Berkeley in 1959. During the 1950s he and John Mason, Ken Price, and Billy Al Bengston worked on solving the technical problems involved in making clay forms of unprecedented size and shape.

Their work—and that of the ceramic sculptors who followed them—increasingly referred not to traditional craft forms but to HIGH ART: Voulkos's nonfunctional plates and vessels are linked to the GESTURALISM of ABSTRACT EXPRESSIONISM; Mason's floor pieces to MINIMALISM; Richard Shaw's trompe-l'oeil still lifes to NEW REALISM; and Robert Arneson's tableaux and objects to POP ART.

See CRAFTS-AS-ART

CHICAGO IMAGISM

▷ **WHO** Roger Brown, Leon GOLUB, Ellen Lanyon, June Leaf, Gladys Nilsson, James Nutt, Ed Paschke, Seymour Rosofsky, H. C. WESTERMANN

$$\textcircled{c}$$

▷ **WHEN** Mid-1950s through 1970s

▷ **WHERE** Chicago

▷ **WHAT** *Imagism* is a blanket term for the FIGURATIVE art characterized by EXPRESSIONISM and SURREALISM that emerged in Chicago following World War II. Images of sex and violence were often rendered in PRIMITIVE- or NAIVE-looking STYLES. They range from Leon Golub's paintings of damaged figures derived from classical sculpture to Gladys Nilsson's and James Nutt's cartoon-style satires of contemporary life. Other artists, including the ASSEMBLAGE maker H. C. Westermann and the painter Ellen Lanyon, created more personal works that had little to do with history or POPULAR CULTURE but frequently incorporated everyday objects and images.

The elder statesman of Chicago Imagism was the local expressionist painter Seymour Rosofsky, and its catalysts were the Chilean Surrealist Matta, who taught at the School of the Art Institute; and Jean Dubuffet, the French ART BRUT painter who delivered an influential lecture called "Anticultural Positions" in 1951 at the Chicago Arts Club. The critic Franz Schulze dubbed the 1950s generation of painters—Golub, Lanyon, Rosofsky—the Monster Roster; the 1960s generation—Roger Brown, Nilsson, Nutt, Ed Paschke, Westermann—branded itself the Hairy Who.

Chicago Imagism's irreverent and frequently incendiary imagery put it in direct opposition to the generally ABSTRACT mainstream centered in New York and Los Angeles. Along with San Francisco–based FUNK and the BAY AREA FIGURATIVE STYLE, Chicago Imagism offered an alternative to that mainstream.

CoBrA

▷ **WHO** Pierre ALECHINSKY (Belgium), Karel APPEL (Netherlands), Cornelis Corneille (Belgium), Asger Jorn (Denmark), Karl Pederson (Denmark)

▷ **WHEN** 1948–51

▷ **WHERE** Northern Europe

▷ **WHAT** Founded in 1948 by the Belgian writer Christian Dotremont and an association of Dutch painters in Amsterdam known as the Experimental Group, CoBrA took its name from the three cities where many of the participants lived—Copenhagen, Brussels, and Amsterdam. Starting in 1948, CoBrA exhibitions were mounted in Amsterdam, Paris, and Liège, and a literary

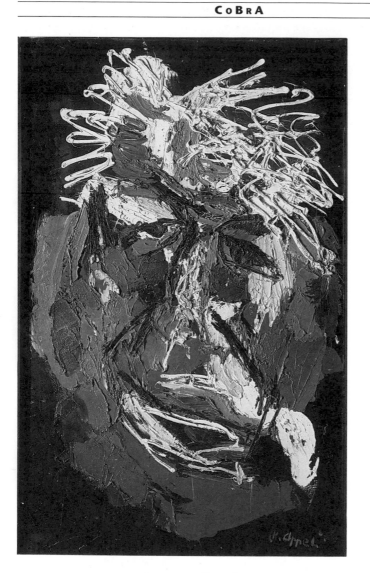

KAREL APPEL (b. 1921).
Portrait of Willem Sandberg, 1956. Oil on canvas, 51 1/4 x 31 7/8 in.
Museum of Fine Arts, Boston; Tompkins Collection.

review was published in Denmark. In 1951 this highly influential group disbanded, although individual members continued to work in what had come to be known as the CoBrA STYLE, characterized by violent brushwork and saturated color. Their ABSTRACTED but still recognizably FIGURATIVE imagery was often derived from prehistoric, PRIMITIVE, or FOLK ART. The high-pitched emotional range of their works runs the gamut from ecstasy to horror.

Along with ABSTRACT EXPRESSIONISM, ART BRUT, and ART INFORMEL, CoBrA was part of the international postwar revolt against cerebral art. Geometric abstraction, CONSTRUCTIVISM, and CONCRETE ART were rejected in favor of EXPRESSIONISM. This emotive response to the rationalized techno-horrors of World War II echoed the origins of DADA following World War I.

COLLAGE

The term *collage* comes from the French verb *coller* (to glue). In English it is both a verb and a noun: to collage is to affix papers or objects to a two-dimensional surface, thus creating a collage.

Picasso produced the first HIGH-ART collage, *Still Life with Chair Caning*, in 1912, when he glued onto his canvas a real piece of oilcloth printed with a caning pattern. By doing that instead of painting the caning pattern directly on his canvas, he forever blurred the distinction between reality and illusion in art. After World War I, DADA artists transformed debris from the street into their sometimes disturbing and politicized collages, while SURREALIST artists created collages that reflected their more psychologically attuned sensibilities. German Dada artists also invented a collage technique using snippets of photographs that is known as *photomontage*.

Postwar collage has been put to many different uses. Jasper Johns painted his images of flags and targets on backgrounds of collaged newsprint in order to produce richly textured, GESTURAL-looking surfaces. PATTERN-AND-DECORATION artists such as Miriam Schapiro, Robert Kushner, and Kim MacConnel have used collage to create brashly colorful and sensuous effects. Other postwar artists who have exploited the technique include Romare Bearden, Wallace Berman, Bruce Conner, Richard Hamilton, George Herms, David Hockney, Jess, Howardena Pindell, Robert Rauschenberg, Larry Rivers, Betye Saar, and Lucas Samaras. The sources of their collage materials range from magazine ads and maps to trash and old clothes.

Décollage, the opposite of collage, involves removing images superimposed on

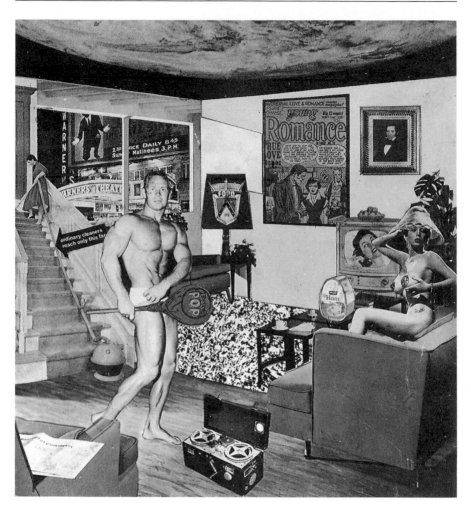

RICHARD HAMILTON (b. 1922).
Just What Is It That Makes Today's Homes So Different, So Appealing?,
1956. Collage on paper, 10 1/4 x 9 3/4 in. Kunsthalle Tübingen,
Tübingen, West Germany; Zundel Collection.

one another. This occurs spontaneously in cities when layers of posters are defaced or weathered, and it is this phenomenon that apparently inspired the pioneering use of *décollage* by the SURREALIST Leo Malet, beginning in 1934. (It has been said that Picasso's and Braque's inspiration for Cubist collage came from the layers of advertising posters that first blanketed Paris during the early twentieth century.) *Décollage* became a popular technique among Parisian NOUVEAU REALISTE artists of the 1950s, including Hérve Télémaque and Mimmo Rotella.

See ASSEMBLAGE

COLOR-FIELD PAINTING

▷ **WHO** Jack Bush (Canada), Nassos Daphnis, Gene Davis, Friedel Dzubas, Helen Frankenthaler, Sam Gilliam, Paul Jenkins, Ellsworth Kelly, Morris Louis, Kenneth Noland, Jules Olitski, Lawrence Poons, Theodoros Stamos

▷ **WHEN** Mid-1950s to late 1960s

▷ **WHERE** United States

▷ **WHAT** As its name indicates, color-field painting has two components—"color" and "field." Rejecting illusions of depth and GESTURAL brushwork, color-field painters applied color in swaths that often span the entire canvas, suggesting that it is a detail of some larger field. Intent on eliminating any distinction between a subject and its background, color-field painters treated the canvas as a single plane. This emphasis on the flatness of the painting mirrored the FORMALIST imperative that painting respect its two-dimensional nature rather than create an illusion of three-dimensionality.

Various other names for color-field painting were coined during the 1950s and 1960s. The most notable was *Post-Painterly Abstraction*, the title of an influential 1964 exhibition at the Los Angeles County Museum, curated by the critic Clement Greenberg. It encompassed what is now called HARD-EDGE PAINT-ING. Another once-popular term was *Systemic Painting*, the title of a 1966 exhibition curated by Lawrence Alloway at the Guggenheim Museum in New York, which featured color-field and hard-edge painters who made systematic variations on a single geometric motif, such as a circle or chevron. Finally, there is *stain painting*, which should be regarded as a subset of color-field painting:

artists such as Helen Frankenthaler and Morris Louis would stain their unprimed canvases by pouring paint rather than brushing it on, usually while working on the floor instead of on an easel or wall.

Just as Frankenthaler's technique was inspired by Jackson Pollock's poured paintings, so, too, was color-field painting an extension of ABSTRACT EXPRESSIONISM. Pollock, with his allover compositions, was the first field painter. The inspiration for the dramatic use of color in color-field painting came from the work of the Abstract Expressionists Mark Rothko and Barnett Newman.

Since color-field painting is invariably ABSTRACT, nature-based color has typically been abandoned in favor of more expressive hues. When examined at close range, the expansive canvases of the color-field painters frequently seem to envelop the viewer in a luxuriant environment of color.

COMBINE—*see* NEO-DADA

COMMODIFICATION

MODERN art had been bought and sold since its inception, but not in sufficient quantities or at high enough prices to command much public attention until the 1960s. Many artists reacted against the new boom in contemporary art with an anticapitalist fervor typical of the 1960s. They created works that were barely visible (such as CONCEPTUAL ART), physically unstable (PROCESS ART), geographically inaccessible (EARTH ART), or highly theoretical (MINIMAL ART). Yet their attempts to thwart the market were to no avail: as with the earlier "anti-art" of DADA, no contemporary art form has eluded the grasp of determined collectors. The most visible event to link contemporary art and big money was the auction of Robert and Ethel Scull's collection of POP ART at Sotheby's New York branch in October 1973. Works of the previous fifteen years brought astronomical prices that established contemporary art as a commodity that had become a valuable investment.

It was not until the 1980s that artists took the notion of art-as-commodity for the subject of their work. (A notable exception was the French artist Yves Klein, whose *Immaterial Pictorial Sensitivity* was a series of ACTIONS in 1961–62 that involved "zones" for the exchange of gold and checks, which were then tossed into the Seine.) Current art invoking commodification ranges from

Jeff Koons's replications of throwaway KITSCH figurines in expensive materials to Mark Kostabi's Warhol-derived art "factory," in which employees produce artworks bearing his name.

See EAST VILLAGE, NEO-GEO

COMPUTER ART—*see* HIGH-TECH ART

CONCEPTUAL ART

▷ **WHO** Marina Abramovíc/Ulay (Netherlands), Ant Farm, Art & Language (Great Britain), John Baldessari, Robert Barry, Iain Baxter (Canada), Joseph BEUYS (Germany), Mel Bochner, Daniel Buren (France), Victor Burgin (Great Britain), James Lee Byars, John Cage, Hanne Darboven (Germany), Terry Fox, Hamish Fulton (Great Britain), Hans HAACKE, Howard Fried, General Idea (Canada), Dan Graham, Douglas Huebler, David Ireland, Allan Kaprow, On Kawara, Paul Kos, Joseph KOSUTH, Richard Kriesche (Austria), Suzanne Lacy, Barry Le Va, Les LEVINE, Richard Long (Great Britain), Tom MARIONI, Jim Melchert, Antoni Miralda (Spain), Robert Morris, Antonio Muntadas (Spain), Morgan O'Hara, Dennis OPPENHEIM, Mike Parr (Australia), Dieter Roth (Germany), Allen Ruppersberg, Bonnie Sherk, Imants Tillers (Australia), Richard Tuttle, Bernar Venet (France), Lawrence Weiner, Tarsua Yamamoto (Japan)

▷ **WHEN** Mid-1960s through 1970s

▷ **WHERE** International

▷ **WHAT** The term *Conceptual art* gained currency after "Paragraphs on Conceptual Art" by the MINIMALIST artist Sol LeWitt appeared in the summer 1967 issue of *Artforum.* (Similar ideas had been articulated earlier in writings by the artists Henry Flint and Edward Kienholz.) *Conceptual art*'s chief synonym is *Idea art.*

In Conceptual art the idea, rather than the object, is paramount. Conceptual artists reacted against the increasingly commercialized art world of the 1960s and the FORMALISM of postwar art—especially the impersonality of then-contemporary Minimalism. To circumvent what they saw as the too-narrow limits of art, Conceptualists used aspects of SEMIOTICS, FEMINISM, and POPULAR CULTURE to create works that barely resembled traditional art objects. What the viewer of Conceptual art saw in the gallery was simply a DOCUMENT of the artist's thinking, especially in the case of linguistic works that assumed the form of words

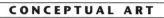
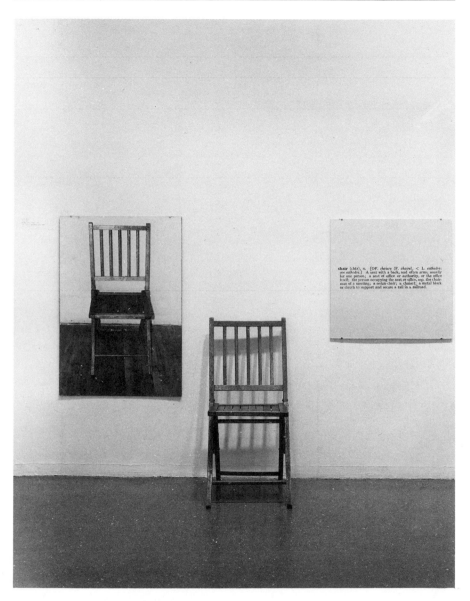

JOSEPH KOSUTH (b. 1945).
One and Three Chairs, 1965. Photograph of chair, wooden folding
chair, and photographic enlargement of dictionary definition of chair,
photo panel: 36 x 24 1/8 in.; chair: 32 3/8 x 14 7/8 x 20 7/8 in.; text panel:
24 1/8 x 24 1/2 in. Collection, The Museum of Modern Art, New York;
Larry Aldrich Foundation Fund.

on a wall. *Conceptualism* soon became an umbrella term used to describe other art forms that were neither painting nor sculpture, such as PERFORMANCE and VIDEO ART, and forms that most viewers saw only in drawings or photographs, such as EARTH ART.

The movement can trace its roots back to the early twentieth-century READY-MADES by the DADA artist Marcel Duchamp, which emphasized the artist's thinking over his manipulation of materials; to the later philosophically oriented ACTIONS of Yves Klein and Piero Manzoni; and to the painted conundrums of Jasper Johns—all of which asked "What is an artwork?" Conceptual art first reached a general audience through two major New York exhibitions in 1970: the Museum of Modern Art's *Information* (curated by Kynaston McShine) and the Jewish Museum's *Software* (curated by Jack Burnham).

The range of Conceptual art thinking is remarkably broad. It encompasses Morgan O'Hara's obsessive documentation of how she spends each waking moment, Robert Morris's construction of a box with the recorded sounds of its own making inside, and John Baldessari's documentation of the letters C-A-L-I-F-O-R-N-I-A, which he placed on the physical locations throughout the state that corresponded to the printed position of each letter on his map. Examples of more socially engaged Conceptualism include Hans Haacke's polling museum visitors for their views of Governor Nelson Rockefeller's support of the Vietnam War, Les Levine's operation of a Canadian-kosher restaurant in New York as an artwork (unbeknownst to its patrons), and Tom Marioni's organization of salon-style gatherings and exhibitions at the Museum of Conceptual Art in San Francisco, which he founded in 1970.

Conceptual art's emphasis on the artist's thinking made any activity or thought a potential work of art, without the necessity of translating it into pictorial or sculptural form. This jettisoning of art objects aroused widespread controversy among artists, viewers, and critics. The artist and theorist Allan Kaprow championed Conceptualism as an interactive form of communication, especially in the wake of visual competition from spectacular, non-art events like the American landing of men on the moon. The critics Robert Hughes (who writes for *Time*) and Hilton Kramer (who wrote for the *New York Times*) looked at Conceptual art and saw an emperor without clothes.

Although the revival of traditional-format painting and sculpture in the late 1970s seems visually far removed from Conceptual art, in fact it absorbed from the earlier movement an interest in story telling, in politics, and in images from art history and popular culture.

CONCRETE ART

▷ **WHO** Josef ALBERS, Max BILL (Switzerland), Jean Dewasne (France), Lucio Fontana (Italy), Richard Paul Lohse (Switzerland), Alberto Magnelli (Italy), Helio Oiticica (Brazil)

▷ **WHEN** 1930s through 1950s

▷ **WHERE** Western Europe, primarily, and the United States

▷ **WHAT** The Dutch artist Theo van Doesburg invented the term *Concrete art* in 1930 to refer to ABSTRACT art that was based not in nature but in geometry and the FORMAL properties of art itself—color and form, in the case of painting; volume and contour, in the case of sculpture. The term was popular before and after World War II, due to the proselytizing of the artist Josef Albers, who emigrated to the United States from Germany in 1933, and of his student Max Bill, who first applied the term to his own work in 1936.

In Concrete art, an appearance of "objectivity" is sought. The artist's personal touch is smoothed over, yielding art objects that sometimes appear to have been made by machine. Individual works vary from the mathematically precise compositions by Richard Paul Lohse, which anticipated OP ART, to Max Bill's undulating three-dimensional abstractions, which suggest the principles of physics and aerodynamics.

Concrete art has lost currency since the 1950s, but the underlying idea that an artwork has value as an independent object, even if it doesn't illuminate social concerns or express an artist's emotions, has been extremely influential. Direct and indirect links connect Concrete art and COLOR-FIELD PAINTING, OP ART, and other CONSTRUCTIVISM-derived styles.

CONSTRUCTIVISM

▷ **WHO** (from the USSR unless otherwise noted) Alexandra Exter, Naum Gabo, El LISSITZKY, Antoine Pevsner, Pablo PICASSO (France), Alexander Rodchenko, Olga Rozanova, Vladimir TATLIN

▷ **WHEN** 1913 through 1920s

▷ **WHERE** Primarily the USSR

▷ **WHAT** This early twentieth-century movement is relevant here because of its decisive influence on MODERN sculpture. *Constructivism* is now often used inaccurately to describe virtually any ABSTRACT sculpture constructed of geometric elements. The term is so frequently misused that the best way to avoid confusion is to examine its original meaning.

Constructivism refers to sculpture that is made from pieces of metal, glass, cardboard, wood, or plastic (often in combination) and that emphasizes space rather than mass. The traditional subtractive or additive ways of making sculpture had focused on mass. (Subtractive means taking away, as in carving wood or stone; additive means building up, as in modeling clay or plaster.)

Constructivism emerged from Georges Braque and Pablo Picasso's Cubist experiments. Translating the angular forms of his paintings and COLLAGES into three dimensions, Picasso created his first sheet-metal-and-wire construction of a guitar in 1912. After the Russian sculptor Vladimir Tatlin saw these works in Picasso's Paris studio a year later, he returned home and began to construct reliefs that were among the first total abstractions in the history of sculpture. He also formulated the influential Constructivist principle of "truth to materials," which asserted that certain intrinsic properties make cylinders the most appropriate shape for metal, flat planes the best for wood, and so on.

In terms of art made during the first quarter of the twentieth century, *Constructivism* is virtually synonymous with *Russian Constructivism.* Many constructions, such as Tatlin's model for the 1,300-foot-high structure *Monument to the Third International* (1919), are prototypes for architectural, stage, or industrial designs. Others are purely abstract but look as though they serve some purpose, such as Alexander Rodchenko's geometric hanging constructions that resemble today's molecular models. These homages to scientific rationality are among the most straightforward representations of the MODERNIST impulse to adapt to the technology of the machine age.

After the Bolshevik Revolution of 1917 the Constructivist artists gained power. Dissension between those interested in a more personal art and those concerned with making utilitarian designs for the masses soon split the group. As the political climate changed in favor of the latter faction in the early 1920s, many of the Russian Constructivists moved to the West. Some went to Germany's technologically oriented Bauhaus school of art and design, ensuring the spread of Constructivist principles throughout Europe and later the United States.

The effect of Constructivism on post–World War II art has been profound. It influenced technique: combining different materials, often by welding, was the chief sculptural method from the 1940s through the early 1960s. Probably more important, it influenced ways of thinking about art in relation to science and technology. That rational approach infused not only KINETIC SCULPTURE, MINIMALISM, and ART-AND-TECHNOLOGY projects but even HARD-EDGE painting and geometric abstraction.

CONTENT

Every work of art ever produced has *content*, or meaning. Analyzing the content of an artwork requires the consideration of subject, form, material, technique, sources, socio-historical context, and the artist's intention (though the artist's interpretation of the work may differ from the viewer's).

There are two widely held misconceptions about content. First, that it is the same as subject. In fact, the subject of a work is just one part of its content. An artist depicts a landscape or a figure, for example, and those are the works' subjects. The subject can usually be identified by sight, whereas the content requires interpretation. Often that interpretation takes into account factors that are invisible in the work, such as the expectations of the patron who commissioned the work or art historical precedents. The content of a landscape might be divine benevolence or humanity's destructive impulses toward the planet. The content of a portrait might range from the glorification of the sitter's social standing to the artist's sexual objectification of the model.

The second common misconception about content is that it is the opposite of form—which includes size, shape, texture, etc. In effective artworks, form and content reinforce one another. For instance, the machine-made look of a HARD-EDGE painting devalues the importance of the artist's personal touch. Psychic depletion is suggested in Alberto Giacometti's pencil-thin figures by both the attenuation of the forms and their pitted metal surfaces.

COOPERATIVE GALLERY—*see* ALTERNATIVE SPACE

COPY ART—*see* HIGH-TECH ART

CRAFTS-AS-ART

▷ **WHO** Rudy AUTIO, Wendell Castle, Dale CHIHULY, Dan Dailey, Marvin Lipofsky, Harvey Littleton, Sam MALOOF, Nance O'Banion, Albert Paley, Peter VOULKOS, Claire Zeisler

▷ **WHEN** First attracted national attention in the 1970s

▷ **WHERE** Primarily the United States

▷ **WHAT** The term *crafts-as-art* refers to the recent elevation of craft materials to art—clay to CERAMIC SCULPTURE, glass to glass sculpture, etc.—and the rise in status of some craftspersons to that of artists.

Until World War II crafts and art were easy to tell apart. Art was generally made of art materials (paint on canvas, bronze, etc.), had serious CONTENT, and served no function around the house. Crafts were made of craft materials (wool, wood, pottery) and were designed to be used.

During the 1950s the lines separating art and craft began to dissolve. Crafts-persons began to create nonfunctioning objects, which became hard to distinguish from sculpture. This move away from the functional occurred first among ceramic sculptors in California and inspired artisans working in glass and metal during the 1960s and 1970s. They, in turn, influenced artists of the 1970s such as Faith Ringgold, Miriam Schapiro, and Christopher Wilmarth to consider new materials. Likewise, many artists of that decade became interested in functional objects, producing ARTISTS' FURNITURE and other hybrid art/non-art forms. A chair being exhibited in a gallery today, for example, may be the work of an artist, an architect, a furniture designer, or a craftsperson.

DADA

▷ **WHO** Jean (Hans) Arp (Germany), Marcel DUCHAMP (France), Max ERNST (Germany), Hannah Höch (Germany), Francis PICABIA (France), Man Ray, Morton Schamberg, Kurt Schwitters (Germany)

▷ **WHEN** 1915 to 1923

▷ **WHERE** New York and Western Europe

▷ **WHAT** Dada, an *early* twentieth-century movement, is included here because the last half-century's art cannot be understood without referring to Dada art forms, ideas, and attitudes.

Dada means a variety of things in a variety of languages, including *hobby horse* in French and *yes, yes* in Slavic tongues. One version of the name's origin has it that in 1916 the poet Tristan Tzara stuck a pen knife in a dictionary at random and it landed on the nonsensical-sounding term.

Dada sprang up during and immediately after World War I; first in the neutral cities of Zürich, New York, and Barcelona, later in Berlin, Cologne, and Paris. It was largely a response to the tragic toll—more than ten million dead—exacted by the "Great War." That the new machine-age technology could wreak such havoc made many wonder whether the price for modernity's material benefits was too high. The Dada artists blamed society's supposedly rational forces of scientific and technological development for bringing European civilization to the brink of self-destruction. They responded with art that was the opposite of rational: simultaneously absurd and playful, confrontational and nihilistic, intuitive and emotive.

Dada, then, is not a STYLE, or even a number of styles, but a world view. Nor were its attitudes embodied only in artworks. Active as citizen-provocateurs rather than studio-bound producers of objects, Dada artists organized incendiary public events. The results varied from the rabble-rousing mixed-media programs at Zürich's Cabaret Voltaire, which anticipated PERFORMANCE ART, to the quasi-philosophical inquiries posed by Marcel Duchamp's many inventions such as the READYMADE.

Jean Arp's chance-derived compositions and Man Ray's threatening objects—an iron with nails on its face titled *Gift* (1921), for example—similarly assaulted traditional notions of what art should be. (Such objects also paved the way for SURREALISM.) Francis Picabia and Duchamp produced paintings, sculptures, and constructions that were more conventional in format, including images of people as machines, which at the time went largely unappreciated.

The aggressive absurdity of much of the Dada art enraged many viewers. Although its critical stance toward bourgeois society is characteristic of MODERN ART, the Dada artists were the most virulent of modernists in their rejection of middle-class morality. (CONCEPTUAL ART and late 1980s artworks examining the role of art as COMMODITY are rooted in Dada ideas and gestures.) Later aptly

dubbed *anti-art*, Dada objects ironically have become valued as priceless masterpieces in today's art world, and Duchamp is now revered, along with Pablo Picasso, as the most influential artist of the twentieth century.

See NEO-DADA

DECOLLAGE—*see* COLLAGE

DECONSTRUCTION—*see* SEMIOTICS

DOCUMENTATION

Documentation has two meanings. Its everyday meaning refers to photographs, videotapes, or written materials related to an artwork's creation, exhibition, or history.

A more complex notion of documentation applies to CONCEPTUAL ART, especially works of EARTH ART and PERFORMANCE ART. Some ephemeral performances or out-of-the-way earthworks—including the private rituals enacted by Vito Acconci or Donna Henes, the geographically inaccessible *Lightning Field* by Walter De Maria, and the short-lived environmental spectaculars by Christo—are known mainly through documentation. When made by the artist himself, this sort of documentation can be art as well as historical record. As such, it is exhibited and sold as art, unlike the work it documents.

EARTH ART

▷ **WHO** Alice Aycock, Christo, Jan Dibbets (Netherlands), Hamish Fulton (Great Britain), Michael HEIZER, Nancy HOLT, Richard Long (Great Britain), Walter De Maria, Ana Mendieta, Mary Miss, Robert Morris, Dennis Oppenheim, Michael Singer, Robert SMITHSON, Alan Sonfist

▷ **WHEN** Mid-1960s through 1970s

▷ **WHERE** Primarily northern Europe and the United States

▷ **WHAT** Earth art, or environmental art, was a broad-based movement of artists who shared two key concerns of the 1960s: the rejection of the commercialization of art, and the support of the emerging ecological movement, with

its "back-to-the-land" antiurbanism and sometimes spiritual attitude toward the planet.

The wide-ranging methods and goals of these artists are best described through examples. Alan Sonfist landscaped urban sites in an attempt to return them to their prehistoric, or natural, states. Nancy Holt constructed astronomically oriented architectural structures suggestive of Stonehenge. Michael Heizer and Robert Smithson moved tons of earth and rock in the deserts of the American West to create massive earth sculptures sometimes reminiscent of ancient burial mounds. Richard Long recorded his excursions through the landscape and the ephemeral arrangements of rocks and flowers he made there in elegantly composed photographs.

Exhibiting photographic DOCUMENTATION of remote works is standard operating procedure for earth artists, as it is for CONCEPTUAL artists. Earth art should also be considered alongside contemporaneous ARTE POVERA and PROCESS ART. While process artists incorporated the rhythms and systems of nature within their work, earth artists actually moved into nature itself. Although aggressive assaults on the landscape like Smithson's spectacular *Spiral Jetty*—a 1,500-foot-long rock-and-salt-crystal jetty in the Great Salt Lake—are the best known of the earthworks, more ecologically sensitive works were produced by artists such as Long, Dennis Oppenheim, Michael Singer, and Sonfist.

EAST VILLAGE

▷ **WHO** Mike BIDLO, Arch Connelly, Jimmy DeSana, John Fekner, Rodney Alan Greenblat, Richard Hambleton, Keith Haring, Marilyn Minter, Nicolas Moufarrege, Peter Nagy, Lee Quinones, Walter Robinson, Kenny SCHARF, Peter Schuyff, Huck Snyder, Meyer Vaisman, David WOJNAROWICZ, Martin WONG, Zephyr, Rhonda Zwillinger

▷ **WHEN** 1981 to 1987

▷ **WHERE** New York

▷ **WHAT** *East Village* means East *Greenwich* Village, until recently a working-class neighborhood in downtown Manhattan. During the early and mid-1980s *East Village* came to stand for an explosion of art, PERFORMANCE ART, and musical activity in the clubs and galleries that helped define the rapidly gentrifying neighborhood.

In terms of visual art, the East Village was characterized by a bustling entrepreneurial scene, with many East Village artists doing double duty as art dealers. This Warholian embrace of commerce was a rejection of the publicly funded activities of the ALTERNATIVE SPACES of the previous decade and a reflection of New York's Wall Street—driven boom economy of the mid-1980s. Collectors of new art garnered considerable publicity, and more than fifty eccentrically named galleries (including Fun, Civilian Warfare, Gracie Mansion, and Nature Morte) sprang up to serve them.

GRAFFITI ART and NEO-EXPRESSIONISM are often associated with the East Village, but other STYLES were made and shown there too. During the mid-1980s CONCEPTUAL and NEO-GEO art began to emerge in the then-fertile environment. The demise of the East Village art scene began in 1985, when the four-year-old Fun Gallery, the first in the neighborhood, closed its doors. By the 1988–89 season, the vast majority of the galleries had either moved to Soho, where rents were now cheaper and patrons more plentiful than in the East Village, or shut down.

ENVIRONMENTAL ART—*see* EARTH ART

ESSENTIALIST—*see* FEMINIST ART

EXPRESSIONISM

Expressionism refers to art that puts a premium on expressing emotions. Painters and sculptors communicate emotion by distorting color or shape or surface or space in a highly personal fashion.

The "opposite" of expressionism is Impressionism, with its quasi-scientific emphasis on capturing fleeting perceptions, such as the appearance of light on a cathedral façade at a specific time of day. Like ABSTRACTION and REPRESENTATION, expressionism and Impressionism are not diametric opposites so much as two ends of a spectrum along which most artworks are positioned.

The adjective *expressionist* is used to describe artworks of any historical era that are predominantly emotive in character. The noun *expressionism* is usually associated with MODERN art but not with any one movement or group of

artists. There have been several expressionist movements; their names are always modified with an adjective, such as German Expressionism or ABSTRACT EXPRESSIONISM, or given another name entirely, such as the "Fauves" (literally the "wild beasts").

Modern expressionism is usually traced back to the works of Vincent van Gogh and the Fauves (Henri Matisse, André Derain, Raoul Dufy, Maurice de Vlaminck), whose idiosyncratic choice of colors was intended to evoke feeling rather than to describe nature. The PRIMITIVIZING art of two early twentieth-century groups—Die Brücke (The Bridge; Erich Heckel, Ernst Kirchner, Karl Schmidt-Rottluff) and Der Blaue Reiter (The Blue Rider; Alexei von Jawlensky, Wassily Kandinsky, Paul Klee, Auguste Macke, Franz Marc, Gabriele Münter)—is known as German Expressionism. The tag ABSTRACT EXPRESSIONIST was applied to American painters of the 1940s and '50s to distinguish them from abstract painters with a more geometric or cerebral—that is, less emotive or intuitive—bent.

In Western society the public regards modern art chiefly as a vehicle for releasing emotion. Despite that widely held view, the current of modern art's mainstream has tended to shift between art emphasizing rational thought and art emphasizing feeling. Following the many CONCEPTUAL ART—derived modes of the 1970s, the expressionist impulse resurfaced with NEO-EXPRESSIONISM, the first of the POSTMODERN movements characterized by an orgasmic explosion of feeling.

FABRICATED PHOTOGRAPHY

▷ **WHO** Harry Bowers, Ellen BROOKS, James Casebere, Bruce Charlesworth, Robert CUMMING, John Divola, Bernard Faucon (France), Fischli and Weiss (Switzerland), Adam Füss (Australia), Barbara Kasten, David Levinthal, Mike Mandel and Larry Sultan, Olivier Richon (Great Britain), Don Rodan, Laurie Simmons, Sandy SKOGLUND, Boyd Webb (Great Britain)

▷ **WHEN** Since the mid-1970s

▷ **WHERE** United States and Western Europe

▷ **WHAT** Although the term *fabricated photography* suggests falsification or fakery, it actually means pictures whose nonhuman subjects have been constructed by the photographer for the sole purpose of being photographed. Imagery varies widely. Ellen Brooks places Barbie-style dolls in miniature tableau settings where they appear to enact the social rituals of contemporary

life. John Divola assaulted an already vandalized lifeguard station with spray paint to create a disturbingly contemporary ruin.

Fabricated photography is a subset of *set-up photography* or *staged photography*, which are more expansive but less frequently used terms. They encompass the type of work described above plus photographs of human or animal actors—such as Cindy Sherman's pictures of herself in costume and William Wegman's images of his dressed-up dogs, Man Ray and Fay Ray. All these approaches reject traditional, observable subjects—Yosemite Falls, a bell pepper, the photographer's lover—in favor of highly theatrical, frankly fictitious ones.

FASHION AESTHETIC

▷ **WHO** Richard AVEDON, Guy Bourdin (France), Frank Majore, Robert MAPPLETHORPE, Helmut Newton (Great Britain), Irving Penn, Herb Ritts, Deborah Turbeville, Chris Van Wangenheim, Bruce Weber

WHEN Since the late 1960s

WHERE Primarily the United States and Western Europe

WHAT The *fashion aesthetic* (or *fashion sensibility*) refers not to fashion photography—commercial work commissioned for advertisements—but to the use of fashion photography's glamorizing style in "art" photographs intended for gallery walls. The fashion photograph—and now the fashion-aesthetic portrait or figure study—relies on bold and simple design flavored with a dash of class and sexiness. Many of its most suggestive qualities have been pirated from AVANT-GARDE art and photography, usually long after the fact. Cubism, which had emerged before World War I, was "borrowed" by Irving Penn and Horst during the 1940s for fashion photo-layouts. Richard Avedon's fascination with physical movement in fashion pictures was rooted in art photography made thirty years earlier by Henri Cartier-Bresson and André Kertesz.

Most photographers producing fashion-aesthetic pictures are also fashion photographers. Art photographers have supported themselves with their fashion shots since fashion photography's inception in the work of early twentieth-century figures such as Baron Adolphe de Meyer, Edward Steichen, Louise Dahl Wolfe, and Cecil Beaton. Despite this crossover, the distinction between a photographer's art photography and his or her fashion photography was strictly delineated. Then, in 1978, the prestigious Metropolitan Museum of Art in

New York eroded this distinction by mounting a major exhibition integrating Avedon's fashion, art, and journalistic pictures.

The situation has grown increasingly confused ever since. Throughout the 1970s Irving Penn straightforwardly applied the fashion aesthetic to garbage and cigarette butts, endowing such gritty subjects with elegance. During the 1980s most photographers utilized the fashion aesthetic to comment on itself. Celebrated photographers like Robert Mapplethorpe and Bruce Weber have synthesized a homoerotic sensibility that virtually merges fashion and art—only the context of who commissioned the pictures and where they were intended to be seen distinguishes the two types of their photographs. All of this work has, incidentally, helped to fuel a market for current and historic fashion-advertising photography comparable to that for film stills and publicity shots.

FEMINIST ART

▷ **WHO** Eleanor Antin, Judith Barry, Lynda Benglis, Helen Chadwick (Great Britain), Judy CHICAGO, Judy Dater, Mary Beth Edelson, Rose English (Great Britain), Feminist Art Workers, Karen Finley, Harmony Hammond, Lynn Hirshman, Rebecca Horn (Germany), Joan Jonas, Mary KELLY (Great Britain), Silvia Kolbowski, Barbara Kruger, Leslie Labowitz, Suzanne LACY, Sherrie Levine, Ana Mendieta, Meredith Monk, Linda Montano, Anne Noggle, Donna-Lee Phillips, Yvonne Rainer, Martha Rosler, Faith Ringgold, Ulrike Rosenbach (Germany), Miriam SCHAPIRO, Carolee Schneemann, Cindy Sherman, Barbara Smith, Nancy Spero, May STEVENS, Rosemarie Trockel (Germany), Hannah Wilke, Sylvia Ziranek (Great Britain)

▷ **WHEN** Since the late 1960s

▷ **WHERE** Primarily Great Britain and the United States

▷ **WHAT** Women artists such as Helen Frankenthaler, Grace Hartigan, and Bridget Riley gained considerable reputations during the 1950s and early 1960s. Although they were female, the CONTENT of their work was not, by design, feminist: that is, it neither addressed the historical condition of women nor could it be identified as woman-made on the basis of appearance alone. Until the end of the 1960s most women artists sought to "de-gender" art in order to compete in the male-dominated, mainstream art world.

The counterculture of the 1960s inspired new and progressive social analyses. The mainstream was no longer regarded as ideologically neutral. Feminist analysis suggested that the art "system"—and even art history itself—had institutionalized sexism, just as the patriarchal society-at-large had done. Feminists employed the classic strategy of the disenfranchised, as did racial minorities, lesbians, and gays: they restudied and reinterpreted history. Of special concern to feminist theorists was the historical bias against crafts vis-à-vis HIGH ART. This new interest in art forms that had traditionally been relegated to the bottom of the status hierarchy (quilts, Persian rugs, Navajo blankets) eventually led to the emergence of PATTERN AND DECORATION in the mid-1970s.

By 1969 overtly feminist artworks were being made and feminist issues raised. That year saw the creation of both WAR (Women Artists in Revolution), an offshoot of the New York–based Art Workers' Coalition, and the Feminist Art Program, led by Judy Chicago at California State University in Fresno. (It soon recruited Miriam Schapiro as codirector and moved to the California Institute of the Arts in Valencia.) Fledgling feminist institutions quickly arose in New York, Los Angeles, San Francisco, and London, including galleries (A.I.R., SoHo 20, the Women's Building, Womanspace); publications (*Women and Art, Feminist Art Journal, Heresies*); and exhibitions (*Womanhouse, Womanpower*). Throughout the 1970s the meaning of feminist art and the roles that politics and spirituality play within it (the latter sometimes in the form of the "Great Goddess") were articulated by thoughtful critics such as Lucy Lippard and Moira Roth. By the end of the decade the position of the essentialists—that there was a biologically determined female identity that should be expressed in women's creations—was challenged by feminist artists and writers who regard that identity as culturally determined or "socially constructed."

Feminist artworks have varied greatly. Predominating in the 1970s were auto-biographical works in many media and cathartic, ritualized PERFORMANCES—including Mary Beth Edelson's *Memorials to the 9,000,000 Women Burned as Witches in the Christian Era* and Suzanne Lacy's and Leslie Labowitz's *In Mourning and in Rage*, a series of events featuring black-hooded figures that was designed to attract the attention of the news media and disseminate information about violence against women at the time of the Hillside Strangler rape-murders in Los Angeles.

The return in the 1980s to traditional media encouraged feminist artists to create works with a CONCEPTUAL—and critical—bent. The notion of the patriarchal "male gaze" directed at the objectified female OTHER has been explored by

artists including Yvonne Rainer, Silvia Kolbowski, and the British artist Victor Burgin. Two examples of recent feminist art that have received widespread attention are Cindy Sherman's photographic investigations of the self in a culture of role playing and Barbara Kruger's evocations of cultural domination through the graphic vocabulary of advertising.

If such works seem less overtly feminist than their predecessors, it is largely because feminist principles have been so widely accepted—despite the brouhaha frequently surrounding the term itself. In opposition to the purity and exclusivity of MODERNISM, feminism called for an expansive approach to art. The feminist use of NARRATIVE, autobiography, decoration, ritual, CRAFTS-AS-ART, and POPULAR CULTURE helped catalyze the development of POSTMODERNISM.

FIGURATIVE

Figurative is a word that is used in two sometimes contradictory ways. Traditionally it has been applied to artworks that are REPRESENTATIONAL rather than completely ABSTRACT. Grounded in nature, such images encompass everything from nudes and portraits to still lifes and landscapes.

According to Webster's dictionary, *figurative* also means "having to do with figure drawing, painting, etc." This sense of the term is gaining popularity. To many speakers, *figurative painting* means paintings of the human figure. You are likely to hear it used both ways.

"FINISH FETISH"—*see* LOS ANGELES "LOOK"

FLUXUS

▷ **WHO** Joseph Beuys (Germany), George BRECHT (Germany), Robert Filiou (France), Ken Friedman, Dick HIGGINS, Ray Johnson, Alison Knowles, George MACIUNAS, Jackson MacLow, Charlotte Moorman, Yoko Ono, Nam June Paik, Daniel Spoerri (Switzerland), Ben Vautier (France), Wolf Vostell (Germany), Robert Watts, Lamonte Young

▷ **WHEN** 1960s

▷ **WHERE** International, having begun in Germany and quickly spread to New York and the northern European capitals. Similar activities were taking place independently in Japan and California.

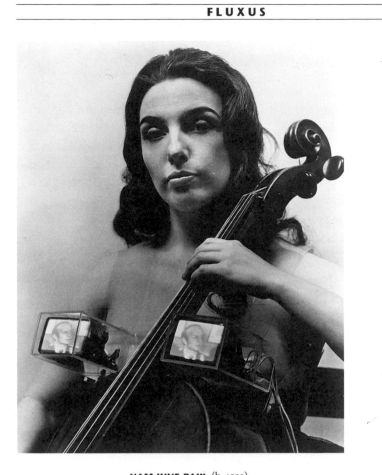

NAM JUNE PAIK (b. 1932).
TV Bra for Living Sculpture, 1969. Television sets and cello (worn by cellist Charlotte Moorman). Photograph © Peter Moore, 1969.

▷ **WHAT** The term *Fluxus* was first used by George Maciunas on an invitation to a 1961 lecture series at the Gallery A/G in New York. Implying *flow* or *change* in several languages, Fluxus is more a state of mind than a STYLE.

With Fluxus artists, social goals often assumed primacy over aesthetic ones. The main aim was to upset the bourgeois routines of art and life. Early Fluxus events—guerrilla theater, street spectacles, concerts of electronic music—were aggressive demonstrations of the libidinal energy and anarchy generally associated with the 1960s. Rather than an alliance with POPULAR CULTURE, Fluxus artists sought a new culture, to be fashioned by AVANT-GARDE artists, musicians, and poets. Mixed media was the typical Fluxus format. Numerous art forms were simultaneously and cacophonously deployed at events that sometimes resembled contemporaneous ACTIONS or later HAPPENINGS, though they tended to be more humorous and open-ended.

Such events ranged from group readings of Haiku-length poems that prescribed simple activities like taking a stroll or burning a Christmas tree to attention-getting events such as the Charlotte Moorman–Nam June Paik collaboration featuring Moorman playing her cello while wearing little more than a brassiere fashioned from miniature television sets.

Fluxus activity was not limited to live events. Mail (or correspondence) art—postcardlike collages or other small-scale works that utilized the mail as a distribution system—were pioneered by Fluxus artists, especially Ray Johnson. Another Fluxus innovation was rubber-stamp art, sometimes in tandem with mail art. Fluxus artworks can sound eccentric and inconsequential, but their underlying iconoclastic attitudes made them influential precursors of CONCEPTUAL and PERFORMANCE art.

FOLK ART—*see* NAIVE ART

FORMAL/FORMALISM

Formalism derives from *form*. A work's "formal" qualities are those visual elements that give it form—its shape, size, structure, scale, composition, color, etc. *Formalism* is generally believed to imply an artistic or interpretive emphasis on form, rather than CONTENT, but form and content are, in fact, complementary aspects in any work.

Although philosophical debates about form were initiated in ancient Greece, the concept of formalism is generally associated with MODERN art and especially with the thinking of three influential theorists: the critics Clive Bell, Roger Fry, and Clement Greenberg. At the beginning of the twentieth century the British writers Bell and Fry sought to create a quasi-scientific system based on visual analysis of an artwork's formal qualities rather than its creator's intentions or its social function. Developed in response to the early modern interest in artworks foreign to the Western tradition—especially Japanese prints and African sculpture—their method was intended to permit the cross-cultural evaluation of art from any place or time.

The formalist approach dominated art criticism and modernist thought after World War II. Its best-known exemplar is the American Clement Greenberg, whose influence rose along with that of American art—chiefly ABSTRACT EXPRESSIONISM and later manifestations of NEW YORK SCHOOL painting and sculpture.

A new generation of articulate formalist critics such as Michael Fried and Rosalind Krauss emerged in the 1960s, but so did the limits of the formalist approach. POP ART, in particular, defied meaningful formal analysis. How could Roy Lichtenstein's images taken from comic books be understood without investigating their social and cultural meanings? Pop art proved to be a precursor of POSTMODERNISM, and since the mid-1970s formalist interpretation has been yielding to more expansive critical approaches based in FEMINISM, SEMIOTICS, and DECONSTRUCTION.

FOUND OBJECT

A found object is an existing object—often a mundane manufactured product—given a new identity as an artwork or part of an artwork. The artist credited with the concept of the found object is Marcel Duchamp. (Georges Braque and Pablo Picasso had already begun to inject bits of non-art material into their pioneering COLLAGES and ASSEMBLAGES of 1912–15, but they significantly altered those materials.) In 1913 Duchamp began to experiment with what he dubbed the *Readymade*. After adding a title to an unaltered, mass-produced object—a urinal or a shovel, for example—he would exhibit it, thereby transforming it into a readymade sculpture. His intention was to emphasize art's intellectual basis and, in the process, to shift attention away from the physical act or craft involved in its creation. Other DADA and SURREALIST artists mined the nostalgic potential of found objects in works less cerebral than Duchamp's.

Post—World War II artists put found objects to a variety of different purposes. They range from Edward Kienholz's chilling tableaux assembled from mannequins and discarded furniture to Haim Steinbach's more theoretical ensembles of domestic objects intended to question whether artworks made of mass-produced components can be simultaneously functional, decorative, and expressive. Joseph Beuys's dog-sled sculpture invokes his personal history, and even painters such as Jasper Johns have utilized found objects (in Johns's case, a broom, a chair, ball bearings) by affixing them to their paintings. Whether old or new, a found object infuses an artwork with meanings associated with its past use or intended function.

See NEO-DADA

FUNK ART

▷ **WHO** Robert Arneson, Clayton Bailey, Bruce Conner, Roy DE FOREST, Mel Henderson, Robert HUDSON, Richard Shaw, William WILEY

▷ **WHEN** Mid-1960s to mid-1970s

▷ **WHERE** San Francisco Bay Area

▷ **WHAT** *Funk* derives from *funky*, a musical term that was applied to numerous visual artists in Northern California starting in the early 1960s. Peter Selz, then director of the University Art Museum in Berkeley, officially christened the movement with the 1967 exhibition *Funk*.

Funk art is offbeat, sensuous, and direct. Humor, vulgarity, and autobiographical narrative are typical elements, although funk art imagery ranges far and wide, from Roy De Forest's paintings of anthropomorphic animals to Robert Hudson's brightly painted sculptural abstractions. Funk artists frequently delighted in the manipulation of unusual materials and FOUND OBJECTS. Their unconventional use of materials not only obscured the division between painting and sculpture but also helped transform clay from a crafts material to a sculptural one.

Funk art was heavily influenced by earlier anti-art movements, especially the playful absurdity of DADA and NEO-DADA. (William Wiley's punning work has been aptly dubbed "Dude Ranch Dada.") Reacting against the seriousness of New York— and Los Angeles—centered abstraction, funk artists have looked to POPULAR CULTURE rather than the history of art for inspiration.

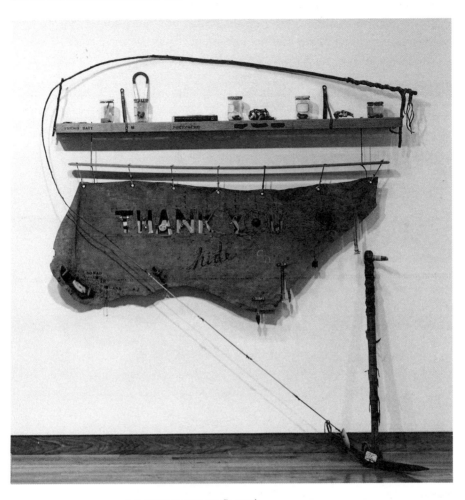

WILLIAM T. WILEY (b. 1937).
Thank You Hide, 1970–71. Wood, leather, pick, found objects, and ink and charcoal on cowhide, 74 x 160 1/2 in. Des Moines Art Center; Coffin Fine Arts Trust Fund, 1970–71.

In 1969 the Chicago artists James Nutt and Gladys Nilsson were guest teachers at the University of California at Davis, an hour's drive north of San Francisco. While working in this bastion of funk art they helped cement the strong bonds between CHICAGO IMAGIST and Bay Area artists.

GESTURE/GESTURALISM

Gesturalism refers to paintings or drawings that emphasize the artist's expressive brushwork. By calling attention to his or her "handwriting," an artist evokes the subjectivity of painting itself.

The expression of artistic personality through gestural brushwork dates back at least as far as the seventeenth-century paintings of Frans Hals and Diego Velázquez and in modern art to the canvases of Edouard Manet. Gesturalism became a vehicle for EXPRESSIONISM starting with the work of Vincent van Gogh, and the two have been linked ever since, most recently in the gestural output of NEO-EXPRESSIONIST artists.

GRAFFITI ART

▷ **WHO** Crash, Daze, Dondi, Fab Five Freddie (also known as Freddie Brathwaite), Futura 2000, Keith HARING, Lady Pink, Lee Quinones, Ramellzee, Samo (aka Jean-Michel Basquiat), Alex Vallauri (Brazil), Zephyr (aka Andrew Witten)

▷ **WHEN** Mid-1970s to mid-1980s

▷ **WHERE** Primarily New York

▷ **WHAT** *Graffito* means "scratch" in Italian, and graffiti (the plural form) are drawings or images scratched into the surfaces of walls. Illicit graffiti (of the "Kilroy was here" variety) dates back to ancient Egypt. Graffiti slipped into the studio as a subject after World War II. Artists such as Cy Twombly and Jackson Pollock were interested in the way it looked, the Frenchman Jean Dubuffet was interested in what it meant as a kind of OUTSIDER ART, and the Spaniard Antoni Tàpies was interested in the ways it could be incorporated into his imagery of urban walls.

During the early 1970s—soon after aerosol spray paint in cans became readily available—New York subway trains were subjected to an onslaught of exuber-

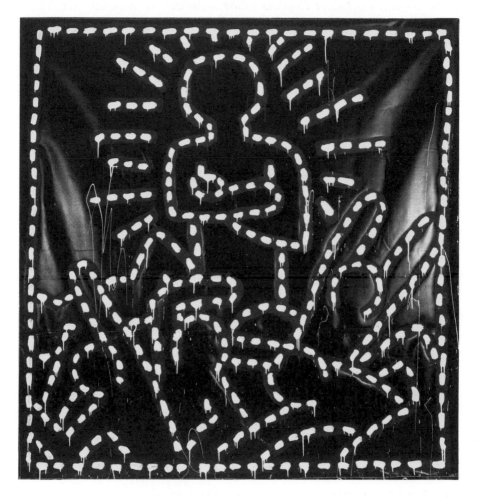

KEITH HARING (b. 1958).
Untitled, 1982. Vinyl ink on tarpaulin, 84 x 84 in. Dannheisser
Foundation.

antly colored graffiti. The words and "tags" (graffiti writers' names) were soon augmented with elaborate cartoon-inspired images. Most graffitists were neither professional artists nor art students but streetwise teenagers from the Bronx and Brooklyn.

Several milestones marked graffiti's move from the street to the gallery: the United Graffiti Artists' 1975 exhibition at New York's Artists Space; Fab Five Freddie's widely discussed spray-painted homage to Andy Warhol's Campbell's soup cans in 1980; the *Times Square Show*, also in 1980, which galvanized the attention of the New York art world; the ongoing support in the form of exhibition opportunities and career counseling provided by Fashion Moda, an ALTERNATIVE SPACE in the Bronx; and, ultimately, the development of a graffiti STYLE by professionally trained artists such as Keith Haring. The year 1983 saw the zenith of graffiti art, with its first major museum exhibition at the Boymans-van Beuningen Museum in Rotterdam and the *Post-Graffiti* exhibition at Sidney Janis's blue-chip gallery.

The popularization of graffiti raised questions of unusual aesthetic and sociological import. Was graffiti vandalism? Or urban FOLK ART? The writer Norman Mailer romanticized it as the anarchic manifestation of social freedom, while critics such as Suzi Gablik charged that ghetto youths were being exploited by a novelty-crazed art market.

Graffiti's move to the galleries proved fatal: by the mid-1980s it already seemed outmoded. Underground "tags" and images designed to be rapidly painted on metal and seen in motion had been transformed into self-parody. Like the latest trend in fashion, graffiti was imported from the streets, commercialized, and then quickly pushed aside.

See EAST VILLAGE

GUTAI—*see* HAPPENING

HAIRY WHO—*see* CHICAGO IMAGISM

HAPPENING

▷ **WHO** Jim Dine, Red Grooms, Al Hansen, Allan KAPROW, Claes Oldenburg, Carolee Schneemann, Robert Whitman

▷ **WHERE** Primarily New York

▷ **WHEN** Early to mid-1960s

▷ **WHAT** The name *Happening* comes from Allan Kaprow's first show at New York's Reuben Gallery in 1959, called *18 Happenings in 6 Parts.* Within three rooms a carefully rehearsed multimedia event unfolded. Performers coolly read fragmented texts (a sample: "I was about to speak yesterday on a subject most dear to you all—art . . . but I was unable to begin"); assumed mimelike poses; painted on canvas; played the violin, flute, and ukelele. Meanwhile, the audience moved from room to room on cue, "becom[ing] part of the happenings" as the invitation had promised. It also became the audience's task to decipher the disconnected events. Kaprow offered little help, having cautioned those attending that "the action will mean nothing clearly formulable so far as the artist is concerned."

Kaprow defined a Happening as an "assemblage of events performed or perceived in more than one time and place"—that is, as an environmental artwork activated by performers and viewers. The artists who made Happenings never issued a group manifesto defining their art form, and that may help account for its variety. Red Grooms's *Burning Building* (1962) was a vaudeville-style evocation of a fire that had performers tumbling out of the set's windows. Claes Oldenburg's eerie *Autobodys* (1963), staged in a Los Angeles drive-in movie theater, was populated primarily by figures on roller skates and black-and-white cars inspired by the limousines prominent in the television coverage of President Kennedy's then-recent funeral.

Some have cited the Happening-like spectacles created by the Japanese Gutai group as precedents for Happenings, but neither the Gutai artists nor their work was known in New York until the early 1960s. (The experimental art group was founded in Osaka in 1954 under the influence of the master-artist Jiro Yoshihara and included the artists Akira Kanayama, Saburo Mirakami, and Kazuo Shiraga.) Precursors closer to home were the various DADA events, with their chance-derived arrangements or compositions. The composer John Cage spread the word about them, first at Black Mountain College in North Carolina and later at the New School for Social Research in New York, where most of the Happening artists attended his classes during the

mid-1950s. The mixing of media and the concern for everyday life in Happenings is part of the larger POP ART phenomenon.

See ACTION/ACTIONISM, FLUXUS, PERFORMANCE ART

HARD-EDGE PAINTING

▷ **WHO** Karl Benjamin, Lorser Feitelson, Frederick Hammersley, Al Held, Ellsworth KELLY, John McLaughlin, Kenneth NOLAND, Jack Youngerman

▷ **WHEN** Late 1950s through 1960s

▷ **WHERE** United States

▷ **WHAT** The term *hard-edge painting* was first used in 1958 by the Los Angeles critic Jules Langsner to describe the ABSTRACT canvases of West Coast painters uninterested in the brushy GESTURALISM of ABSTRACT EXPRESSIONISM. The following year the critic Lawrence Alloway applied the term to American paintings with surfaces treated as a single flat unit. The distinction between figure and background was eliminated in favor of the allover approach pioneered by Jackson Pollock a decade earlier. Unlike Pollock's free-form compositions, hard-edge paintings are typically geometric, symmetrical, and limited in palette. Other precursors from the 1950s include Ad Reinhardt, Leon Polk Smith, and Alexander Liberman.

Hard-edge paintings vary from Kenneth Noland's chevron-patterned compositions to Ellsworth Kelly's oddly shaped monochrome paintings on canvas or metal. The machine-made look of such works pointed ahead to the three-dimensional "primary structures" of MINIMALISM. Although the precision and impersonality of hard-edge painting distinguish it from the spontaneous-looking compositions of COLOR-FIELD PAINTING, the two styles overlapped, and artists such as Noland worked in both modes.

HIGH ART—*see* POPULAR CULTURE

HIGH-TECH ART

▷ **WHO** Art[n], Nancy Burson, Harold Cohen (Great Britain), Douglas Davis, Peter D'Agostino, Paul Earls, Ed Emshwiller, Perry Hoberman, Jenny Holzer, Milton Komisar, Bernd Kracke (Germany), Bruce Nauman, Nam June Paik, Sonya

Rapoport, Alan Rath, Bryan Rogers, James Seawright, Sonia Sheridan, Eric Staller, Wen-ying Tsai, Stan Vanderbeek, Woody Vasulka, Ted Victoria

▷ **WHEN** Since the 1970s

▷ **WHERE** Primarily the United States

▷ **WHAT** High-tech art is not a movement; it is contemporary art made with sophisticated technology, including computers, lasers, holograms, photo-copiers, facsimile machines, satellite transmissions, and the like. The range of such work is broad, from sensuous copy-machine prints by Sonia Sheridan to computer-driven drawing-and-painting machines by Milton Komisar. The most effective high-tech art transcends its hardware. It can explore themes related to technology (as in Alan Rath's *Voyeur*, a humanoid construction with video monitors for eyes) or simply employ a particular technology to help con-vey meaning, just as a painter might select acrylic over oil paints for a desired effect. CONCEPTUAL ART encouraged artists to use any materials necessary for the communication of their ideas.

In many instances, the hardware and expertise required for high-tech artworks is difficult to obtain and utilize. It has frequently been provided by corpora-tions or by institutions such as the Massachusetts Institute of Technology's Center for Advanced Visual Studies, which sprang from the ART-AND-TECHNOLOGY movement. That movement of the 1960s mirrored the profound optimism about technology embodied in MODERNISM, but more recent art is likely to express the ambivalence toward it shared by many denizens of POSTMODERN society.

HOLOGRAPHY—*see* HIGH-TECH ART

HYPER-REALISM—*see* PHOTO-REALISM

IDEA ART—*see* CONCEPTUAL ART

INSTALLATION

▷ **WHO** Terry Allen, Joseph BEUYS (Germany), Christian Boltanski (France), Jonathan Borofsky, Marcel Broodthaers (Belgium), Daniel BUREN (France), Chris Burden, Bruce Charlesworth, Terry Fox, Howard Fried, GENERAL IDEA (Canada), Frank Gillette, Group Material, Hans HAACKE, Helen and Newton HARRISON, Lynn Hirshman, David Ireland, Patrick Ireland, Robert IRWIN, Irwin (Yugoslavia), Ilya Kabakov (USSR), Joseph Kosuth, Sol LeWitt, Donald Lipski, Walter De Maria, Tom Marioni, Michael McMillen, Mario Merz (Italy), Antonio Muntadas (Spain), Maria Nordman, Nam June Paik, Judy PFAFF, Michelangelo PISTOLETTO (Italy), Sandy Skoglund, Alexis Smith, James Turrell, Bill Viola

▷ **WHEN** Since the 1970s

▷ **WHERE** United States, primarily, and Europe

▷ **WHAT** The everyday meaning of *installation* refers to the hanging of pictures or the arrangement of objects in an exhibition. The less generic, more recent meaning of *installation* is a site-specific artwork. In this sense, the installation is created especially for a particular gallery space or outdoor site, and it comprises not just a group of discrete art objects to be viewed as individual works but an entire ensemble or environment. Installations provide viewers with the experience of being surrounded by art, as in a mural-decorated public space or an art-enriched cathedral.

Precedents for installations date mainly from the POP ART—era of the late 1950s and 1960s. The most notable are Allan Kaprow's "sets" for HAPPENINGS, Edward Kienholz's tableaux, Red Grooms's theatrical environments such as *Ruckus Manhattan*, Claes Oldenburg's *Store* filled with his plaster renditions of consumer objects, and Andy Warhol's enormous prints in the form of wallpaper.

Unlike many of the works mentioned above, most installations are unsalable. Some examples: Judy Pfaff creates dramatic environments comprising thousands of throwaway elements that evoke undersea gardens or dreamlike fantasy worlds. Daniel Buren makes installations of stripes applied to structures that comment by their placement on the physical or social character of the site. Donald Lipski brings together hundreds of manufactured objects to create witty, three-dimensional variants of allover painting.

Installations generally are exhibited for a relatively brief period and then dismantled, leaving only DOCUMENTATION. Their unsalability and their labor-

intensiveness proved an unsatisfying combination in the increasingly market-attuned art world of the early 1980s. Today the term *installation* is sometimes applied to permanent, site-specific, sculptural ensembles created for corporate or public settings.

See LIGHT-AND-SPACE ART, PATTERN AND DECORATION, PUBLIC ART

JUNK SCULPTURE

▷ **WHO** Arman (France), Lee Bontecou, CESAR (France), John CHAMBERLAIN, Eduardo Paolozzi (Great Britain), Robert Rauschenberg, Richard Stankiewicz, Jean Tinguely (Switzerland)

▷ **WHEN** Primarily the 1950s

▷ **WHERE** Europe and the United States

▷ **WHAT** Junk sculptures are ASSEMBLAGES fashioned from industrial debris. Their roots can be traced to the Cubist COLLAGES and constructions by Pablo Picasso and Georges Braque. The real originator of junk sculpture, however, is the German DADA artist Kurt Schwitters, who began to create assemblages and collages from trash gathered in the streets after World War I.

By World War II the Western nations—especially the United States—had inadvertently pioneered the production of industrial refuse on a grand scale. Dumps and automobile graveyards became a favorite haunt of artists who gathered auto parts and other manufactured cast-offs. They welded them into art or sometimes presented them as FOUND OBJECTS relocated from the trash heap to the gallery.

The range of effects created with these materials is striking. César had entire cars compressed into squat and strangely beautiful columns that clearly reveal their origins as vehicular junk. Lee Bontecou combines steel machine parts with fabric to produce ABSTRACT reliefs that typically suggest a face-vagina with horrific zipper-teeth. The use of discarded materials in such works eloquently comments on the "throwaway" mentality of postwar consumerism. It also implies that welded iron and steel are more appropriate sculptural materials for the machine age than carved marble or cast bronze.

KINETIC SCULPTURE

▷ **WHO** Yaacov Agam (Israel), Pol Bury (France), George Rickey, Nicolas Schöffer (France), Jesus Rafael Soto (Venezuela), Jean Tinguely (Switzerland)

▷ **WHEN** Late 1950s through 1960s

▷ **WHERE** International, but primarily of interest to Europeans

▷ **WHAT** "Kinetic sculpture" is sculpture that contains moving parts, powered by hand or air or motor. It began when the DADA artist Marcel Duchamp mounted a spinnable bicycle wheel on a stool in 1913. In the 1920s the Eastern European artists Naum Gabo and László Moholy-Nagy started to experiment with kinetic sculpture that resembled machines. Shortly thereafter the American Alexander Calder invented the mobile, a delicately balanced wire armature from which sculptural elements are suspended.

Kinetic sculptures are not limited to any one STYLE, but they do share a germinal source of inspiration: the twentieth-century infatuation with technology. The term encompasses a wide variety of approaches. The metal rods of George Rickey's constructions sway in the wind, responsive to the natural elements. Jean Tinguely's kinetic JUNK SCULPTURE *Homage to New York* (1960) destroyed itself in the Museum of Modern Art's garden and demonstrated a darkly satirical view of the industrial era.

The use of modern machinery in kinetic sculpture made it a precursor of—and inspiration for—artists' experiments with more advanced hardware such as lasers and computers. Although these HIGH-TECH works are technically kinetic sculptures, they are more often considered in conjunction with the movement known as ART AND TECHNOLOGY.

A few younger artists create kinetic sculpture today, most notably Mark Pauline and Survival Research Laboratory. This San Francisco–based group orchestrates cacophonous spectacles in which horrific, essentially low-tech machines do battle with one another, evoking the militarization of technology and the gritty realities of life in the urban jungle.

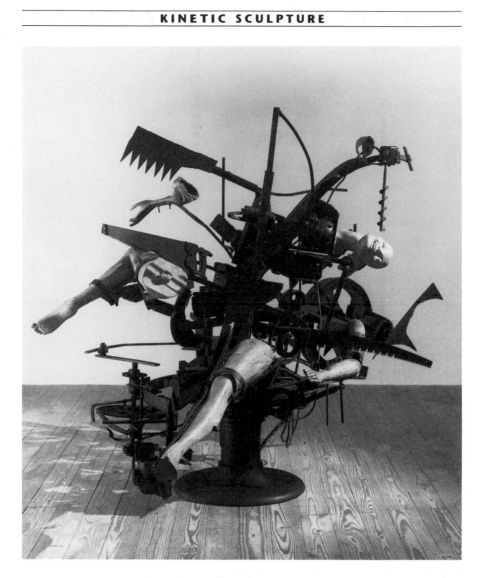

JEAN TINGUELY (b. 1925).
Dissecting Machine, 1965. Motorized assemblage: painted cast iron
and welded-steel machine parts with mannequin parts, 72 7/8 x 74 x
83 7/8 in. The Menil Collection, Houston.

KITSCH

Kitsch refers to the LOW-ART artifacts of everyday life. It encompasses lamps in the shape of the Eiffel Tower, paintings of Elvis Presley on velvet, and lurid illustrations on the covers of romance novels. The term comes from the German verb *verkitschen* (to make cheap). Kitsch is a by-product of the industrial age's astonishing capacity for mass production and its creation of disposable income.

The critic Clement Greenberg characterized kitsch as "rear-guard" art—in opposition to AVANT-GARDE art. Kitsch, he observed (in "Avant-Garde and Kitsch," published in *Partisan Review* in fall 1939), "operates by formulas . . . it is vicarious experience and faked sensation. It changes according to style, but remains always the same. Kitsch is the epitome of all that is spurious in the life of our time." He defined kitsch broadly to include jazz, advertising, Hollywood movies, commercial illustration—all of which are generally regarded now as POPULAR CULTURE rather than kitsch. Although Greenberg's definition of kitsch is overly expansive, his analysis of how it operates remains apt. Today *kitsch* is most often used to denigrate objects considered to be in bad taste.

Attitudes toward kitsch became more complicated with the advent of POP ART in the early 1960s. What had been dismissed as vulgar was now championed by individuals who were fully aware of the reviled status of the "low-art" objects of their affections. This ironic attitude toward kitsch came to be known as "camp," following the publication of the essay "Notes on 'Camp'" by the cultural commentator Susan Sontag in *Partisan Review* in fall 1964.

Obscuring the distinctions between low and HIGH ART was key to the repudiation of MODERNISM and the emergence of POSTMODERNISM. Beginning in the late 1970s kitsch became a favorite subject for such artists as Kenny Scharf, who depicts characters from Saturday-morning cartoons, and Julie Wachtel, who APPROPRIATES figures from goofy greeting cards.

See SIMULATION

LIGHT-AND-SPACE ART

▷ **WHO** Michael Asher, Robert IRWIN, Maria Nordman, Eric Orr, James TURRELL, Doug Wheeler

▷ **WHEN** Late 1960s through 1970s

▷ **WHERE** Southern California

▷ **WHAT** The use of radically new art-making materials and the dematerialization of the art object characterize light-and-space art. It can be considered a descendant of the earlier LOS ANGELES "LOOK," whose practitioners experimented with unusual materials such as cast resin and fiberglass.

As immaterial as CONCEPTUAL ART, light-and-space art focuses less on ideas than on sensory perceptions. Robert Irwin has created numerous INSTALLATIONS in which constantly changing natural light—often filtered through transparent scrims—is used to redefine a space. For viewers, his mysterious light-shot environments intensify sensory awareness and heighten the experience of nature itself in the form of light.

Works of light-and-space art have frequently—and aptly—inspired either scientific or metaphysical interpretations. Irwin and James Turrell, for instance, investigated the phenomenon of sensory deprivation (which influenced the development of their similarly spare light-works) as part of the ART-AND-TECHNOLOGY program initiated by the Los Angeles County Museum of Art in 1967. For his series of works on the theme of alchemy, Eric Orr has used natural light as well as blood and fire.

LOS ANGELES "LOOK"

▷ **WHO** Peter Alexander, Larry BELL, Billy Al Bengston, Joe Goode, Robert IRWIN, Craig KAUFFMAN, John McCRACKEN, Kenneth Price, DeWain Valentine

▷ **WHEN** Mid- to late 1960s

▷ **WHERE** Los Angeles and environs

▷ **WHAT** The *Los Angeles "look"*—a more neutral phrase than the slangily pejorative *Finish Fetish* or *L.A. Slick*—refers to two- and three-dimensional ABSTRACTIONS, usually crafted from fiberglass or resins. Glossy and impersonal, with slick finishes suggestive of the machine-made, they have often been compared to automobiles and surfboards, two iconic staples of life in Southern California.

In their simplicity and abstraction, such works are certainly an offshoot of then-contemporary MINIMALISM. But unlike rigorously theoretical Minimalist art, these works are upbeat and accessible. Their often bright colors and man-ufactured appearance recall POP ART's evocation of commercial products.

The work itself ranges from the simple standing or leaning slabs by John McCracken and Peter Alexander to objects that incorporate light, such as Larry Bell's glass boxes and Robert Irwin's white disks. (Such works paved the way for the LIGHT-AND-SPACE-ART of the 1970s.) For some, the Los Angeles "look" constitutes Southern California's most substantive contribution to the history of postwar art. In the mid-1980s artists such as McCracken were rediscovered by NEO-GEO artists in New York interested in abstraction and the look of every-day domestic objects.

LOW ART—*see* POPULAR CULTURE

LYRICAL ABSTRACTION—*see* COLOR-FIELD PAINTING

MAIL ART—*see* FLUXUS

MANIPULATED PHOTOGRAPHY

▷ **WHO** Ellen Carey, Walter Dahn (Germany), Joan Fontcuberta (Spain), Benno Friedman, Jack Fulton, Paolo Gioli (Italy), Judith Golden, Susan Hiller (Great Britain), Astrid Klein (Germany), Jerry McMillan, Arnulf RAINER (Austria), Lucas SAMARAS, Deborah Turbeville, Lynton Wells, Joel-Peter WITKIN

▷ **WHEN** Since the mid-1970s

▷ **WHERE** Europe and the United States

▷ **WHAT** A manipulated photograph has been altered, embellished, or assaulted. A variety of GESTURAL "manipulating" techniques have been utilized by photographers during the past two decades. Arnulf Rainer draws on his prints, producing EXPRESSIONISTIC self-portraits. Lucas Samaras treats the still-wet emulsions of his Polaroid prints like finger paints, creating a tumult of pat-tern. Joel-Peter Witkin scribbles on his negatives, yielding disturbingly surreal compositions.

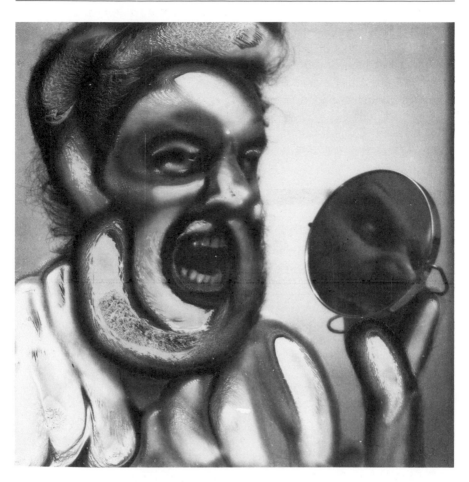

LUCAS SAMARAS (b. 1936).
Photo-Transformation, November 12, 1973, 1973. SX Polaroid print on paper, image: 3 x 3 1/8 in. High Museum of Art, Atlanta; Gift of Lucinda W. Bunnen

At the turn of the century some photographers marked or hand colored their photographs in order to emulate more prestigious print media such as etching. The techniques of today's manipulators are inspired less by history than by the desire to subvert STRAIGHT PHOTOGRAPHERS' concern only for the medium's documentary capabilities ("FABRICATING" photographers are similarly motivated to create fictional subjects) and to make expressive pictures that may resemble paintings as much as photographs.

MALE GAZE—*see* FEMINIST ART

MEDIA ART

▷ **WHO** Ant Farm, Joseph BEUYS (Germany), Border Art Workshop, Chris Burden, Lowell Darling, Gran Fury, Group Material, Guerrilla Girls, Jenny Holzer, Leslie Labowitz and Suzanne Lacy, Les LEVINE, Mike Mandel and Larry Sultan, Antonio MUNTADAS (Spain), Marshall Reese, Martha Rosler, Krzysztof Wodiczko

▷ **WHEN** Since the 1970s

▷ **WHERE** Primarily the United States

▷ **WHAT** *Media*, in this case, refers not to the physical constituents of art, such as acrylic paint or bronze, but to the mass media. Art of this type assumes the form of such far-flung means of communication as newspapers, television, advertising posters, and billboards. Media art is a subset of CONCEPTUAL ART, and its chief precursor is POP ART, with its attraction to POPULAR CULTURE. Former advertising illustrator Andy Warhol used tabloid photographs as the sources for his silkscreened images of movie stars and disasters. Unlike Warhol, most media artists have been highly critical of the mass media and their methods of manipulating public opinion.

Some have attempted to reveal the ideological biases of the mass media. Chris Burden, in the widely broadcast satirical videotape *Chris Burden Promo* (1976), targeted the media's cult of personality by putting his name at the end of a list of revered artists that begins with Michelangelo. Others, such as the Guerrilla Girls and Gran Fury, have functioned as muckraking journalists by providing the public with little-known information about sexism and the AIDS crisis in the form of posters that they paste on New York walls. Challenging the notion that only the rich and powerful have access to the media,

Les Levine purchased billboard space in Great Britain during the early 1980s to reactivate dialogue about Northern Ireland's civil war through such oblique messages as "Block God." Such approaches reveal that the extensive influence of art on the media is now reciprocated in the form of media art.

MEDIATION—*see* VIDEO ART

MINIMALISM

▷ **WHO** Carl ANDRE, Ronald Bladen, Dan FLAVIN, Mathias Goeritz (Mexico), Donald JUDD, Sol LEWITT, Robert Mangold, Brice Marden, Agnes Martin, John McCracken, Robert Morris, Dorothea Rockburne, Robert Ryman, Nobuo Sekie (Japan), Richard SERRA, Tony Smith, Frank Stella, Kishio Suga (Japan), Katsuo Yoshida (Japan)

▷ **WHEN** 1960s to mid-1970s

▷ **WHERE** Primarily the United States

▷ **WHAT** The term *Minimalism* emerged in the writings of the critic Barbara Rose during the mid-1960s. "ABC Art," the title of an influential article she wrote for the October 1965 issue of *Art in America*, did not catch on as a name for the movement, but in that article she referred to art pared down to the "minimum," and by the late 1960s *Minimalism* was commonly being used. It aptly implies the movement's MODERNIST goal of reducing painting and sculpture to essentials, in this case the bare-bones essentials of geometric abstraction. Primarily descended from early twentieth-century CONSTRUCTIVISM, Minimalism was heavily influenced by the clarity and severity of works by the postwar artists Barnett Newman, Ad Reinhardt, and David Smith. Minimalism is the first art movement of international significance pioneered exclusively by American-born artists.

Minimalist painting eliminated REPRESENTATIONAL imagery and illusionistic pictorial space in favor of a single unified image, often composed of smaller parts arranged according to a grid. Despite this tendency toward mathematically regular compositions, Minimalist painting varies widely—from the evocation of the sublime in the nearly monochrome canvases by Agnes Martin or Robert Ryman to the spare and rigorous essays in geometry by Robert Mangold or Brice Marden.

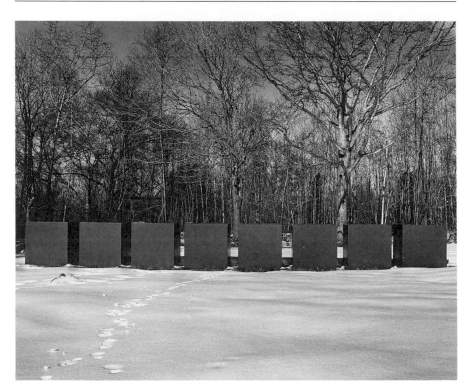

DONALD JUDD (b. 1928).
Untitled, 1967. Rolled steel with auto lacquer; 48 x 48 x 48 in. each.
Collection Philip Johnson.

Minimalism was more frequently associated with sculpture than painting. Minimalist sculpture also eliminated representational imagery, pedestals (human scale predominated), and sometimes even the artist's touch. Typically produced by industrial fabricators, such elemental geometric forms came to be known as *primary structures*, after an influential show of the same name organized by Kynaston McShine at New York's Jewish Museum in 1966.

Committed to the ideal of creating new forms rather than recycling old ones, Minimalist sculptors hoped to transcend the production of mere art objects by producing three-dimensional works that straddled the boundary between art and the everyday world. Robert Morris's boxlike cubes and Donald Judd's shelflike slabs resembled the similarly geometric forms of then-contemporary International Style architecture and late-modern interior design. Despite the artists' interest in infiltrating the urban environment, the public generally found their works inaccessible. Ironically, Minimalism became the sculptural STYLE of choice for corporate collections during the 1970s, at the same time that the sleek glass boxes of International Style architecture came to symbolize corporate power.

Minimalism dominated the art of the late 1960s just as ABSTRACT EXPRESSIONISM had dominated the art of the 1950s—and as no single style would do in the 1970s. International variants arose in Mexico and in Japan, where an important school of Minimalist sculpture, called *Mono-ha*, was centered in Tokyo between 1968 and 1970.

The term *Post-Minimalism* was coined by the critic Robert Pincus-Witten and appeared first in "Eva Hesse: Post-Minimalism into Sublime," in the November 1971 *Artforum*. Pincus-Witten used it to distinguish the more embellished and pictorial approach of Richard Serra's cast-lead works and Eva Hesse's pliable hangings from the stripped-down, prefabricated look of pre-1969 Minimalist works by Judd and Morris. The late 1980s saw the return of the sleek, machined look of Minimalism in the work of young sculptors who rejected the high-pitched emotionalism of NEO-EXPRESSIONISM.

See NEO-GEO

MOBILE—*see* KINETIC SCULPTURE

MODERNISM

Generically, *modern* refers to the contemporaneous. All art is modern to those who make it, whether they are the inhabitants of Renaissance Florence or twentieth-century New York. Even paintings being made today in a fifteenth-century STYLE are still modern in this sense.

As an art historical term, *modern* refers to a period dating from roughly the 1860s through the 1970s and is used to describe the style and the ideology of art produced during that era. It is this more specific use of *modern* that is intended when people speak of modern art or MODERNISM—that is, the philosophy of modern art.

What characterizes modern art and modernism? Chiefly, a radically new attitude toward both the past and the present. Mid-nineteenth-century Parisian painters, notably Gustave Courbet and Edouard Manet, rejected the depiction of historical events in favor of portraying contemporary life. Their allegiance to the new was embodied in the concept of the *avant-garde*, a military term meaning "advance guard." Avant-garde artists began to be regarded as ahead of their time. Although popularly accepted, this idea of someone's being able to act "outside history," apart from the constraints of a particular era, is rejected by art historians.

Crucial to the development of modernism was the breakdown of traditional sources of financial support from the church, the state, and the aristocratic elite. The old style of patronage had mandated artworks that glorified the institutions or individuals who had commissioned them. Newly independent artists were now free to determine the appearance and CONTENT of their art but also free to starve in the emerging capitalist art market. The scant likelihood of sales encouraged artists to experiment. The term "art for art's sake"—which had been coined in the early nineteenth century—was now widely used to describe experimental art that needed no social or religious justification for its existence.

Modern art arose as part of Western society's attempt to come to terms with the urban, industrial, and secular society that began to emerge in the mid-nineteenth century. Modern artists have challenged middle-class values

by depicting new SUBJECTS in dislocating new styles that seemed to change at a dizzying pace. Certain types of content—the celebration of technology, the investigation of spirituality, and the expression of PRIMITIVISM—have recurred in works of different styles. The celebration of technology and science took the form of the glorification of speed and movement seen in Futurism, and the use of scientific models of thinking by artists linked with CONSTRUCTIVISM, CONCRETE ART, and the ART-AND-TECHNOLOGY movement. The investigation of spirituality embodied in early ABSTRACTION, LIGHT-AND-SPACE ART, and the shamanistic rituals by ACTION and FEMINIST artists was a reaction against the secularism and materialism of the modern era. Expressions of primitivism in Post-Impressionism, Cubism, and German EXPRESSIONISM simultaneously reflected new contacts with Asian, African, and Oceanic cultures "discovered" through imperialism and a romantic longing to discard the trappings of civilization in favor of a mythical Golden Age.

Modern art, especially abstract art, was thought by FORMALIST critics to progress toward purity; in the case of painting, this meant a refinement of the medium's essential qualities of color and flatness. (The flattened treatment of pictorial space and concern for the "integrity" of the PICTURE PLANE culminated in the monochrome paintings of the 1950s and 1960s.) This progressive reading of modern art posited a direct line of influence running from Impressionism to Post-Impressionism and on to Cubism, Constructivism, expressionism, DADA, SURREALISM, ABSTRACT EXPRESSIONISM, POP ART, and MINIMALISM, virtually ignoring the contribution of artists working outside Paris or New York.

This idea of progress was especially popular during the late modern era, the twenty-five years or so after World War II. In retrospect that linear view seems to mirror the frenetic output of products, and their instant obsolescence, in the modern industrial age. A booming market for contemporary art emerged in the 1960s with a flurry of stylistic paroxysms that seemed exhilarating to some observers but struck others as a parody of fashion's constantly moving hemlines. Many artists reacted by attempting to create unsalable works.

Modernism's apotheosis of avant-garde novelty—what the American critic Harold Rosenberg called the "tradition of the new" in his 1959 book of that name—encouraged artists to innovate. One aspect of that innovation was the use of odd new art-making materials (including FOUND OBJECTS, debris, natural

light, HIGH-TECH equipment, and the earth itself); new processes and media (COLLAGE, ASSEMBLAGE, VIDEO, and COMPUTER ART); and new forms (abstraction, APPROPRIATION, CRAFTS-AS-ART, INSTALLATIONS, and PERFORMANCE ART).

See POSTMODERNISM

MONO-HA—*see* MINIMALISM

MONSTER ROSTER—*see* CHICAGO IMAGISM

MULTICULTURALISM

Multiculturalism is the opposite of ethnocentricity. In terms of the visual arts, it describes the increasingly widespread opposition among curators, critics, and artists to the elevation of the European cultural tradition over those of Asia, Africa, and the indigenous or nonwhite populations of the Americas. The concept gained currency in the United States and Europe during the late 1980s partly because of the dramatic influx of nonwhite immigrants and the often racist responses triggered by such migrations. The instant transmission of information and ideas across national borders made possible by contemporary technology has also encouraged multiculturalism.

Multiculturalism rejects the vestiges of colonialism embodied in tendencies to regard art from other cultures either as "primitive" or as the exotic products of cultural OTHERS. It demands that works of art from non-European cultures be considered on their own terms. The Centre Georges Pompidou in Paris mounted the controversial exhibition *Les Magiciens de la terre* in 1989. Its coupling of works by well-known Western artists and works by third-world artists unknown to the art world frequently revealed radically different ideas about the nature of art itself. In the United States during the late 1980s several exhibitions of Hispanic and Chicano art were aptly criticized for their blanket interpretation of such art as NEO-EXPRESSIONISM—a designation that ignores the cultural roots from which the work springs.

MULTIPLE

▷ **WHO** Yaacov Agam (Israel), Jonathan Borofsky, Alexander Calder, John Chamberlain, Mark di Suvero, Marcel Duchamp, Ellsworth Kelly, Edward

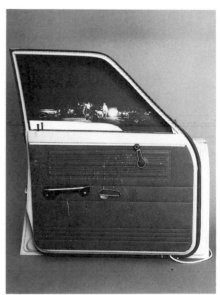

EDWARD KIENHOLZ (b. 1927).
Sawdy, 1971. Car door, mirrored window, automotive lacquer,
polyester resin, silkscreen fluorescent light, galvanized sheet metal,
39 1/2 x 36 x 7 in. National Gallery of Art, Washington, D.C.; Gift of
Gemini G.E.L., 1981.

Kienholz, Isamu Noguchi, Claes Oldenburg, Robert Rauschenberg, Man Ray, Daniel Spoerri (Switzerland), Joe Tilson (Great Britain), Jean Tinguely (Switzerland), Victor Vasarely (Hungary)

▷ **WHEN** Since about 1960

▷ **WHERE** Europe and the United States

▷ **WHAT** A multiple is a three-dimensional artwork produced in quantity. Multiples have rarely been made in large numbers, despite a considerable amount of rhetoric about making art affordable through mass production. They are part of a long tradition. Since the Renaissance, prints (etchings and lithographs) and statuary (in bronze and china) have been fabricated by workshops or factories in limited numbers or "editions" that made them cheaper than unique artworks but still desirable as originals. Multiples are now distributed by print publishers or art dealers who invariably discuss them in terms of editions.

In 1955 the artists Yaacov Agam and Jean Tinguely suggested the idea of doing multiples to the Parisian art dealer Denise René. Four years later the artist Daniel Spoerri founded Editions M.A.T. (Multiplication Arts Transformable) in Paris, which produced reasonably priced multiples in editions of one hundred by Alexander Calder, Marcel Duchamp, Man Ray, Tinguely, Victor Vasarely, and others. Developments in the early 1960s such as the PRINT REVIVAL and POP ART's interest in the mass-produced object made the idea seem especially promising. That promise was realized in the late 1960s with the emergence of collectors attracted to the investment potential of these relatively low-priced works of contemporary art.

NAIVE ART

Naive art is produced by artists who lack formal training but are often obsessively committed to their art making. It may appear to be innocent, childlike, and spontaneous, but this is usually deceptive. Naive artists frequently borrow conventional compositions and techniques from the history of art, and many maintain a remarkably consistent level of quality. Grandma Moses is probably the best-known naive artist of our era.

There is a general naive STYLE. In painting this tends toward bright colors, abundant detail, and flat space. In sculpture (or architectural constructions), it often involves assembling junk or cast-off materials in exuberant constructions such as Simon Rodia's Watts Towers in Los Angeles.

The modern interest in naive art stems from MODERNISM's fascination with "primitive" cultures and unconscious states of mind. The development of ABSTRACTION has made the distortions of naive art seem part of the mainstream. The first evidence of this phenomenon may be the popularity of Henri Rousseau, a former Sunday painter whose charmingly abstracted fantasies seemed appealingly AVANT-GARDE to Pablo Picasso and his circle in early twentieth-century Paris.

Naive art should not be confused with folk art. Folk art features traditional decoration and functional forms specific to a culture. (Folk art has been generally corrupted by the demands of tourism.) Naive art is a product of individual psyches rather than communal history, and it tends to be decorative and nonfunctional. A virtual synonym for *naive art* is *Outsider art*, although the latter is sometimes regarded more narrowly as the work of those actually outside mainstream society, such as prisoners and psychotics.

See ART BRUT, PRIMITIVISM

NARRATIVE ART

▷ **WHO** Jo Harvey Allen, Terry Allen, Eleanor Antin, Ida Applebroog, John Baldessari, Jonathan Borofsky, Joan Brown, Colin Campbell (Canada), Bruce Charlesworth, Sue Coe, Robert Colescott, Robert Cumming, Oyvind Fahlström (Sweden), Eric Fischl, Vernon Fisher, Leon Golub, Jörg Immendorff (Germany), Jean Le Gac (France), Alfred Leslie, Duane Michals, Grégoire Mueller (Switzerland), Odd Nerdrum (Norway), Dennis Oppenheim, Faith Ringgold, Allen Ruppersberg, Alexis Smith, Earl Staley, Mark Tansey, Hervé Télémaque (France), William Wegman, Bruce and Norman Yonemoto

▷ **WHEN** Since the mid-1960s

▷ **WHERE** Europe and the United States

▷ **WHAT** Narrative—or story—art represents events taking place over time. These events may, however, be compressed into a single image that implies something that has already happened or is about to take place.

Painting, of course, has told stories since at least the time of the ancient Egyptians. Starting in the Renaissance, "history painting"—paintings of events from biblical or classical history—acquired the highest status. Nineteenth-century painting and sculpture depicted not only great moments in history

but also domestic dramas of a decidedly sentimental nature. Such subjects were rejected by MODERN painters during the late nineteenth century in favor of scenes from contemporary life. Later modern artists sought to purge painting and sculpture of narrative. Story telling was thought best pursued by writers rather than visual artists, and *literary* became an insult in the argot of modern art.

By the 1960s the modernist insistence on abstraction and the taboo against narrative had made telling tales irresistible to many artists. POP ART, NEW REALIST painting and sculpture, and NOUVEAU REALISME all provided FIGURATIVE imagery into which narratives could be read—whether or not they were intended by the artist.

The most popular form of visual narrative now is painting, with PERFORMANCE, INSTALLATIONS, and VIDEO ART the runners-up. Narrative artwork ranges from Bruce Charlesworth's amusing "who done it" installations suggestive of B novels to Faith Ringgold's affecting autobiographical stories written and painted on quilts. (Words are a frequent element in narrative art.) The narrative approach seems especially suited to psychological self-examination and the investigation of the role-playing that is so conspicuous an element of late twentieth-century social interaction.

See ALLEGORY

NATURALISM—*see* REALISM

NEO—*see* POST-

NEO-DADA

▷ **WHO** Wallace Berman, Bruce Conner, Edward Kienholz, Jasper JOHNS, Robert RAUSCHENBERG

▷ **WHEN** Mid-1950s to mid-1960s

▷ **WHERE** United States

▷ **WHAT** The term NEO-DADA was first applied to the work of Jasper Johns, Allan Kaprow, Robert Rauschenberg, and Cy Twombly in an unattributed comment in the January 1958 issue of *Artnews* magazine. It has come to be associated

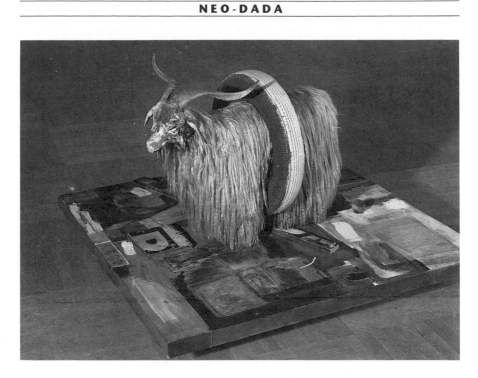

ROBERT RAUSCHENBERG (b. 1925).
Monogram, 1955–59. Mixed-media construction, 48 x 72 x 72 in.
Moderna Museet, Stockholm.

primarily with the work of Johns and Rauschenberg rather than that of Kaprow and Twombly, but it is also appropriate to apply it to the slightly later ASSEMBLAGES by Wallace Berman, Bruce Conner, and Edward Kienholz.

The *Artnews* evocation of DADA referred to two aspects of the early twentieth-century movement. First, there was a Dada-like sense of paradox and ambiguity embodied in Johns's paintings of targets, numbers, and maps that filled the entire surface of the canvas. Second, there was a connection to Marcel Duchamp, Kurt Schwitters, and other Dada artists in Rauschenberg's use of junk and FOUND OBJECTS to create "combines"—hybrid painting-sculptures. (For one of them, the artist used his own mattress and quilt as his "canvas.")

Neo-Dada provided a bridge between ABSTRACT EXPRESSIONISM and POP ART. Johns and Rauschenberg shared the former's predilection for GESTURAL brushwork and grand scale but rejected the sublimity of Abstract Expressionism in favor of everyday imagery. In this regard they influenced the development of Pop art. Neo-Dada's counterpart in Europe was NOUVEAU REALISME.

NEO-EXPRESSIONISM

▷ **WHO** Luis Cruz Azaceta, Georg Baselitz (Germany), Jean-Michel Basquiat, Jonathan BOROFSKY, Sandro Chia (Italy), Francesco CLEMENTE (Italy), Chema Cobo (Spain), Robert Colescott, Sue Coe, Enzo Cucchi (Italy), Rainer Fetting (Germany), Eric Fischl, Gérard Garouste (France), Nancy Graves, Jörg IMMEN-DORFF (Germany), Oliver Jackson, Roberto Juarez, Anselm KIEFER (Germany), Per Kirkeby (Denmark), Christopher LeBrun (Great Britain), Robert Longo, Markus Lupertz (Germany), Helmut Middendorf (Germany), Malcolm Morley, Robert MORRIS, Mike Parr (Australia), A. R. Penck (Germany), Mimmo Paladino (Italy), Ed Paschke, David Salle, Salome (Germany), Julian SCHNABEL, José María Sicilia (Spain), Earl Staley

▷ **WHEN** Late 1970s to mid-1980s

▷ **WHERE** International

▷ **WHAT** The first use of the term *Neo-Expressionism* is undocumented, but by 1982 it was being widely used to describe new German and Italian art. An extremely broad label, it is disliked—as are so many media-derived tags—by many of the artists to whose work it has been applied.

Neo-Expressionism (often shortened to *Neo-Ex*) was a reaction against both

CONCEPTUAL ART and the MODERNIST rejection of imagery culled from art history. Turning their backs on the Conceptual art modes in which they had been trained, the Neo-Expressionists adopted the traditional formats of easel painting and cast and carved sculpture. Turning to modern and premodern art for inspiration, they abandoned MINIMALIST restraint and Conceptual coolness. Instead their art offered violent feeling expressed through previously taboo means—including GESTURAL paint handling and ALLEGORY. Because it was so widespread and so profound a change, Neo-Expressionism represented both a generational changing of the guard and an epochal transition from modernism to POSTMODERNISM.

It is difficult to generalize about the appearance or CONTENT of Neo-Expressionist art. Its imagery came from a variety of sources, ranging from newspaper headlines and SURREALIST dreams to classical mythology and the covers of trashy novels. The German artists have invoked early twentieth-century EXPRESSIONISM to deal with the repression of German cultural history following World War II. Some American painters, such as Julian Schnabel, use eclectic historical images to create highly personal and allusive works. Others, such as Sue Coe, refer to contemporary events to create pointed social commentary.

Neo-Expressionism's return to brash and emotive artworks in traditional and accessible formats helped fuel the booming art market of the 1980s and marked the end of American dominance of international art.

See EAST VILLAGE, TRANSAVANTGARDE

NEO-GEO

▷ **WHO** Ashley Bickerton, Peter Halley, Jeff Koons, Meyer Vaisman

▷ **WHEN** Mid-1980s

▷ **WHERE** New York

▷ **WHAT** *Neo-Geo* is short for "neo-geometric CONCEPTUALISM." It is used, confusingly, to refer to the art of the four very different artists noted above. It probably limits the confusion to apply *Neo-Geo* only to the work of those four artists, although the evocative use of domestic objects as sculptural material by Haim Steinbach and Swiss artist John Armleder does seem closely related.

Jeff Koons's stainless-steel replicas of KITSCH consumer objects, including whiskey decanters in the form of celebrity portraits, are far from geometric

and certainly better understood as APPROPRIATION art. They have little in common with Peter Halley's paintings of linked rectangles (or "cells") inspired by Jean Baudrillard's SIMULATION theory. Both Ashley Bickerton and Meyer Vaisman made "wall sculptures"—thick paintings that extend from the wall and can be viewed from three sides. Vaisman coupled photographic blowups of canvas weave with fragmented images of faces or figures; Bickerton produced paint-encrusted ABSTRACTIONS that evoke household objects or even surfboards. What this disparate work does share is an interest in the cool ironies of POP ART and the use of Conceptual art to address issues related to the nature of the art market during New York's economic boom of the 1980s.

Many regard the term *Neo-Geo* as nothing more than a marketing device, important as an emblem of art-world careerism (Vaisman was also an EAST VILLAGE dealer who showed the work of Koons and Halley) and of the art market's insatiable appetite for the new, rather than as an aesthetic signpost. It has come to be associated with an October 1986 show at the prestigious Sonnabend Gallery in New York that certified the meteoric rise of the four young artists. A poorly received 1987 exhibition of work from the Saatchi Collection in London called *New York Art Now* dampened international enthusiasm for the "movement." By 1989 the term itself was rarely heard, although the artists associated with it continue to receive widespread attention.

NEW IMAGE

▷ **WHO** Nicholas Africano, Jennifer Bartlett, Jonathan BOROFSKY, Neil JENNEY, Robert MOSKOWITZ, Susan Rothenberg, Joel Shapiro, Pat Steir, Donald Sultan, Joe Zucker

▷ **WHEN** Mid-1970s to early 1980s

▷ **WHERE** United States

▷ **WHAT** The name *New Image* derives from the Whitney Museum of American Art's 1978 show *New Image Painting*, curated by Richard Marshall. Although the exhibition was derided as a grab bag of disparate styles—it showcased paintings by many of the artists listed above—it did point to two crucially important phenomena: the return of recognizable FIGURATIVE imagery after a decade of MINIMALISM; and the return of the familiar paint-on-canvas format after a decade of the non-objects of CONCEPTUAL ART.

The progenitor of New Image painting is former ABSTRACT EXPRESSIONIST Philip

Guston. By 1970 he had abandoned the shimmering abstractions for which he was known in favor of idiosyncratic cartoonlike scenes of the tragic human comedy. None of the New Image painters mimicked Guston's highly personal style; it was his gutsy eccentricity that proved catalytic.

Each of the New Image painters charted a highly individual course, but many of their works do create the effect of a figure tentatively emerging from an ABSTRACT background. Consider, for example, Susan Rothenberg's sketchy horses, Nicholas Africano's tiny characters, and Robert Moskowitz's silhouetted objects—all seen against essentially abstract and PAINTERLY backgrounds. Other artists identified as New Image painters applied more Conceptual approaches. Neil Jenney coupled painted images with punning, explanatory titles limned on frames; Jennifer Bartlett produced paintings on steel plates that systematically explored painting's language of abstraction and REPRESENTATION through dozens of differently handled versions of the same subject; and Jonathan Borofsky created large INSTALLATIONS composed of paintings, mechanical sculptures, FOUND OBJECTS, and texts, all intended to evoke a dreamy faux-naïf consciousness.

Although it is difficult to generalize about so varied a group of artists, New Image painting anticipated the postmodern interest in figurative imagery and even, in the case of Pat Steir, the APPROPRIATION of historical painting as a source of SUBJECTS. During the late 1970s New Image was sometimes regarded in tandem with PATTERN AND DECORATION—two nearly diametrically opposed routes back to traditional-format painting after an era in which it had been abandoned.

NEW REALISM

▷ **WHO** William Bailey, Jack Beal, William Beckman, Martha Erlebacher, Janet Fish, Lucian FREUD (Great Britain), Gregory Gillespie, Neil Jenney, Alex KATZ, Alfred LESLIE, Sylvia Mangold, Alice NEEL, Philip Pearlstein, Fairfield Porter, Joseph Raffael, Neil Welliver

▷ **WHEN** 1960s through 1970s

▷ **WHERE** Primarily the United States

▷ **WHAT** By 1962 the term *New Realism* was being used in the United States and France (where it was called *NOUVEAU REALISME*) as a name for POP ART. That use never caught on in the United States, and the term began to signify instead a

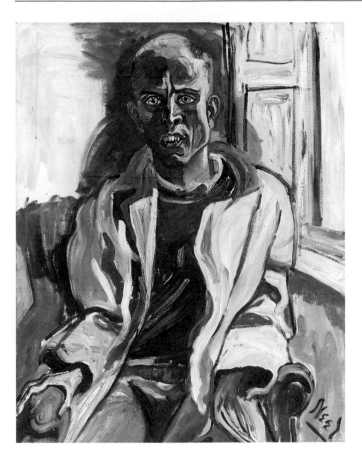

ALICE NEEL (1900–1984).
Randall in Extremis, 1960. Oil on canvas, 36 x 28 in. Robert Miller
Gallery, New York.

new breed of REALISM. The traditional variety had linked humanistic CONTENT with the illusionistic REPRESENTATION of observed reality and the rejection of flattened pictorial space derived from ABSTRACTION.

By contrast, New Realism—although a radical departure from the ABSTRACT EXPRESSIONISM that dominated the 1950s—incorporated the flattened space, large scale, and simplified color of MODERNIST painting. Some New Realist artists like Alfred Leslie had, in fact, switched from abstract to representational painting.

New Realism is too broad a term to have much meaning except as a shorthand for a FIGURATIVE alternative to the abstraction of Abstract Expressionism or MINIMALISM. It has taken many forms, from Fairfield Porter's serene land-scapes to Alice Neel's slyly psychological portraits, and from the abstracted nudes by Philip Pearlstein to the cerebral self-portraits by William Beckman. The term also tends to imply a nongestural or nonexpressionistic handling of paint that suggests fidelity to appearances. The belief that New Realist artists are primarily motivated by an interest in the way things look is belied by the psychic probing of Lucian Freud's work or the radically simplified stylizations of Alex Katz—two artists associated with New Realism.

NEW WAVE

New Wave was a journalistic tag initially—and pejoratively—applied to new French filmmakers of the late 1950s, including François Truffaut and Jean-Luc Godard. (It is still used to refer to contemporary filmmakers such as the German director Wim Wenders.) During the mid- to late 1970s it began to be applied to a new generation of pop musicians in the United States, some of whom were art-school graduates. The increasingly theatrical and eclectic nature of PERFORMANCE ART had encouraged many art students to form bands such as Romeo Void and the spectacularly successful Talking Heads. California art-school graduates from institutions like the San Francisco Art Institute opened storefront ALTERNATIVE SPACES that showcased music and performance as well as exhibitions. An EXPRESSIONISTIC type of advertising poster developed that would influence NEO-EXPRESSIONIST painting.

Soon *new wave* began to be applied, imprecisely, to the visual arts. Two large-scale exhibitions in New York thrust the new-wave aesthetic into the media. The first was the *Times Square Show* of 1980, organized by Collaborative Projects, Inc., and the alternative space Fashion Moda. A decaying former massage parlor was transformed into an illegal, multistory exhibition space. For the first time, GRAFFITI artists were brought together with a new generation

of painters and sculptors (including John Ahearn and Tom Otterness) who were reacting against the antiobject orientation of CONCEPTUAL art. Offering an alternative to the austerity of all-white galleries, the circuslike show created an appealing amalgam of the gallery, the club, and the streets. By the time the second exhibition extravaganza, *New York New Wave* (curated by René Ricard), opened at P.S. 1 in September 1981, the term *new wave* simply referred to the mix of graffiti, Neo-Expressionist, and EAST VILLAGE art that would dominate the first half of the 1980s. Now—as with film—it is merely a synonym for the new and the abrasive.

NEW YORK SCHOOL—*see* SCHOOL OF PARIS

NONOBJECTIVE—*see* ABSTRACT/ABSTRACTION

NONREPRESENTATIONAL—*see* ABSTRACT/ABSTRACTION

NOUVEAU REALISME

▷ **WHO** (from France unless otherwise noted) Arman, César, Christo (Bulgaria), Yves KLEIN, Mimmo Rotella, Niki de Saint Phalle, Daniel Spoerri (Switzerland), Jean TINGUELY (Switzerland)

▷ **WHEN** Late 1950s to mid-1960s

▷ **WHERE** France

▷ **WHAT** The term *Nouveau Réalisme* was coined by the French critic Pierre Restany and appeared on a manifesto signed by many of the artists noted above on October 27, 1960. It translates as "NEW REALISM," but in English that name has come to stand for a more conventional sort of realist painting. To complicate matters further, POP ART, too, was once called *New Realism*, and it is Pop art to which Nouveau Réalisme is closely related.

The Nouveaux Réalistes favored the grittiness of everyday life over the elegantly imaginative and introspective products of 1950s-style ABSTRACTION. Their individual approaches to making art, though varied, all constituted a reaction against the international dominance of ABSTRACT EXPRESSIONISM, ART INFORMEL, and TACHISME. They shared this attitude with that of their American

contemporaries the NEO-DADAISTS Jasper Johns and Robert Rauschenberg and the HAPPENING artist Allan Kaprow.

The manifesto that the Nouveaux Réalistes signed in Yves Klein's apartment in 1960 called only for "new approaches to the perception of the real." Its vagueness well suited the diversity of their art. As a group they are best known for their use of junk and FOUND OBJECTS: Arman creates witty ASSEMBLAGES of musical instruments or domestic appliances and Daniel Spoerri affixed the remains of meals to wooden panels.

OP ART

▷ **WHO** Yaacov Agam (Israel), Richard Anuszkiewicz, Lawrence Poons, Bridget RILEY (Great Britain), Victor VASARELY (Hungary)

▷ **WHEN** Mid-1960s

▷ **WHERE** Europe and the United States

▷ **WHAT** *Op art* is short for *optical art;* other names for this STYLE are *retinal art* and *perceptual abstraction.* The sculptor George Rickey coined the term in 1964, in conversation with Peter Selz and William Seitz, two curators at the Museum of Modern Art. Op art, actually Op painting, is always abstract, and the *optical* refers to "optical illusion": Op paintings create the illusion of movement. Parallel wavy black lines set against a white background, for instance, convincingly suggest movement and depth in Bridget Riley's vibrant works.

Op's antecedents date back at least as far as Josef Albers's courses on color theory and optical experimentation at the Bauhaus school of art in Germany during the late 1920s. Op art's moment of greatest celebrity came in 1965 with the Museum of Modern Art's exhibition *The Responsive Eye.* But soon after that Op art was recycled as a motif in fabric and interior design, and having come to symbolize stylistic change for its own sake, it quickly faded from the scene. Because it epitomized trendy stylistic turnover it was picked up in the late 1980s by APPROPRIATION artists such as Philip Taaffe and Ross Bleckner, who were investigating MODERN art's succession of styles.

ORGANIC ABSTRACTION—*see* ABSTRACT/ABSTRACTION

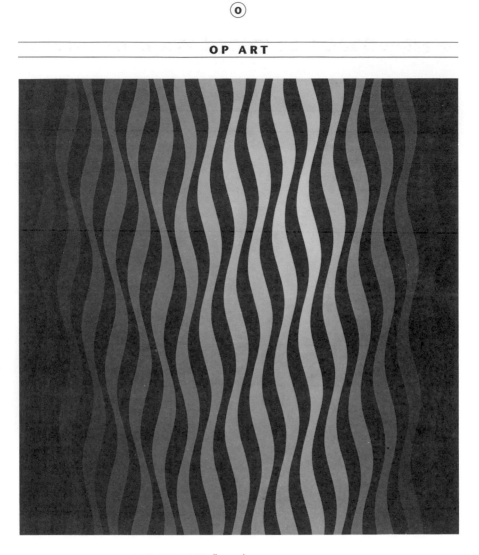

BRIDGET RILEY (b. 1931).
Drift No. 2, 1966. Acrylic on canvas, 91 1/2 x 89 1/2 in. Albright-Knox Art Gallery, Buffalo; Gift of Seymour H. Knox, 1967.

THE OTHER

The concept of "the Other" refers to women, people of color, inhabitants of the so-called Third World, lesbians, and gays—that is, all groups that have traditionally been denied economic and political power. Its origins have sometimes been traced to the French theorist Simone de Beauvoir's *Second Sex*, a pioneering work of existentialism-suffused feminism written in 1949.

To regard people as Others is to see them as objects rather than as subjects driven by psychological needs and desires similar to the viewer's. (Adherents of the influential French psychoanalytic theorist Jacques Lacan tend to view the first Other as the mother.) This is, of course, the foundation of prejudice and a psychic defense against understanding people different from oneself.

The Other entered the discourse of artists and critics in the late 1970s and began to be frequently heard in the mid-1980s. The cultural historian Edward Said ably utilized this concept in his investigations of "Orientalism," nineteenth- and twentieth-century depictions of Asians and Africans by Western artists that failed to accord them the psychological complexity and humanity with which Europeans were depicted. The 1984 traveling exhibition *Difference: On Representation and Sexuality*, organized by the critic Kate Linker for the New Museum of Contemporary Art in New York, examined the social construction of gender and sexuality in both film and the visual arts. The late 1980s saw a growing number of visual artists in the United States and Great Britain addressing issues of "Otherness."

See MULTICULTURALISM

OUTSIDER ART—*see* NAIVE ART

PAINTERLY

The Swiss art historian Heinrich Wölfflin coined this term in 1915 in order to distinguish the optical qualities of Baroque painting from Neoclassical painting. As he saw it, the loose and GESTURAL paint handling, or "painterly" quality, of the former focuses the viewer's attention on dazzling visual effects, whereas the sculptural linearity of the latter invites touch. The opposite of *painterly* is not *sculptural* but linear. The term *linearity* is only rarely heard anymore, but *painterly* is often used to describe paint handling that is loose, rapid, irregular, gestural, dense, uneven, bravura, EXPRESSIONIST, or that calls attention to itself in any other way.

FORMALIST critics after World War II adopted Wölfflin's dualism as a strategy for championing ABSTRACT painting. Although the idea of "painterly painting" may seem redundant, it corresponds with MODERN notions of an art form's progressing toward its "essence"—in painting's case, an emphasis on flatness, color, and tactile paint surfaces.

The critic Clement Greenberg suggested calling ABSTRACT EXPRESSIONISM *painterly abstraction*, and in 1964 he curated an influential show of COLOR-FIELD and HARD-EDGE painting at the Los Angeles County Museum called *Post-Painterly Abstraction*.

PAPIER COLLE—see COLLAGE

PARALLEL GALLERY—*see* ALTERNATIVE SPACE

PATTERN AND DECORATION

▷ **WHO** Brad Davis, Tina Girouard, Valerie Jaudon, Joyce Kozloff, Robert KUSHNER, Kim MacCONNEL, Rodney Ripps, Miriam SCHAPIRO, Ned Smyth, Robert Zakanitch

▷ **WHEN** Mid-1970s to early 1980s

▷ **WHERE** United States

▷ **WHAT** By the mid-twentieth century the adjective *decorative* was firmly established as an insult in contemporary art parlance. The prevailing critical view of decoration as trivial has rarely been shared by non-Western cultures, as is evident from the complex and sophisticated patterning of Islamic, Byzantine, and Celtic art. Inspired by such sources—as well as by carpets, quilts, fabrics, mosaics and other crafts, both Eastern and Western—a group of artists in the mid-1970s began to create works that challenged the taboo against decorative art.

Unlike so many other "isms," Pattern and Decoration (or *P and D*) actually *was* a movement. Feeling alienated from the concerns of the mainstream art world, the Pattern-and-Decoration artists—many of them from Southern California—gathered in a series of meetings in Robert Zakanitch's New York studio during the fall of 1974. They met to discuss the nature of decoration and their attraction to it. Some had been influenced by the feminist concern for womanmade crafts such as quilts and Navajo blankets. Others, including

the critic Amy Goldin, were fascinated with non-Western art forms. Their desire to raise the status of decoration in contemporary art resulted in a number of panel discussions and public presentations during 1975. Many of the Pattern-and-Decoration artists would soon begin to show with the then-fledgling New York art dealer Holly Solomon.

Although they were reacting against MINIMALISM, Pattern-and-Decoration artists often started with the same flattening grid frequently employed by Minimalist painters. The effects they achieved, however, are precisely the opposite of the rigorously theoretical Minimalist canvases. They produced large, boldly colored paintings or sewn works on unstretched fabric that suggest flower-patterned wallpaper (in the case of Robert Zakanitch), Japanese fans (by Miriam Schapiro), and Celtic-inspired interlaces (by Valerie Jaudon). Proceeding from an understanding of decoration's role not just in art but in domestic and public places, Pattern-and-Decoration artists also create functional objects and INSTALLATIONS—Ned Smyth and Joyce Kozloff in tile, Tina Girouard in linoleum, Kim MacConnel by painting on 1950s furniture.

PERFORMANCE ART

▷ **WHO** Vito ACCONCI, Laurie ANDERSON, Eleanor Antin, Anna Banana (Canada), Bob and Bob, Eric Bogosian, Stuart Brisley (Great Britain), Nancy Buchanan, Chris BURDEN, Scott Burton, Theresa Hak Kyung Cha, Ping Chong, George Coates, Colette, Papo Colo, Paul Cotton, Ethyl Eichelberger, Karen Finley, Terry Fox, General Idea (Canada), Jan Fabre (Belgium), Gilbert and George (Great Britain), Guillermo Gómez-Peña, Rebecca Horn (Germany), Joan Jonas, Leslie Labowitz, Suzanne Lacy, Tom Marioni, Tim Miller, Meredith MONK, Linda Montano, Nice Style—the World's First Pose Band (Great Britain), Luigi Ontani (Italy), Gina Pane (Italy), Mike Parr (Australia), Ulrike Rosenbach (Germany), Rachel Rosenthal, Carolee Schneemann, Jill Scott (Australia), Stelarc (Australia), the Waitresses, Robert WILSON

▷ **WHEN** Since the late 1960s

▷ **WHERE** International

▷ **WHAT** The term *performance art* is extraordinarily open-ended. Since the late 1970s it has emerged as the most popular name for art activities that are presented before a live audience and that encompass elements of music, dance, poetry, theater, and video. The term is also retroactively applied to earlier live-art forms—such as BODY ART, HAPPENINGS, ACTIONS, and some FLUXUS and

FEMINIST ART activities. This diffusion in meaning has made the term far less precise and useful.

Starting in the late 1960s many artists wanted to communicate more directly with viewers than painting or sculpture allowed, and their ways of doing so were inspired by a variety of visual art sources. These ranged from early twentieth-century DADA events (composer John Cage helped spread the word about them in postwar New York) to Jackson Pollock's painting for a film camera in 1950. Until the late 1970s artists specifically rejected the term *performance* for its theatrical implications.

The type of performance art that began in the late 1960s was primarily a CONCEPTUAL activity, and such events bore little resemblance to theater or dance. Instead, they took place in galleries or outdoor sites, lasted anywhere from a few minutes to a few days, and were rarely intended to be repeated. A few examples suggest the variety of approaches to performance during this era. Starting in 1969 the British duo Gilbert and George dubbed themselves "living sculpture" and appeared as robotic art objects in their exhibitions or on the streets of London. For *Seedbed*, part of his January 1972 show at New York's Sonnabend Gallery, Vito Acconci masturbated under a ramp on which audience members walked while listening to his microphone-amplified responses to their presence. *Duet on Ice* (1975) found Laurie Anderson on a Bologna street corner teetering on ice skates and playing classical and original compositions on the violin until the blocks of ice encasing the skate's blades melted. And in 1977 Leslie Labowitz created *Record Companies Drag Their Feet*, a performance designed to focus attention on the use of exploitative images of women on album covers and in society at large. Many artists of this generation (Scott Burton, Gilbert and George, and Vito Acconci among them) have since moved from making performances to making art objects.

A second generation of performance artists emerged in the late 1970s. Rejecting the austerity of Conceptual art and its traditionally critical approach to POPULAR CULTURE, the first generation of artists raised on TV moved performance out of the galleries. Performance can now be seen in theaters, clubs—as music or stand-up comedy—on videotape or film. Performance, usually with striking visual elements, often seems synonymous with AVANT-GARDE dance, drama, or music. The 1980s has produced numerous "cross-over" talents whose roots can be traced to performance and the visual arts. They

LAURIE ANDERSON (b. 1947).
United States Part II, 1980. Photograph by Paula Court, New York.

include the musicians Laurie Anderson and David Byrne, the actors Ann Magnuson and Spalding Gray, the comics Whoopi Goldberg and Eric Bogosian, the new vaudevillian Bill Irwin, and the opera designer Robert Wilson.

PHOTOMONTAGE—*see* COLLAGE

PHOTO-REALISM

▷ **WHO** Robert BECHTLE, Claudio Bravo (Chile), John Clem Clarke, Chuck CLOSE, Robert Cottingham, Rackstraw Downes, Don Eddy, Richard ESTES, Janet Fish, Audrey Flack, Ralph Goings, Richard McLean, Malcolm MORLEY

▷ **WHEN** Mid-1960s to mid-1970s

▷ **WHERE** Primarily the United States

▷ **WHAT** The New York art dealer Louis Meisel is generally credited with origi- nating the term *Photo-Realism*. (It prevailed over *Realism, Sharp-Focus Realism*, and, in Europe, *Hyper-Realism*.) Photo-Realism is just what the name implies: a type of REALIST painting whose subject is the photograph, or the pho- tographic vision of reality. In his painting of a family posed in front of its late 1950s car, Robert Bechtle, for instance, was more concerned with the flattening effect of the camera on the image than with the nostalgic depiction of subur- ban family life. Put another way, it is the photographic effect that interests many Photo-Realist painters as much as their subjects.

Most Photo-Realists specialize in a certain type of subject: Richard Estes in photographs of highly reflective windows; Audrey Flack in photographs of sym- bolic still lifes seen from above; and Malcolm Morley in photographs of travel- ers on glamorous cruise ships. The polyvinyl sculptures of Duane Hanson and John De Andrea—who work from casts of clothed or unclothed models—can be considered the three-dimensional equivalent of Photo-Realism.

When Photo-Realist paintings appeared in large numbers at Documenta 5—the 1972 version of the important German mega-exhibition—most critics derided it as intolerably backward looking. In fact, the banality of the images, the tech- nique of painting from slides projected onto the canvas, the shallow pictorial space, and the use of thinly applied acrylic paint link many Photo-Realist paintings with POP ART.

MALCOLM MORLEY (b. 1931).
On Deck, 1966. Magnacolor on liquitex ground on canvas, 83 3/4 x 63 3/4 in. The Metropolitan Museum of Art, New York; Gift of Mr. and Mrs. S. Brooks Barron, 1980.

PICTURE PLANE

The concept of a picture plane originated during the Renaissance and spurred the development of the principles of perspective. It is not the physical surface of a painting but an imaginary one, which theorists and critics have traditionally equated with a window separating viewers from the image. The picture plane can be "punctured" in a variety of ways: by the depiction of an out-of-scale object in the foreground that appears to occupy the space between the forward limits of the pictorial space and the viewer; or—in the case of an ABSTRACTION—by the inclusion of an illusionistic rendering of, say, an X painted with its shadow so it appears to leap off the surface of an otherwise flat composition. FORMALIST critics of the 1950s and the '60s inveighed against violations of the "integrity of the picture place" (a common phrase) in pursuit of absolute flatness.

PLURALISM

Pluralism is the opposite of a clearly defined mainstream. It refers to the coexistence of multiple STYLES in which no single approach commands the lion's share of support or attention. Although all kinds of art—from REALIST to ABSTRACT and impressionist to EXPRESSIONIST—were produced simultaneously throughout the MODERN period, in the 1920s modern art began to be regarded as a tidy succession of styles originating in the late nineteenth century. During the 1950s ABSTRACT EXPRESSIONISM was seen as the culmination of that development, and critical interest was focused on it to the exclusion of other approaches.

By the mid-1960s a more variegated tapestry of contemporary art was being woven: POP ART, COLOR-FIELD PAINTING, and MINIMALISM were all receiving critical and commercial attention. The 1970s were pluralist with a vengeance. New styles and new media included ARTE POVERA, CONCEPTUAL ART, CRAFTS-AS-ART, EARTH ART, FEMINIST ART, MEDIA ART, PATTERN AND DECORATION, PERFORMANCE, and VIDEO, among many others. The pluralism of the 1970s clearly sprang from the political and cultural upheavals of the late 1960s. Women, for instance, achieved quantitatively larger representation in the art world than at any previous period in history.

The complexity of the pluralist art scene of the 1970s—the decade most associated with pluralism—alienated some observers. Critics hostile to pluralism decried the emphasis on forms other than painting and sculpture, which

demanded radically new criteria of evaluation. Others viewed the situation as open rather than chaotic and maintained that it more accurately reflected the diversity of contemporary society. The subsequent decline of NEO-EXPRESSIONISM in the mid-1980s has been followed by a pluralist situation in which virtually all forms of work are exhibited and written about.

POLITICAL ART

Every artwork is political in the sense that it offers a perspective—direct or indirect—on social relations. Andy Warhol's images of Campbell's soup cans, for instance, celebrate consumer culture rather than criticize it. Jackson Pollock's ABSTRACTIONS proclaim the role of the artist as a free agent unencumbered by the demands of creating recognizable images. The politics are almost invariably easier to spot in pre-MODERN works, such as portraits of kings or popes that frankly announce themselves as emblems of social power.

Milestones of twentieth-century political art include Soviet AVANT-GARDE art from about 1920, Mexican mural paintings and the United States' WPA projects of the 1930s, and Pablo Picasso's *Guernica* (1937). Many of these works take leftist positions supporting the distribution of art to mass audiences or criticizing official policies. Right-wing views were expressed in the art and architecture of the Nazi and Fascist regimes. Paintings of Aryan youths promoted Hitler's genocidal dreams, and ambitious architectural programs linked the Italian and German governments with the authority of classical Greece and Rome. During the 1930s and '40s debate raged among American artists such as Stuart Davis and Arshile Gorky over whether an artist should make straightforwardly political art by using recognizable imagery or create abstractions free of overt politics. The latter viewpoint eventually prevailed, largely due to the Hitler-Stalin Pact of 1939, which many artists and intellectuals regarded as a betrayal.

In current usage *political art* refers to works with overtly political subjects made to express criticism of the status quo. Political artists include Rudolf Baranik, Victor Burgin, Sue Coe, Leon Golub, Felix González-Torres, Hans Haacke, Jerry Kearns, Suzanne Lacy, Martha Rosler, May Stevens, and collective groups such as the Border Art Workshop, Feminist Art Workers, Gran Fury, Group Material, and the Guerrilla Girls. The efficacy of political art becomes a thornier matter when questions of distribution, context, and audience are considered. Can a painting sold for $100,000 to a bank or a multinational cor-

poration function critically? Some politically inclined artists have turned to CONCEPTUAL ART or to making posters for the street in order to control not only the production of their art but also its distribution and context.

POP ART

▷ **WHO** Robert Arneson, Jim Dine, Oyvind Fahlström, Richard HAMILTON (Great Britain), David Hockney (Great Britain), Robert Indiana, Ron Kitaj (Great Britain), Roy LICHTENSTEIN, Claes OLDENBURG, Eduardo Paolozzi (Great Britain), Sigmar Polke (Germany), Mel Ramos, James Rosenquist, Ed Ruscha, Wayne Thiebaud, Andy WARHOL, Tom Wesselmann

▷ **WHEN** Late 1950s through 1960s

▷ **WHERE** Primarily Great Britain and the United States

▷ **WHAT** *Pop* stands for *popular* art. The term *Pop art* first appeared in print in an article by the British critic Lawrence Alloway, "The Arts and the Mass Media," which was published in the February 1958 issue of *Architectural Design*. Although Pop art is usually associated with the early 1960s (*Time, Life,* and *Newsweek* magazines all ran cover stories on it in 1962), its roots are buried in the 1950s. The first Pop work is thought to be Richard Hamilton's witty COLLAGE of a house inhabited by fugitives from the ad pages called *Just What Is It That Makes Today's Home So Different, So Appealing?* (1956). That work was first seen at *This Is Tomorrow*, an exhibition devoted to POPULAR CUL-TURE, by the Independent Group of the Institute of Contemporary Arts in London. The show that thrust Pop art into America's consciousness was *The New Realists*, held at New York's Sidney Janis Gallery in November 1962.

Precedents for Pop art include DADA, with its interest in consumer objects and urban debris, and the paintings and collages of Stuart Davis, an American MOD-ERNIST who used Lucky Strike cigarette packaging as a subject in the 1920s. Chronologically closer at hand, Jasper Johns's NEO-DADA paintings of everyday symbols like the flag were crucially important to American Pop artists. Some observers regard NOUVEAU REALISME as the precursor of Pop. In fact, the rap-prochement with popular culture that was epitomized by Pop art seems to have been part of the ZEITGEIST of the 1950s in England, France, and the United States.

Popular culture—including advertising and the media—provided subjects for Pop artists. Andy Warhol mined the media for his iconic paintings and

silkscreened prints of celebrities such as Marilyn Monroe, and Roy Lichtenstein borrowed the imagery and look of comic strips for his drawings and paintings. Claes Oldenburg transformed commonplace objects like clothespins and ice bags into subjects for his witty large-scale monuments.

Pop art was simultaneously a celebration of postwar consumerism and a reaction against ABSTRACT EXPRESSIONISM. Rejecting the Abstract Expressionist artist's heroic personal stance and the spiritual or psychological content of his work, Pop artists took a more playful and ironic approach to art and life. Pop painting did not, however, eschew the spatial flatness that had come to characterize twentieth-century AVANT-GARDE painting.

POSTMODERNISM, NEO-GEO, and APPROPRIATION art—grounded in popular culture, the mass media, and SEMIOTIC interpretation—could never have happened without the precedent of Pop art.

POPULAR CULTURE

Popular culture used to be called *mass culture*, which is now an outmoded term. Made up of a multitude of forms of cultural communication—illustrated newspapers, movies, jazz, pop music, radio, cabaret, advertising, comics, detective novels, television—it is a distinctly MODERN phenomenon that was born in urban Western Europe during the nineteenth century. A nascent working class with a bit of leisure time on its hands created a demand for new art forms that were more accessible than opera, classical music, ACADEMIC painting, traditional theater, and literature. Those elite art forms, developed for aristocratic audiences, required education to be understood. They are known as *high art;* popular (or pop) culture is often referred to as *low art*. The competition between high and low culture peaked in the 1950s and '60s with debates over whether intellectuals (and children) should watch television, whether POP ART *was* art, and other cultural controversies.

For the first half of the twentieth century, the gulf separating high art and popular culture was cavernous. Modern art regarded itself as revolutionary and critical of bourgeois, or middle-class, culture. Uncompromisingly idealistic and frequently hard to sell, it stood apart from commerce. Popular culture, on the other hand, was defined by its commercial success or failure. Although many modern artists were fascinated with jazz or the movies of Charlie Chaplin, their fascination surfaced only indirectly in their art. The popular entertainments offered at music halls and cabarets, for instance, were

frequently portrayed by early modern painters. But for the most part they made paintings of these nightspots, rather than inexpensive prints or advertising posters. The high-art status of their works was never in doubt.

With the advent of Pop art about 1960, this changed. Art was no longer insulated from the consumer-oriented imagery that had become so distinctive a feature of mid-twentieth-century life. The seeds of the symbiotic relationship between art and popular culture that were planted in the Pop art of the 1960s blossomed in the CONCEPTUAL ART of the 1970s. PERFORMANCE, MEDIA, and VIDEO artists of the second half of that decade frequently took as their subjects pop-cultural forms, including soap operas, B novels, and advertisements. Ironically, this reconciliation between popular culture and high art signaled the success of the modernist demand for the portrayal of contemporary experience. Artists could no longer see themselves as beleaguered outsiders confronting a backward-looking bourgeois establishment. (Many began to appear in liquor advertisements beginning in the mid-1980s.) In POSTMODERN art, hostility toward popular culture has been replaced by direct engagement with it. NEO-EXPRESSIONIST painters, for example, were just as likely to take their motifs from Saturday-morning cartoons as from art historical depictions of Marie Antoinette frolicking in milkmaid's attire.

See KITSCH

POST-

Post- is a prefix attached to another term to signify *after.* POST-MINIMALISM means "after MINIMALISM"; POSTMODERNISM means "after MODERNISM," and so on. The use of the term is a modern development. It was first applied to the Post-Impressionists—Paul Cézanne, Paul Gauguin, Georges Seurat, Vincent van Gogh, and others—the major French painters who followed the Impressionists.

That these painters shared little besides their excellence and their historical moment points to the problematic nature of *post*—save in such objective terms as *postwar.* Its use is likely to mislead or mask the real meaning of movements or artworks by implying that they are primarily reactions to what preceded them rather than independent phenomena. (The term *neo*—meaning "new," as in NEO-EXPRESSIONISM—is similarly problematic.) Ultimately, this rush to judgment—we usually think of new work in terms of what we already

know—results in a linear but not necessarily accurate vision of history. Such terms frequently obscure, rather than enhance, the understanding of art.

POST-MINIMALISM—*see* MINIMALISM

POSTMODERNISM

The term *postmodernism* probably first appeared in print in Daniel Bell's *End of Ideology* (1960). Charles Jencks began to apply it to architecture a decade later, when it was also widely invoked in connection with Judson-style dance, which was named after the Judson Memorial Church in Greenwich Village and championed everyday or "vernacular" movement. It was not until the late 1970s that the term began to be routinely used by art critics. Its definition was so vague then that it meant little more than "after MODERNISM" and typically implied "against modernism."

Many theorists believe that the transition from modernism to postmodernism signified an epochal shift in consciousness corresponding to momentous changes in the contemporary social and economic order. Multinational corporations now control a proliferating system of information technology and mass media that renders national boundaries obsolete. (Images of artworks that appear in the art magazines, for example, are instantly accessible to an international audience.) Postmodern or postindustrial capitalism has successfully promoted a consumerist vision that is causing a rapid redrawing of the East-West boundaries established after World War II. The ecological revolt that dawned during the 1960s—as did most of the changes that distinguish postmodernism from modernism—signaled a loss of modern faith in technological progress that was replaced by postmodern ambivalence about the effects of that "progress" on the environment. Just as modern culture was driven by the need to come to terms with the industrial age, so postmodernism has been fueled by the desire for accommodation with the electronic age.

Following World War II, modern art making and art theory grew more reductive, more prescriptive, more oriented toward a single, generally abstract mainstream. (Many other kinds of art were being produced, but that kind of art and theory received the bulk of support from the art establishment.) With MINIMALISM, artists of the 1960s reached ground zero—creating forms stripped down almost to invisibility—and the historical pendulum was set back in

motion. Modernism's unyielding optimism and idealism gave way to the broader, albeit darker, emotional range of postmodernism.

Building directly on the POP, CONCEPTUAL, and FEMINIST ART innovations of the 1960s and '70s, postmodernists have revived various genres, subjects, and effects that had been scorned by modernists. The architect Robert Venturi succinctly expressed this reactive aspect of postmodernism by noting, in his influential treatise *Complexity and Contradiction in Architecture* (1966), a preference for "elements which are hybrid rather than 'pure,' compromising rather than 'clean,' ambiguous rather than 'articulated,' perverse as well as 'interesting.'..."

It is important to distinguish what is new about postmodernism from what is a reaction against modernism. In the latter category is the widespread return to traditional genres such as landscape and history painting, which had been rejected by many modernists in favor of abstraction, and a turning away from experimental formats such as PERFORMANCE ART and INSTALLATIONS. APPROPRIATION artists challenge the cherished modern notion of AVANT-GARDE originality by borrowing images from the media or the history of art and re-presenting them in new juxtapositions or arrangements that paradoxically function in the art world as celebrated examples of innovation or a new avant-garde. Such practices are one source of the difficulty in defining this open-ended term—many observers speak of *postmodernisms*.

One distinctly new aspect of postmodernism is the dissolution of traditional categories. The divisions between art, POPULAR CULTURE, and even the media have been eroded by many artists. Hybrid art forms such as furniture-sculpture are now common. In terms of theorizing about art, earlier distinctions between art criticism, sociology, anthropology, and journalism have become nonexistent in the work of such renowned postmodern theorists as Michel Foucault, Jean Baudrillard, and Fredric Jameson.

Perhaps the clearest distinction between modern and postmodern art involves the sociology of the art world. The booming art market of the 1980s fatally undermined the modern, romantic image of the artist as an impoverished and alienated outsider. What many term the Vincent van Gogh model of the tormented artist has been replaced by the premodern ideal of the artist as a (wo)man of the world, à la Peter Paul Rubens, the wealthy Flemish artist and diplomat who traveled widely throughout European society during the seven-

teenth century. The postmodern phenomenon of retrospective exhibitions for acclaimed artists in their thirties puts heavy pressure on artists to succeed at an early age and frequently results in compromises between career concerns and artistic goals, a problem unknown to the generations of modern artists who preceded them.

POST-PAINTERLY ABSTRACTION—*see* COLOR-FIELD PAINTING

PRIMARY STRUCTURE—*see* MINIMALISM

PRIMITIVISM

There are several kinds of primitivism. There is art by prehistoric or non-Western peoples. (In this case the terms *primitive* and *primitivism* frequently appear in quotes to suggest the inaccuracy and ethnocentricity of such characterizations.) There are subjects or forms borrowed from non-Western sources, including Gauguin's renderings of Tahitian motifs and Picasso's use of forms derived from African sculpture. There is also work by artists who are self-taught, but *primitivism* is rarely used that way anymore.

The idea of primitivism stems in large part from the sentimental notion of the "Noble Savage" as a superior being untainted by civilization, which was popularized by the eighteenth-century French philosopher Jean-Jacques Rousseau. Imperial conquests in Asia, Africa, and Oceania brought exotic foreign cultures to the attention of Europeans. Showcased in the spectacular expositions and fairs of the nineteenth century, the arts and crafts of non-Western peoples offered artists expressive, non-NATURALISTIC alternatives to the illusionistic tradition that had prevailed in Western art since the Renaissance.

The desire to express a truth that transcended mere fidelity to appearance was a fundamental tenet of MODERNISM. Although non-Western art provided many European artists with a model for emotive and sometimes antirational art, they frequently misinterpreted it. Fierce-looking West African masks, for instance, were seen as representations of the mask maker's own inflamed feelings, when they were actually produced as talismans to insure a tribe's good fortune in battle.

The compelling desire to invest art with emotional or spiritual authenticity distinguishes modern from Victorian art, which tried to instruct or divert viewers. To communicate genuine feeling, modern artists turned to a multitude of primitivizing forms and approaches. The motif of the shaman in FEMINIST, ACTION, and PERFORMANCE ART alludes to the prehistoric connection between art, religion, and magic. EARTH ART may evoke prehistoric places of worship. The abundance of childlike imagery in modern art, epitomized in paintings by Paul Klee, embodies the related yearning to escape adulthood and "civilized" social responsibilities. The GRAFFITI or ART BRUT artist's role as a social outsider implies the rejection of an over-civilized world. In Western culture, romantic myths of primitivism are among the most enduring ideas of the last two hundred years..

See THE OTHER

PRINT REVIVAL

▷ **WHO** The foremost printer-publishers are Cirrus Editions Limited (Los Angeles); Crown Point Press (San Francisco); Experimental Workshop (San Francisco); Gemini G.E.L. (Graphics Editions Limited) (Los Angeles); Landfall Press (Chicago); Parasol Press Ltd. (New York); Tamarind Lithography Workshop (Albuquerque); Tyler Graphics, Ltd. (Mount Kisco, New York); Universal Limited Art Editions (ULAE) (West Islip, New York).

▷ **WHEN** Since the late 1950s

▷ **WHERE** United States

▷ **WHAT** *Print revival* is actually a misnomer, because the European tradition of fine prints by artists had never really caught on in the United States in the first place. A few pre—World War II American MODERNISTS, such as John Marin and Edward Hopper, did make prints, but their output was irregular, and the small art-buying public here was uncomfortable with the idea of more than a single "original" inherent in printmaking.

The distance separating American artists and printmakers began to shrink in the late 1930s as European artists fleeing Hitler arrived in New York. Along with them came Stanley William Hayter, the renowned English printer who moved his printmaking studio, Atelier 17, from Paris to New York in 1941. He collaborated with such artists as Mark Rothko and Willem de Kooning, instructing them in numerous lithographic and etching techniques. In 1950 he returned to Paris, although New York's Atelier 17 remained open until 1955.

The print revival began in earnest when Tatyana Grosman opened Universal Limited Art Editions in West Islip on Long Island in 1957, followed by the artist June Wayne's establishment of Tamarind Lithography Workshop in 1960 in Los Angeles. Grosman and Wayne are widely credited with initiating unprecedented interest in American lithography; Kathan Brown would soon do the same for etching at Crown Point Press in the San Francisco Bay Area. All three enabled the most critically acclaimed contemporary artists to experiment with printmaking in collaboration with master printers.

A milestone in the history of American printmaking was the production of Robert Rauschenberg's six-foot-high *Booster* (1967) at Gemini G.E.L. At that time the largest lithograph ever created, it mixed lithographic and screenprinting techniques to achieve the effects that Rauschenberg desired. CONCEPTUAL artists' emphasis on finding the appropriate means to realize an idea stimulated printers and artists to experiment. This spirit of innovation and eclecticism has been America's major contribution to printmaking. Similar approaches are now common in Europe, having been pioneered at the Kelpra Studio in London, where founder Chris Prater began working with artists in 1961. Today there are few contemporary artists of note throughout Europe, Latin America, and the United States who do not include printmaking in their repertoire.

See MULTIPLES

PROCESS ART

▷ **WHO** Lynda Benglis, Joseph Beuys (Germany), Agnes Denes, Sam Gilliam, Hans HAACKE, Eva HESSE, Jannis Kounellis (Italy), Robert Morris, Richard Serra, Keith Sonnier

▷ **WHEN** Mid-1960s to early 1970s

▷ **WHERE** -United States and Western Europe

▷ **WHAT** In process art the means count for more than the ends. The artist sets a process in motion and awaits the results. Eva Hesse used malleable materials like fiberglass and latex to create ABSTRACT forms that seem to spring from the interactions of her unstable materials and that are slowly decomposing over time. In Hans Haacke's plexiglass cubes, or "weather boxes," water

HANS HAACKE (b. 1936).
Condensation Cube, 1963–65. Acrylic, plastic, water, and the climate
in the area of the display, 11 3/4 x 11 3/4 x 11 3/4 in. John Weber Gallery,
New York.

condenses and evaporates in response to the changing levels of light and temperature in the gallery.

Process art was "certified" by two important museum exhibitions in 1969: *When Attitudes Become Form*, curated by Harold Szeeman for the Berne Kunsthalle, and *Procedures/Materials*, curated by James Monte and Marcia Tucker for the Whitney Museum of American Art in New York. Antecedents of process art include Jackson Pollock's ABSTRACT EXPRESSIONIST poured paintings and the slightly later stain paintings by COLOR-FIELD artists such as Helen Frankenthaler. For Pollock and Frankenthaler, the appearance of their work depended partly on chancy processes and the viscosity of specific paints.

MINIMALISM was a crucial catalyst, for process artists reacted against its impersonality and FORMALISM. They sought to imbue their work with the impermanence of life by using materials such as ice, water, grass, wax, and felt. Instead of platonic, abstract forms that would be at home anywhere in the Western world, they made their works "site specific," sometimes by scattering components across a studio floor or outdoor setting.

Process artists' commitment to the creative process over the immutable art object reflects the 1960s interest in experience for its own sake. Also, they hoped to create nonprecious works with little allure for the newly booming art market. Process art should be considered alongside other anti-Minimalist trends of that day such as ARTE POVERA, CONCEPTUAL ART, EARTH ART, and PERFORMANCE ART.

PUBLIC ART

▷ **WHO** Dennis Adams, Stephen Antonakos, Siah ARMAJANI, Alice Aycock, Judy Baca, Scott BURTON, Mark di Suvero, Jackie Ferrara, R.M. Fischer, Dan Flavin, Richard Fleischner, Richard HAAS, Lloyd Hamrol, Michael Heizer, Doug Hollis, Nancy Holt, Robert IRWIN, Valerie Jaudon, Luis Jiminez, Joyce Kozloff, Roy Lichtenstein, Mary Miss, Robert Morris, Max Neuhaus, Isamu NOGUCHI, Claes Oldenburg, Albert Paley, Richard Serra, Tony Smith, Ned Smyth, Alan Sonfist, Athena Tacha

▷ **WHEN** Since the late 1960s

▷ **WHERE** United States

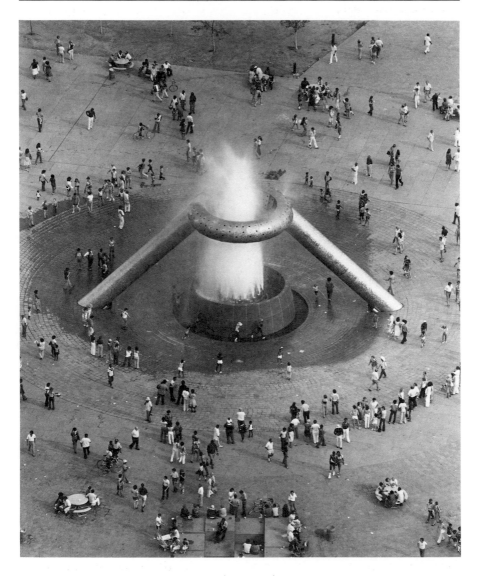

ISAMU NOGUCHI (1904–1988).
Horace E. Dodge and Son Memorial Fountain, 1978. Stainless steel, with granite base, height: 24 ft. Philip A. Hart Plaza, Detroit.

▷ **WHAT** In the most general sense, *public art* is simply art produced for—and owned by—the community. This notion of art is as old as art itself, dating back to prehistoric cave-painting and idol-carving. The history of art encompasses far more examples of public than private art, ranging from the frescoes and sculpture of temples and cathedrals to the commemorative statuary created for public squares.

Radical changes came with MODERN art. The AVANT-GARDE search for the new was incompatible with the aim of reaching a wide public. So, too, was the modernist emphasis on the purity of individual art forms, which mandated that the traditional relationship of sculpture and architecture, for instance, be dissolved. By the late 1950s this had led to the construction of myriad unembellished buildings with ABSTRACT sculptures—what today's architects and public artists jokingly call "plop art"—placed on their sterile plazas.

Public art is related to a couple of government initiatives of the late 1960s: the percent-for-art programs and the National Endowment for the Art's Art in Public Places program. The percent-for-art programs now operating in about half of the states and many cities and counties set aside for art a certain percentage (usually one percent) of the construction budget for a public project. The Art in Public Places program assists communities with funding and expertise in commissioning and acquiring artworks for public sites.

Changes in thinking about the nature of art itself in the late 1960s dovetailed with such official encouragement. Many artists were leaving their studios to create EARTHWORKS and other environmental forms that demanded an architectural rather than a studio scale. The challenges of realizing such complex projects provided artists with not merely the necessary skills but also the willingness to collaborate and hence abandon the complete control that comes from working in a studio.

Hostility to a small number of public artworks that some observers found inappropriate led to heated controversies in the 1980s. Maya Lin's abstract Vietnam War Memorial in Washington, D.C., was augmented with Frederick Hart's more conventional FIGURATIVE sculpture, and Richard Serra's SITE-SPECIFIC *Tilted Arc* sculpture was removed from its lower Manhattan site in 1989 after years of legal and administrative wrangling. One outcome of such disputes has been the widespread adoption of procedures that encourage greater community input and bring artists into the design process at an earlier stage.

Public artworks range from Joyce Kozloff's tiled murals in subway stations to Max Neuhaus's SOUND SCULPTURES for similar sites; from Isamu Noguchi's multi-

acre parks and plazas to Richard Haas's trompe-l'oeil murals that transform
drab walls into architectural fantasies, and from Dennis Adams's politically
probing bus-shelter images to Judy Baca's murals of the history of Los Angeles
and its Hispanic communities painted on the concrete walls of the Los Angeles
River. Artists are even designing what were once anonymous architectural
elements, such as seating, lighting, and ornamental pavements.

READYMADE—*see* FOUND OBJECT

REALISM

Realist art—like realist literature—originated in mid-nineteenth-century
France. It was pioneered by the painter Gustave Courbet, who announced
that never having seen an angel, he could certainly never paint one. His
resolve to be truthful to his own experience made him a forebear of
MODERNISM.

In its original, nineteenth-century sense, *realism* implied not just the accurate
depiction of nature, but an interest in down-to-earth everyday subjects.
Naturalism referred only to an artist's fidelity to appearances. Carried to its
illusionistic extreme, naturalism results in *trompe-l'oeil*—literally "fool-the-
eye"—painting. By the mid-twentieth century the distinction between the two
had largely disappeared, and today *realism* and *naturalism* are used inter-
changeably.

Apart from the SURREALISTS, who invented a naturalistic style of portraying their
often unnatural dreams, and the German artists of the *Neue Sachlichkeit* (or
New Objectivity) movement, who laced their realist portraits with biting psy-
chological insights, AVANT-GARDE artists rejected realism in favor of ABSTRACTION.
(*Neue Sachlichkeit* and Surrealist artists were roundly criticized for their use of
recognizable figurative imagery.) During the 1950s realism disappeared from
critical consideration, only to emerge at the end of the decade with POP ART
and NEW REALISM. The scope of today's realism is capacious, most of it falling
into the loose category of New Realism. Effective realist art, such as Eric
Fischl's psychologically charged renderings of domestic drama, recalls the
nineteenth-century sense of the term as a powerful means of commenting
on—and illuminating—contemporary experience.

REGIONALISM

Regionalism has two meanings—one that predates World War II and one that follows it. The earlier use, which gained currency in the mid-1930s, applies to American artists of that day who rejected MODERNISM in favor of developing independent styles. The Regionalists—also known as the American Scene painters—included Thomas Hart Benton, Grant Wood, and John Steuart Curry. Although they were usually regarded as conservative defenders of family and flag, this view is oversimplified. Benton, for instance, held unorthodox views that were evident in his satirical paintings of midwestern life.

A second meaning of regionalism has emerged since World War II and New York's apotheosis as international art capital. As New York claimed center stage, artists in other centers of art-making activity, such as Los Angeles, San Francisco, and Chicago, were relegated to marginal status. (Artists who worked in NEW YORK SCHOOL—derived modes were considered mainstream no matter where they lived.)

Regionalism tends to be used pejoratively, with the connotation of provincialism. Unlike the prewar Regionalist "school," latter-day regionalism is largely a function of geography rather than philosophy. New York remains the center of the international art world, but its dominance is being challenged. Decentralization has been fueled by real-estate costs that make New York a prohibitively expensive place for artists and critics to live, by the emergence of regional art publications such as the *New Art Examiner* that provide alternative viewpoints, and by the emergence of art schools such as the California Institute of the Arts, which educated many of the most eminent American artists of the 1980s. The virtually instant communication available today suggests that the notion of a physical center and outlying regions may soon be irrelevant.

See BAY AREA FIGURATIVE STYLE, CHICAGO IMAGISM, LOS ANGELES "LOOK"

REPRESENTATION

A representation is a depiction of a person, place, or thing. *Representational* refers to artworks with a recognizable subject, as opposed to works that are termed ABSTRACT.

The interpretation of representations is nearly synonymous with the study of images and symbols known as *iconography.* The study of representations may, however, range further afield than those of iconography, to address the

mass media or aspects of POPULAR CULTURE such as advertising, which had previously been outside the art historian's scope. Such analyses are often interdisciplinary. The study of representations of the elderly, for example, might encompass images and texts found in the news media, film, advertising, and art of various cultures.

RUBBER-STAMP ART—*see* FLUXUS

SALON—*see* ACADEMIC ART

SCHOOL OF PARIS

School of Paris is a rather vague term for numerous movements in MODERN art that emanated from Paris during the first half of the twentieth century. Chief among them were Fauvism, Cubism, and SURREALISM.

The term also refers to Paris's pre-eminent position as the center of modern art from its inception until World War II. Following the war the United States came to dominate art making among the Western allies, just as it dominated the group's political and economic life. *The New York School*—beginning with ABSTRACT EXPRESSIONISM and including, according to some observers, COLOR-FIELD PAINTING and MINIMALISM—is invariably invoked in triumphant opposition to the School of Paris it "dethroned."

SEMIOTICS

All communication requires the use of signs, language itself being the most universal system of signs. Semiotics is the science of those signs. Although the term is several hundred years old, semiotics is largely a twentieth-century phenomenon. Semiotic analysis has been trained on numerous subjects, ranging from snapshots and comic strips to body language and the barking of dogs. Artists and critics became interested in it during the 1960s following the emergence of POP ART, which rejected the language of art in favor of that of advertising. CONCEPTUAL artists used the languagelike codes of the mass media, structural anthropology, and other disciplines previously outside the scope of art and impervious to FORMALIST criticism.

Semiotics is rooted in separate investigations by the Austrian philosopher Ludwig Wittgenstein and the Swiss linguist Ferdinand de Saussure early in this century. Instead of analyzing classical philosophical propositions or concepts involving ethics or aesthetics, they analyzed the language in which they were couched in search of their underlying nature and biases. Their work foretold the increasingly important role of communications and the packaging and pro- motion of ideas in MODERN culture. They noted that language provides the chief metaphor for organizing meaning, used to describe phenomena as dis- similar as the "genetic code" and the "fashion vocabulary."

Semiotics has provided an analytical tool for writers: Roland Barthes used it to analyze photography, and Umberto Eco applied it to architecture. Some artists—including the Conceptual and FEMINIST artists Judith Barry, Victor Burgin, Hans Haacke, and Mary Kelly—*deconstruct* social stereotypes, myths, and clichés about gender and power that are communicated and reinforced by mass-media sign systems. *Deconstruction* is a semiotics-derived analysis that reveals the multiplicity of potential meanings generated by the discrepancy between the ostensible CONTENT of a "text"—which may be a work of art—and the system of visual, cultural, or linguistic limits from which it springs.

One and Three Chairs (1965), by the Conceptual artist Joseph Kosuth, exempli- fies a semiotic approach to the nature of meaning. It comprises a wooden folding chair, a full-scale photograph of that chair, and the dictionary definition of *chair*. In the vocabulary of semiotics the wooden chair is a "signifier," the definition of *chair* is the "signified"; and together they equal the "sign." Kosuth augmented this simple equation by providing the photograph of the chair as a substitute for the viewer's perception of the real chair, thereby suggesting that art—unlike semiotics—may not be reducible to scientific principles.

SET-UP PHOTOGRAPHY—*see* FABRICATED PHOTOGRAPHY

SHAPED CANVAS

▷ **WHO** Lucio Fontana (Italy), Ellsworth KELLY, Kenneth Noland, Leon Polk Smith, Richard Smith (England), Frank STELLA

▷ **WHEN** 1960s

▷ **WHERE** United States and Europe

SHAPED CANVAS

FRANK STELLA (b. 1936).
Darabjerd III, 1967. Synthetic polymer on canvas, 120 x 180 in.
Hirshhorn Museum and Sculpture Garden, Smithsonian Institution,
Washington D.C.; Gift of Joseph H. Hirshhorn, 1972.

▷ **WHAT** Paintings are usually rectangular, but circular pictures, or tondos, were popular in Europe during the Renaissance and there are examples of oval- and diamond-shaped canvases in early twentieth-century art. The term *shaped canvas* gained currency as more than a neutral descriptor with the exhibition of Frank Stella's "notched" paintings at the Leo Castelli Gallery in September 1960. These were MINIMALIST paintings in which symmetrically arranged pinstripes echoed the unconventional shape of the stretched canvas. The imagery and the underlying canvas were integrated; the painting became less an illusionistic rendering than an independent object, the two-dimensional counterpart of Minimalism's three-dimensional PRIMARY STRUCTURES.

Although such works sometimes seemed to synthesize painting and sculpture, the intention was precisely the opposite. A single, extremely flat surface was maintained, in contrast to later multilevel three-dimensional ASSEMBLAGES and reliefs, most notably by Stella himself, that did obliterate the distinction between painting and sculpture. Contemporary painters have put the non-rectangular format to a variety of different purposes, ranging from the fragmented imagery spread across Elizabeth Murray's brash multicanvas works to the spirituality of Ron Janowich's ABSTRACTIONS.

SIMULACRUM—*see* SIMULATION

SIMULATION

A simulation is a replica, something false or counterfeit. The terms *simulation* and *simulacrum* (the plural is *simulacra*) are virtual synonyms in current art parlance. Although *simulation* can accurately be used to describe a forgery or the reenactment of a newsworthy event, in the art world it usually refers to the POSTMODERN outlook of Jean Baudrillard and other French thinkers whose beliefs became influential in the late 1970s.

Baudrillard asserts that we can no longer distinguish reality from our image of it, that images have replaced what they once described. Or, in the SEMIOTIC language of "The Precession of Simulacra," published first in the September 1983 issue of *Art & Text*, "It is no longer a question of imitation, nor of reduplication . . . [but] of substituting signs of the real for the real itself." Responding to the new technology that facilitates the endless reproduction or cloning of information and images—television, facsimile machines, even genetic engineering—Baudrillard suggests that the notion of authenticity is essentially meaningless. His work poses the questions: What is an original? And where

do public events leave off and the flow of images representing and interpreting them begin?

Baudrillard's line of reasoning dovetailed with some artists' concerns about the meaning of originality at the end of the MODERN era, an epoch that had placed so high a premium on AVANT-GARDE originality. Artists such as Sarah Charlesworth, Clegg and Guttmann, Peter Halley, Barbara Kruger, Sherrie Levine, Allan McCollum, and Richard Prince—and critics writing about them— often referred to Baudrillard's notion of the simulacrum. Many of these artists are associated with APPROPRIATION, the self-conscious use of images culled from art history or POPULAR CULTURE. During the mid-1980s the term *simulationism* was briefly popular.

SITE SPECIFIC—*see* INSTALLATION

SITUATIONISM

▷ **WHO** André Bertrand (France), Benjamin Constant (Netherlands), Guy DEBORD (France), Asger JORN (Denmark), Giuseppe Pinot Gallizio (Italy), Spur Group (Germany)

▷ **WHEN** 1957 to 1972

▷ **WHERE** Western Europe

▷ **WHAT** The Situationist International was founded in 1957 when two earlier AVANT-GARDE groups—the Lettrist International and the Movement for an Imaginist Bauhaus—formally merged. Highly theoretical, Situationism emerged from an analysis of Western society that indicted capitalism for its transformation of citizens into passive consumers of the depoliticized media spectacle that had replaced active participation in public life. (This viewpoint is best articulated in Guy Debord's influential 1967 book, *Society of the Spectacle.*)

Situationism's roots can be traced back to the SURREALIST mission of radically disrupting conventional, bourgeois life. It can, in fact, be considered a post-war form of Surrealism, in which the emphasis on the psychological unconscious was replaced by an interest in the concepts of *détournement* (diversion or displacement), *dérive* (drift), and *urbanisme unitaire* (integrated city life). *Urbanisme unitaire* necessitated the creation of artworks that crossed the boundaries separating art forms—paintings larger than buildings, for

instance—and of urban environments as locales for *Situations*, or meaningful social interactions.

These theoretical concerns were translated into a variety of artistic approaches with a shared intellectual foundation but no common STYLE. Asger Jorn exhibited "détourned" works painted over partially obliterated cheap reproductions of art, calling into question the value of originality and authorship. Giuseppe Pinot Gallizio created 145-meter-long, city-scaled "industrial" paintings satirizing automation, which he sold by the meter. Magazines, posters, and films were also produced, primarily by the Spur Group and Debord.

By the mid-1960s Situationist art making had largely given way to theoretical writing and political organizing. The French general strike of May 1968 owed much to Situationist ideas and was immortalized in the Situationist posters and cartoons that embodied the goals of the student Left. The Situationist International was dissolved in 1972. A major Situationist exhibition, *On the Passage of a Few People through a Rather Brief Moment in Time*, was mounted by the Centre Georges Pompidou in 1989 and proved controversial in its attempt to present this highly politicized movement through art objects and historical artifacts.

Situationism vitally influenced the development of British punk art, inspired some European CONCEPTUAL and ARTE POVERA artists, and presaged the strategies of POSTMODERNISTS like Barbara Kruger and Richard Prince, who subvert the visual idioms of advertising.

SNAPSHOT AESTHETIC

▷ **WHO** Larry Clark, Bruce Davidson, Robert FRANK, Lee FRIEDLANDER, Joel Meyerowitz, Garry WINOGRAND

▷ **WHEN** Late 1950s through 1970s

▷ **WHERE** Primarily the United States

▷ **WHAT** The vast majority of twentieth-century photographs have been either photojournalistic images or snapshots taken by amateurs. The least self-conscious or sophisticated of photographic approaches, amateur snapshots follow certain conventions determined by the camera itself and by popular ideas about what a photograph should look like.

Snapshots are almost invariably views of people or the landscape, made at eye

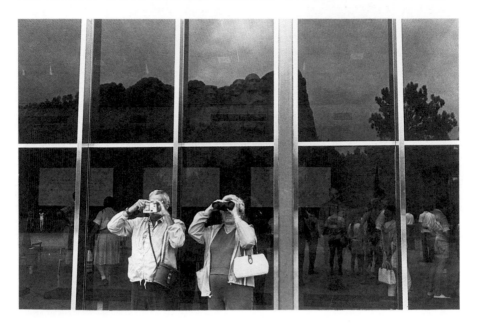

LEE FRIEDLANDER (b. 1934).
Mount Rushmore, South Dakota, 1969. Gelatin-silver print,
7 7/16 x 11 1/8 in. Philadelphia Museum of Art; Purchased with a grant
from the National Endowment for the Arts and matching funds con-
tributed by Lynne and Harold Honickman, the J. J. Medveckis
Foundation, Harvey S. Shipley Miller and J. Randall Plummer, and
D. Robert Yarnall, Jr.

level, with the subject in middle distance and in natural light. The central placement of the subject often allows random bits of reality to sneak into the edges of the picture. It is this unplanned "marginalia" that endows some snapshots with a complexity and humanity otherwise achieved only by the most skilled professional photographers.

During the 1960s and 1970s this naive but powerful approach exerted a tremendous influence on art photography. The originator of this aesthetic was Robert Frank, who in 1959 published a book of black-and-white photographs called *The Americans*. This Beat-era, on-the-road vision of America as an amalgam of parking lots, gas stations, backyards, and small-town politicians and their constituents was simultaneously a compelling and a damning look at the frequently romanticized small-town American scene. Frank's project was revolutionary not merely for his sometimes mundane subjects but also for the relatively straightforward STYLE of his pictures. Although it rejected the ennobling, even mystical aims of Ansel Adams, Alfred Stieglitz, Edward Weston, and other pioneers of STRAIGHT PHOTOGRAPHY, the camera-derived, unembellished snapshot aesthetic is a tributary of the straight photographic mainstream.

The irony and detachment inherent in the snapshot aesthetic aligned it with POP ART, which was developing at the same time. Both took as their point of departure the world as it is, rather than as it ought to be. Garry Winogrand and Lee Friedlander, for example, produced pictures about American rites, foibles, and obsessions previously unexplored by photographers. Their often random-looking compositions attempted to embody the flux and flow of rapidly changing contemporary lifestyles, usually with tongue-in-cheek humor. The apparent artlessness of such work masked its own conventions, including the production of relatively small prints and virtually exclusive use of black-and-white—rather than color—film.

SOCIAL REALISM

Social Realism is a term with two meanings, one coined prior to World War II, the other after. The original meaning refers to leftist political art produced during the 1920s and 1930s, primarily in the United States, Mexico, Germany, and the Soviet Union. It was not originally used to mean any particular STYLE, and Social Realist works range from the ambitious Mexican mural cycles by Diego Rivera and José Clemente Orozco to the paintings on topical themes of class struggle by the American Ben Shahn. The bias of Social Realism against

ABSTRACTION and toward the didactic illustration of political subjects gave it a pronounced anti-MODERNIST flavor.

Today, *Social Realism* (often mistakenly called *Socialist Realism*) has become a pejorative term for banal, REALIST images of the working class meant to be accessible to every viewer, of any age or IQ. It is frequently, though not exclusively, identified with communist countries, including the Soviet Union, China, and North Korea. Such propagandistic works have been produced by the thousands, but Social Realism is no longer the officially sanctioned art-making approach anywhere.

SOTS ART

▷ **WHO** (all Soviet born) Eric BULATOV, Valeriy Gerlovin and Rimma Gerlovina, Ilya Kabakov, Kazimir Passion Group, KOMAR and MELAMID, Alexander Koslapov, Leonid Lamm, Leonid Sokov, Alexander Yulikov

▷ **WHEN** Since the early 1970s

▷ **WHERE** Europe, United States, and USSR

▷ **WHAT** The term *Sots art* was coined by Komar and Melamid in 1972 in Moscow, where the now American-based collaborators were then living. A friend had likened the mass-cultural imagery they were using to Western POP ART, which inspired their ironic wordplay on Socialist art.

Socialist stood for the SOCIAL REALIST view of art that had dominated Soviet culture since the time of Stalin. A Soviet doctrine promulgated in 1934 demanded artworks "national in form and Socialist in content." By the end of the 1960s official artistic production had degenerated into hackneyed ACADEMIC images of Revolutionary heroes and heroines, assembly lines, and workers on tractors.

Artists began to APPROPRIATE and subvert these clichéd images of nationalism, gender, and power. To do this, they utilized parody, ironic juxtapositions, and dislocating backdrops against which they set their subjects. Komar and Melamid, for instance, painted a 1972 double self-portrait of themselves in the manner of countless state portraits of Lenin and Stalin; Leonid Sokov created viciously satirical sculptures of Soviet leaders.

These "unofficial"—as opposed to government-supported—artists found it impossible to exhibit their work in the USSR. The Sots art group issued a

manifesto and tried to participate in an open-air exhibition of 1974, which was dubbed the "Bulldozer" show after officials mowed it down. In the wake of the ensuing international criticism a follow-up show was mounted two weeks later, but the Sots artists were never permitted to hold a group exhibition exclusively devoted to their work.

During the 1970s many of the Sots artists were allowed to emigrate, primarily to New York. (Not until the inception of Gorbachev's *glasnost* in the late 1980s would the line separating "official" and "unofficial" art begin to dissolve.) The first major New York exhibition offering Sots art was Komar and Melamid's 1976 show (smuggled out of Moscow) at Ronald Feldman Fine Arts; the most important was the traveling group show *Sots Art*, mounted by the New Museum of Contemporary Art in 1986.

Sots art is the first AVANT-GARDE art movement within the USSR since the 1930s. The Pop art–like irreverence of Sots art, its interest in mass communication and cultural signs (or SEMIOTICS), and its appropriation-based method all link it with the international rise of POSTMODERNISM in the late 1970s.

SOUND ART

▷ **WHO** Laurie Anderson, John Anderton (Great Britain), Chris Apology, Rosland Bandt (Australia), Connie Beckley, Charles and Mary Buchner, Phil Dadson (New Zealand), Paul Earls, Brian Eno, Terry FOX, Doug HOLLIS, Paul Kos, Alvin Lucier, Tom Marioni, Max NEUHAUS, Bruce Nauman, Pauline Oliveiros, Dennis Oppenheim, Nam June Paik, Jill Scott (Australia), Wen-ying Tsai (China), Yoshi Wada

▷ **WHEN** 1970s

▷ **WHERE** International

▷ **WHAT** The *art* half of the term *sound art* announces that such works, composed primarily of sound, are made by visual artists (or by crossover PERFORMANCE artists). Sound art is usually presented in visual-art venues—galleries, museums, environments, and PUBLIC ART and performance sites—or on audio-cassette "magazines."

Luigi Russolo first assailed the division between art and music with his 1913 Futurist manifesto *The Art of Noise* and with his orchestras of strange instru-

ments (gurglers, shatterers, buzzers, and the like) used to suggest the auditory ambience of the street. What would become the CONCEPTUAL ART aspect of this art-music fusion was initiated when a screw was allegedly dropped into DADA artist Marcel Duchamp's READYMADE, *A Bruit secret (With Hidden Noise)* (1916). After World War II, Duchamp's disciple John Cage continued in this spirit with his silent compositions designed to focus attention on ambient sound. They were predicated on Cage's assertion that "Music never stops, only listening." HAPPENINGS and FLUXUS events frequently included sound or music.

Sound sculpture took off as a Conceptual art form beginning in the late 1960s and, like so many other Conceptual art forms, peaked in the 1970s. Many Conceptual artists, including Bruce Nauman and Jill Scott, created sound works while simultaneously working in other media such as INSTALLATIONS and video. Two 1970 shows—at New York's Museum of Contemporary Crafts and San Francisco's Museum of Conceptual Art—suggested how widespread the use of sound by artists was becoming.

Today artists are using sound to chart a variety of courses. Some, including Laurie Anderson, incorporate pop music within their theatrical performances. Others, such as Brian Eno, Doug Hollis, and Max Neuhaus, create subtly textured sound environments. Hollis's outdoor works, for instance, are sometimes triggered by natural phenomena such as the wind. It is environments such as these, which focus almost entirely on the aural, that are most often considered "sound art." Chris Apology puts sound to highly conceptual purposes in the *Apology Line*, an interactive phone service in New York in which callers may apologize and hear confessions by others.

STAGED PHOTOGRAPHY—*see* FABRICATED PHOTOGRAPHY

STAIN PAINTING—*see* COLOR-FIELD PAINTING

STORY ART—*see* NARRATIVE ART

STRAIGHT PHOTOGRAPHY

▷ **WHO** Ansel ADAMS, Berenice Abbott, Diane ARBUS, Eugène Atget (France), Bill Brandt (England), Henri CARTIER-BRESSON (France), Imogen Cunningham, Walker EVANS, Robert FRANK (Switzerland), Lee Friedlander, Lewis Hine, Dorothea Lange, Albert Renger-Patzsch (Germany), Alfred STIEGLITZ, Paul Strand, Edward Weston, Garry Winogrand

▷ **WHEN** 1900 through 1970s

▷ **WHERE** Europe and the United States

▷ **WHAT** The term *straight photography* probably originated in a 1904 exhibition review in *Camera Work* by the critic Sadakichi Hartmann, in which he called on photographers "to work straight." He urged them to produce pictures that looked like photographs rather than paintings—a late nineteenth-century approach known as *Pictorialism*. To do so meant rejecting the tricky darkroom procedures that were favored at the time, including gum printing, the glycerine process, and scratching and drawing on negatives and prints. The alternative demanded concentrating on the basic properties of the camera and the printing process.

The great MODERNIST tradition of straight photography resulted from the thinking of Hartmann and many others. It featured vivid black-and-white photographs ranging from Eugène Atget's luminous images of a rapidly disappearing Parisian cityscape to Imogen Cunningham's striking nudes of her husband on Mount Rainier. It was often considered equivalent, especially during the first half of the century, to documentary photography—loosely, the pictorial equivalent of investigative reporting. Documentary photography was epitomized by Lewis Hine's turn-of-the-century images of slum dwellers and the government-sponsored portraits of the Depression-era poor by Walker Evans and Dorothea Lange.

Straight photography is so familiar that it is easy to forget that it is an aesthetic, no less artificial than any other. The fact that black-and-white pictures may look more "truthful" than color prints, for instance, points to just one of straight photography's highly influential conventions. After World War II the orthodoxies of straight photography began to be challenged. Unconventional approaches emerged, including an interest in eccentric lighting, blurred images of motion, and tilting of the frame for expressive effect. So, too, was there widespread interest in the SNAPSHOT AESTHETIC, and finally, even the use of color.

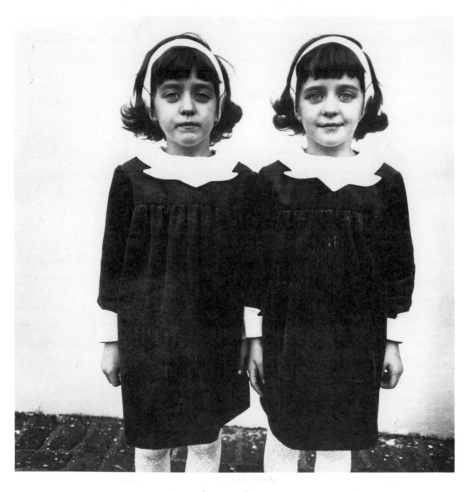

DIANE ARBUS (1923–1971).
Identical Twins, Roselle, New Jersey, 1966. Gelatin-silver print,
14 3/4 x 14 1/4 in. Collection, The Museum of Modern Art, New York;
Richard Avedon Fund.

The debate over whether photography is an art raged for nearly a century. The early twentieth-century photographer, publisher, critic, and gallery owner Alfred Stieglitz linked straight photography's destiny to modernism by simultaneously championing it along with modern painting and sculpture. While straight photographs have been exhibited in museums and galleries since 1909, a market for them did not really develop until the 1970s, when painting and sculpture in traditional formats were in unusually short supply.

Straight photography has lost much of its prestige as POSTMODERN photographers have rejected its once-dominant tenets. They now produce works that counter the purist emphasis on straight photographic process (MANIPULATED PHOTOGRAPHY), on documentary veracity (FABRICATED and MANIPULATED PHOTOGRAPHY), and on maintaining the distinction between art and POPULAR CULTURE (FASHION AESTHETIC).

STYLE

There is no such thing as a work of art without a style. The idea of style as defined by art history is rooted in the belief that artworks from a particular era (the T'ang Dynasty, the Italian Renaissance, the 1960s) share certain distinctive visual characteristics. These include not only size, material, color, and other FORMAL elements, but also subject and CONTENT.

Artists cannot transcend the limits of their era. (Forgeries of Jan Vermeer's seventeenth-century works that were painted by the notorious forger Hans van Meegeren fifty years ago seemed authentic then but now loudly announce themselves as works of the 1930s and '40s.) Without the twentieth-century tradition of spatially flattened abstraction behind them, it's difficult to imagine that the PATTERN-AND-DECORATION artists of the 1970s would have turned to Middle Eastern rugs and tiles for inspiration. If consumer society had not mushroomed after World War II, POP ART could not have come into being.

Other factors such as locale, training, and perhaps even gender—this has been the subject of heated debate among feminists and nonfeminists—affect the styles of individual artists. A multitude of personal styles contribute to the stylistic currents of a given era. No artist's style is likely to completely embody any one particular style; it is, after all, individuality and personality that contemporary Westerners value in art.

SURREALISM

▷ **WHO** Jean (Hans) Arp (Germany), Joseph Cornell, Salvador Dali (Spain), Max ERNST (Germany), Frida Kahlo (Mexico), René Magritte (Belgium), André MASSON (France), Matta (Chile), Joan MIRO (Spain), Meret Oppenheim (Switzerland), Pablo Picasso (Spain), Man Ray, Yves Tanguy (France), Remedios Varo (Mexico)

▷ **WHEN** 1924 to 1945

▷ **WHERE** Primarily in Europe, but also in Latin America and the United States

▷ **WHAT** Surrealism, the movement that dominated the arts and literature during the second quarter of the twentieth century, is included here because it is central to MODERN art. Its enduring importance derives from both its innovative subjects and its influence on postwar ABSTRACT painting.

The term *Surrealism* is now used too indiscriminately. It was coined by the French poet Guillaume Apollinaire in 1917 to refer to his freshly minted drama *Les Mamelles de Tirésias* and to Pablo Picasso's set designs for the ballet *Parade.* Its meaning was articulated by the French poet André Breton in the first "Manifesto of Surrealism" (1924), which is Surrealism's birth certificate. Breton defined it as "pure psychic automatism by which it is intended to express . . . the true function of thought. Thought dictated in the absence of all control exerted by reason, and outside all aesthetic or moral preoccupations."

Surrealism is a direct outgrowth of DADA; the two are often considered in tandem, and the Dada artists Max Ernst and Jean Arp were bridges to Surrealism. Dada contributed such essentials as experimentation with chance and accident, interest in FOUND OBJECTS, BIOMORPHISM, and automatism (pictorial free association). The Surrealists gave these Dada concerns a psychological twist, helping to popularize the Freudian fascination with sex, dreams, and the unconscious.

During the 1920s two styles of Surrealist painting developed. The first is exemplified by the bizarre, hallucinatory dream images of Salvador Dali and others, which are rendered in a precise, REALIST style. To many observers, that return to illusionistic FIGURATION marked a regressive step in the course of increasingly abstract modern art. This sort of dream imagery entered the popular imagination not only through art but also via film, fashion, and advertising.

The second, actually earlier, Surrealist approach was the automatism favored by Joan Miró and André Masson. Lyrical and highly abstract, their composi-

tions present loosely drawn figures or forms in shallow space that evoke Native American pictographs and other forms of non-European art.

The Paris-based Surrealists remained an organized cadre of writers and artists throughout the 1930s. Hitler's rise to power and the prospect of war sent many of them to New York. There they provided the role models for Arshile Gorky, the last of the official Surrealist painters, and the artist who helped point the way from the automatic variety of Surrealism to ABSTRACT EXPRESSIONISM.

SYNESTHESIA—*see* ABSTRACT/ABSTRACTION

SYSTEMIC PAINTING—*see* COLOR-FIELD PAINTING

TACHISME—*see* ART INFORMEL

TRANSAVANTGARDE

▷ **WHO** (all Italian) Sandro Chia, Francesco Clemente, Enzo Cucchi, Nicola De Maria, Mimmo Paladino, Remo Salvadori

▷ **WHEN** Late 1970s to mid-1980s

▷ **WHERE** Italy

▷ **WHAT** The term *Transavantgarde* is the invention of the Italian critic Achille Bonito Oliva. He has defined Transavantgarde art as traditional in format (that is, mostly painting or sculpture); apolitical; and, above all else, eclectic. The Transavantgarde artists APPROPRIATE images from history, POPULAR CULTURE, and non-Western art.

Oliva's characterization of the Transavantgarde is essentially a definition of NEO-EXPRESSIONISM, coined before that term caught on. Although he intended his description to apply to the international Neo-Expressionist mainstream that emerged in the early 1980s, it has become identified only with Italian artists of that sensibility.

VIDEO ART

▷ **WHO** Vito Acconci, Max Almy, Laurie Anderson, ANT FARM, Robert Ashley, Stephen Beck, Dara Birnbaum, Colin Campbell (Canada), Peter D'Agostino, Douglas Davis, Juan Downey, Ed Emshwiller, Terry Fox, Howard Fried, Gilbert and George (Great Britain), Frank Gillette, Dan Graham, John Greyson (Canada), Doug Hall, Julia Heyward, Gary Hill, Rebecca Horn (Germany), Joan Jonas, Michael Klier (Germany), Paul KOS, Richard Kriesche (Austria), Shigeko Kubota, Marie Jo Lafontaine (Belgium), Les Levine, Joan Logue, Chip Lord, Mary Lucier, Stuart Marshall (Great Britain), Robert Morris, Antonio Muntadas (Spain), Bruce NAUMAN, Tony Oursler, Nam June PAIK, Adrian Piper, Klaus Rinke (Germany), Ulrike Rosenbach (Germany), Martha Rosler, Jill Scott (Australia), Richard Serra, Michael Snow (Canada), Keith Sonnier, John Sturgeon, Skip Sweeney and Joanne Kelly, Target Video, Top Value Television, T. R. Uthco, Stan Vanderbeek, Woody and Steina Vasulka, Edin Velez, Bill Viola, Bruce and Norman Yonemoto

▷ **WHEN** Since the mid-1960s

▷ **WHERE** International

▷ **WHAT** Video art is video made by visual artists. It originated in 1965, when the Korean-born FLUXUS artist Nam June Paik made his first tapes on the new portable Sony camera and showed them a few hours later at Cafe à Go Go in New York's Greenwich Village.

Video is a medium, not a STYLE. Artists use video technology in remarkably varied ways. Some (including Paul Kos, Mary Lucier, Jill Scott, and Bill Viola) make videotapes to be used in PERFORMANCE ART or in INSTALLATIONS. Others (such as Les Levine, Martha Rosler, and the Vasulkas) create videotapes to be screened on video monitors in art museums or galleries. Still others (including Skip Sweeney and Joanne Kelly, Edin Velez, and the Yonemotos) prefer to broadcast or cablecast their videotapes on television, a modus operandi that requires conforming to the costly technical standards and corporate values of the networks and independent channels. For many video artists, the unresolved relationship of art video and television remains a perennial issue.

The best way to suggest the astonishing variety of video art is to cite a few examples. Frank Gillette's six-monitor video installation *Aransas* (1978) created a portrait of the swampy Aransas landscape that literally surrounded viewers. The German artist Michael Klier's *Der Riese* (*The Giant*, 1983) is a collage of "found" video footage from surveillance cameras. Joan Jonas's *Organic*

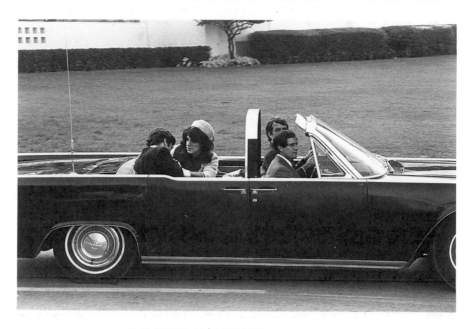

T. R. UTHCO and **ANT FARM.**
The Eternal Frame, 1976. Production still by Diane Andrews Hall.
Collection of the artist.

Honey's Vertical Roll (1973) used the rolling images of poorly adjusted video monitors as an expressive distortion. Ant Farm and T. R. Uthco's *Eternal Frame* (1976), re-creates John Kennedy's assassination in Dallas and raises disturbing questions about our increasingly mediated—or indirect, media-derived experience—of reality. For *Leaving the Twentieth Century* (1982), Max Almy utilized the latest computer-based technology to create special effects rarely seen before in artists' video.

As in performance art, video's CONCEPTUAL ART—oriented first generation has given way to a second, POSTMODERN generation. Almy is typical of that generation, creating works attuned to POPULAR CULTURE rather than critical of it. *Leaving the Twentieth Century*'s high-tech imagery synched to rock music seemed to anticipate the MTV style of music videos, which appeared soon after the release of her tape.

XEROGRAPHY—*see* HIGH-TECH ART

ZEITGEIST

This German word (pronounced tsīt-gīst) has entered the English language untranslated. It literally means "spirit of the time" and suggests the mood and thinking of a given era or, colloquially, "what's in the air." In art terms Zeitgeist refers to certain characteristics of a period or moment: the melancholic introspection of the *fin de siècle* (1890s); the optimism and experimentation of the 1960s; POSTMODERNISM's ironic embrace of tradition and history.

Page numbers in **boldface** refer to main entries for art movements, art forms, and critical terms.
Page numbers in *italics* refer to illustrations.

155; fashion aesthetic in, **75—76**, 155; manipulated, **96—98**, *97*, 155; snapshot aesthetic in, 14, **147—49**, *148*, 153; straight, 98, 149, **153—55**, *154*

photomontage, 59

Photo-Realism, 23, **124**, *125*

Photo-Transformation, November 12, 1973, (Samaras), *97*

Picabia, Francis, 43, 69, 70

Picasso, Pablo, 27, 28, 35, 40, 42, 50, 52, 56, 59, 60, 66, 67, 71, 81, 91, 107, 127, 133, 156

pictorialism, 153

picture plane, 103, **126**

Piene, Otto, 43

Pincus-Witten, Robert, 22, 101

Pindell, Howardena, 59

Piper, Adrian, 158

Pistoletto, Michelangelo, 47, 90; work by, *18*

pluralism, 41, **126—27**

political art, *24*, **127—28**

Polke, Sigmar, 42, 128

Pollock, Jackson, 11, 36—37, 46, 62, 84, 88, 122, 127, 137; work by, *9*

Poons, Lawrence, 61, 117

Pop art, 11, 13, 14, *16*, 17, 20, 42, 43—44, 56, 62, 81, 88, 90, 94, 96, 98, 103, 106, 108, 110, 112, 113, 116, 124, 126, **128—29**, 130, 132, 140, 142, 149, 150, 151, 155

popular culture, 63, 78, 82, 94, 98, 122, 128—29, **129—30**, 132, 142, 146, 157, 160

Porter, Fairfield, 113, 115

Portland Public Services Building (Graves), 28

Portrait of George (Arneson), *14*

Portrait of Willem Sandberg (Appel), *58*

post-, **130—31**

Post-Graffiti, 29, 86

Post-Impressionism, 103, 130

Post-Minimalism, 22, 101, 130

postmodernism, 15, 19, 27, 38, 40, 42, 50, 74, 78, 81, 89, 94, 111, 113, 129, 130, **131—33**, 145, 147, 151, 155, 160

post-painterly abstraction. *See* color-field painting

Post-Painterly Abstraction, 18, 61, 120

Prater, Chris, 135

Pre-Raphaelites, 37

Presence of the Past, The, 27

Price, Kenneth, 56, 95

primary structure, 19, 88, 101, 145. *See also* Minimalism

Primary Structures, 19, 101

primitivism, 57, 59, 74, 103, 104, 107, **133—34**. *See also* Art Brut; naive art

Prince, Richard, 42, 48, 146, 147

print revival, 13, 50, 106, **134—35**

Prinzhorn, Hans, 44

Probing the Earth, 25—26

Procedures/Materials, 21, 137

process art, 21, 47, 62, 72, **135—37**, *136*

P.S. 1 (New York), 116

public art, 20, 32, 50, **137—40**, *138*

Q

Quinones, Lee, 72, 84

R

Raffael, Joseph, 113

Rainer, Arnulf, 38, 96

Rainer, Yvonne, 44, 76, 77

Ramellzee, 84

Ramos, Mel, 128

Randall in Extremis (Neel), *114*

Raphael, 42

Rapoport, Sonya, 88—89

Rath, Alan, 89

Rauschenberg, Robert, 18, 43, 44, 50, 59, 91, 106, 108, 110, 117, 135; work by, *109*

Ray, Man, 69, 70, 106, 156

readymade, 52, 65, 70, 81, 152. *See also* found object

realism, 36, 115, **140**, 150. *See also* Photo-Realism

Redon, Odilon, 40

Reese, Marshall, 98

regionalism, 37, **141**. *See also* Bay Area figurative style; Chicago Imagism

Reinhardt, Ad, 53, 88, 99

René, Denise, 106

Renger-Patzsch, Albert, 153

representation, 35, 78, 115, **141—42**

Responsive Eye, The, 18, 117

Restany, Pierre, 15, 116

retinal art. *See* Op art

Reuben Gallery (New York), 14, 87

Ricard, René, 116

Richon, Olivier, 74

Richter, Gerhard, 42

Rickey, George, 18, 92, 117

Riley, Bridget, 76, 117; work by, *118*

Ringgold, Faith, 69, 76, 107, 108

Rinke, Klaus, 54, 158

Ripps, Rodney, 120

Ritts, Herb, 75

Rivera, Diego, 149

Rivers, Larry, 59

Robinson, Walter, 72

Rockburne, Dorothea, 99

PHOTOGRAPHY CREDITS

The photographers and the sources of photographic material other than those indicated in the captions are as follows:

Courtesy John Berggruen Gallery, San Francisco, page 10;
Courtesy Galerie Saint Etienne, New York, page 20;
Gianfranco Gorgoni, courtesy John Weber Gallery, New York, page 19;
Courtesy Gracie Mansion Gallery, New York, page 32;
© Jasper Johns/VAGA, New York, page 13;
Courtesy Hokin Kaufman Gallery, Chicago, page 25;
Julius Kozlowski, page 22;
Minnette Lehmann, page 55;
© 1985 Les Levine, page 23;
P. Pellion, courtesy of the artist, page 18;
Gary Quesada/Balthazar Korab Photography, Troy, Michigan, page 138;
Scott W Santoro/WORKSIGHT, backcover;
Courtesy Tony Shafrazi Gallery, New York, page 85;
Harry Shunk, page 100;
Courtesy Holly Solomon Gallery, page 79;
Squidds and Nunns, page 9;

© 1974 C page 39.

OFFICIALLY WITHDRAWN